Titian

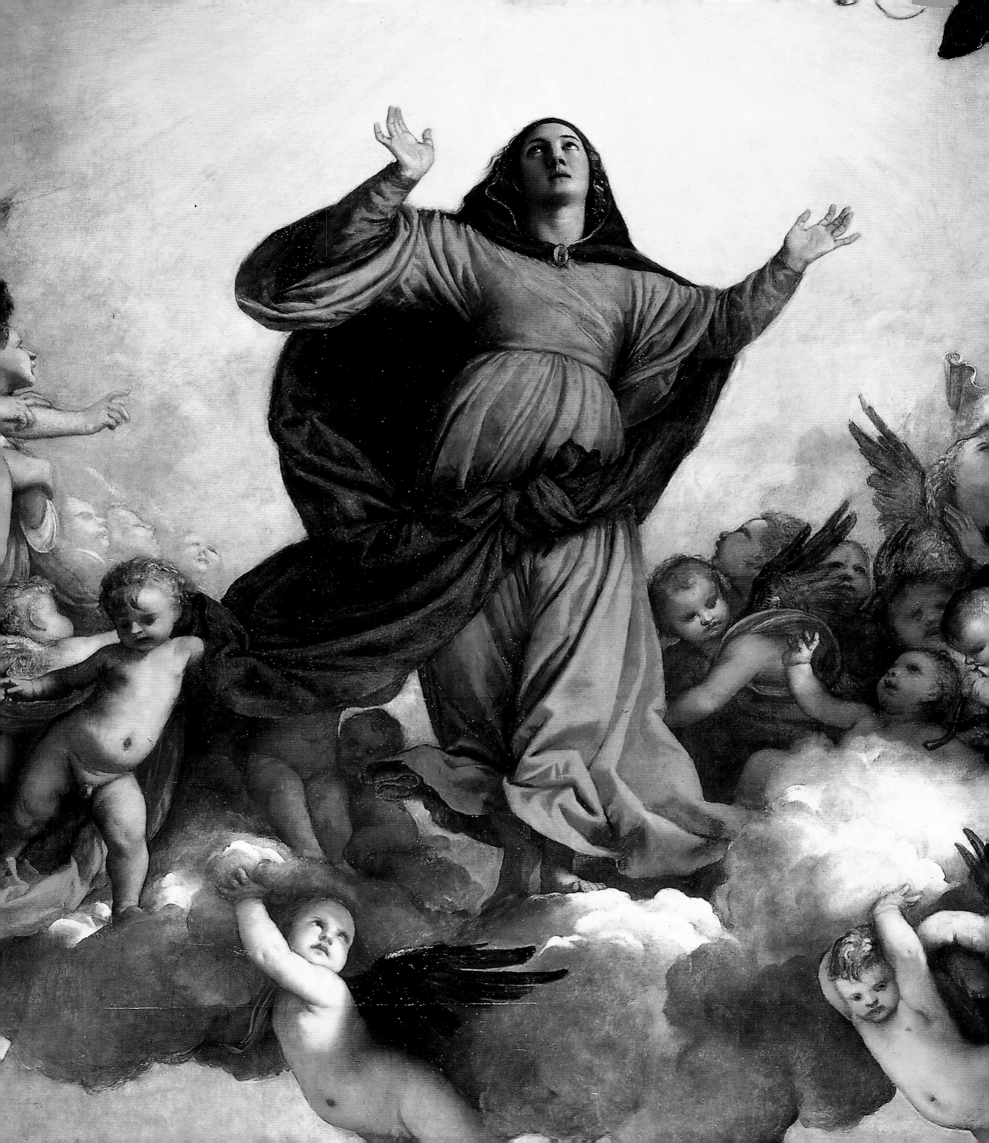

Marion Kaminski

Tiziano Vecellio, known as

Titian

1488/1490–1576

KÖNEMANN

1 (frontispiece)
Assumption of the Virgin (detail ill. 27), 1516–1518
Oil on wood, 690 x 360 cm
Santa Maria Gloriosa dei Frari, Venice

Copyright © 1998 Könemann Verlagsgesellschaft mbH
Bonner Strasse 126, D-50968 Cologne

Art Director: Peter Feierabend
Project Manager and Editor: Ute E. Hammer
Assistant: Jeannette Fentroß
Editor: Anja Eichler
Layout: Andi Huck, Aladdin Jokosha
Production Manager: Detlev Schaper
Assistant: Nicola Leurs
Production: Mark Voges
Reproductions: CLG Fotolitho, Verona

Original title: *Tizian. Meister der italienischen Kunst.*

Copyright © 1998 for the English edition
Könemann Verlagsgesellschaft mbH

Project Manager and Editor: Sally Bald
Assistant: Susanne Kassung
Translation from the German: Fiona Hulse
Contributing Editor: Chris Murray
Typesetting: Greiner & Reichel, Cologne
Production: Mark Voges
Printing and Binding: Neue Stalling, Oldenburg

Printed in Germany

ISBN 3-8290-0257-2

10 9 8 7 6 5 4 3 2

Contents

The Early Years:
Tiziano Vecellio of Pieve di Cadore — Bellini — Giorgione

2 Agostino Caracci
Titian, 1587
Copperplate engraving, 32.7 x 23.6 cm
Staatliche Museen zu Berlin – Preußischer Kulturbesitz,
Kupferstichkabinett, Berlin

This copperplate engraving was completed after a
painting portraying Titian at over sixty years old. The
painting in question is the earliest surviving self portrait
of the artist; there are no portraits of Titian in his youth.

Though biographies were written about Titian while
he was still alive, we do not know when he was
born. One of these accounts of his life was written by
his close friend, the writer and art theorist Lodovico
Dolce (1508–1568). In 1557, in his book entitled
"Dialogue on Painting, or L'Aretino", Dolce writes
that Titian was about twenty years old when he was
working in the "Fondaco dei Tedeschi" in 1507. A
second biographer, the Florentine artist, architect and
art historian Giorgio Vasari (1511–1574) also gave
Titian's date of birth as being in about 1488 or 1490.
Despite this, it was for a long time believed that Titian
had been born very much earlier, around 1476. The
reason is that in a letter written to the king of Spain
in 1571, Titian himself claims to be 95 years old.
He probably did this, however, to speed up long
overdue payments. If it were true, it would mean that
he was about a hundred years old when he died in
1576. But even if he was not born until about 1490 –
which the chronology of his works shows to be much
more likely – he would still have enjoyed an
exceptionally long and creative life. During the course
of almost 70 years, Titian succeeded in constantly
renewing and developing his art in a way scarcely any
other artist has succeeded in doing either before or
since.

During the last few years of the 15th century,
Tiziano Vecellio, then aged about nine or ten, came to
Venice with his elder brother Francesco, who was also
to become a painter, in order to start his training at the
workshop of the mosaicist Sebastiano Zuccato
(?–1527). They came from the small alpine village of
Pieve di Cadore, now about 40 kilometers from the
Austrian border, where their family had lived for many
years. Their parents, Lucia and Gregorio di Conte dei
Vecelli, were respectable people of modest means.
Their grandfather had successfully defended his native
village against the army of Emperor Maximilian. It is
not known why Titian's father sent his sons to their
uncle in Venice in order to be trained as artists. But he
will always indisputably deserve the credit of having
recognized and fostered their talent.

At the beginning of the 16th century, the city to
which the brothers moved was one of the most densely
populated in Europe. The Venetians were proud to call
their city state – which at this time owned large tracts
of land on the mainland called the "Terraferma", and
in Istria and the south-east Mediterranean – a republic.
It was ruled by aristocrats, and it was from amongst
them that the Senate and the Doge – the head of state
whose duty it was to attend official functions – were
elected. Next, there was a layer of wealthy citizens, the
cittidani; and then the great mass of more or less
impoverished citizens, the *popolo,* who made up the
majority of the population. They too were also
involved in the administration of the state, mainly
through a number of official posts that were not open
to aristocrats (in order to prevent too much power
being concentrated in their hands), but also through
religious brotherhoods, the scuole.

At the beginning of the 16th century, Venice had
suffered severely as a result of the struggle for
supremacy in Italy between the emperor, the pope and
king of France. At times Venice had even been at risk
of losing its entire mainland territories. But the island
city itself had scarcely ever been attacked and had
never been conquered. Its walls of water were too
impenetrable. There was peace at the heart of the city
state. The prosperity which had been won through
international trade, and also through the combination
of a stable form of government and a cleverly thought-
out administrative system, ensured that Venice was
probably the most secure city in Europe. Moreover, its
citizens enjoyed a high degree of intellectual and
religious freedom, as long as they did not endanger the
republic (though we know now just how binding such
a principle can be).

As Lodovico Dolce recorded, the young Titian soon
left the workshop of Zuccato the mosaicist and took
up painting. He entered the workshop of Venice's
leading painters, which at the time was run by Gentile
Bellini (1429–1507). Its reputation was founded
upon the work of his father, Jacopo Bellini (ca.
1400–1470). Gentile's younger brother Giovanni (ca.
1430–1516) was considered throughout northern
Italy to be one of the most progressive artists. Gentile
was, however, far more successful as far as public
honors were concerned. In 1469 he was ennobled
by the emperor; and in 1479 he was officially sent
by the Republic to Turkey in order to paint the sultan.
The commission he received to renovate the paintings
in the "Sala del Gran Consiglio", the great council
hall in the Doge's Palace, was the most important
commission the Venetian state was in a position
to award. However, Titian soon left Gentile and
devoted himself to Giovanni Bellini, whose style
dominated Venetian art in the late 15th and early 16th
centuries.

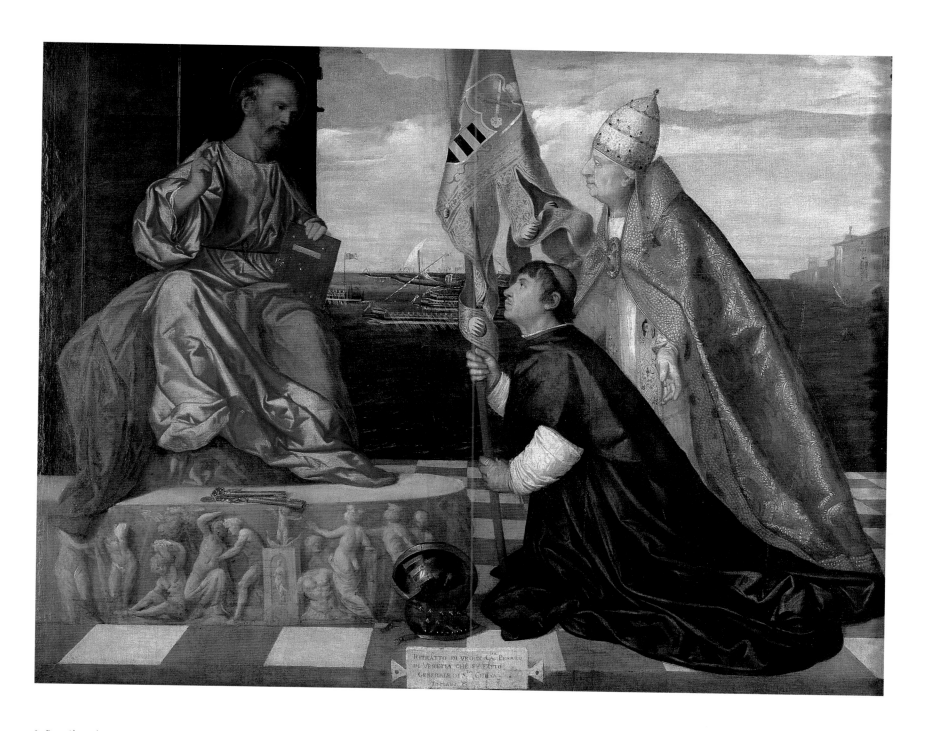

3 *Pope Alexander VI Presenting Jacopo Pesaro to Saint
Peter*, 1502–1512 or ca. 1520
Oil on canvas, 145 x 183 cm
Koninklijk Museum voor Schone Kunsten, Antwerp

This work, which some scholars consider one of Titian's
earliest, was painted to commemorate the naval defeat of
the Turks by the allied fleets of Spain, Venice and the
Pope in 1502. The commander of the papal fleet was the
Venetian Cardinal Jacopo Pesaro, who commissioned this
work. Kneeling in front of St. Peter, he is wearing the
black cloak of the Maltese knights and holding a standard
bearing the coat of arms of Pope Alexander VI. The pope
stands behind, recommending him to St Peter. In Venice
at this time, the depiction of someone other than a saint
in this situation was very unusual.

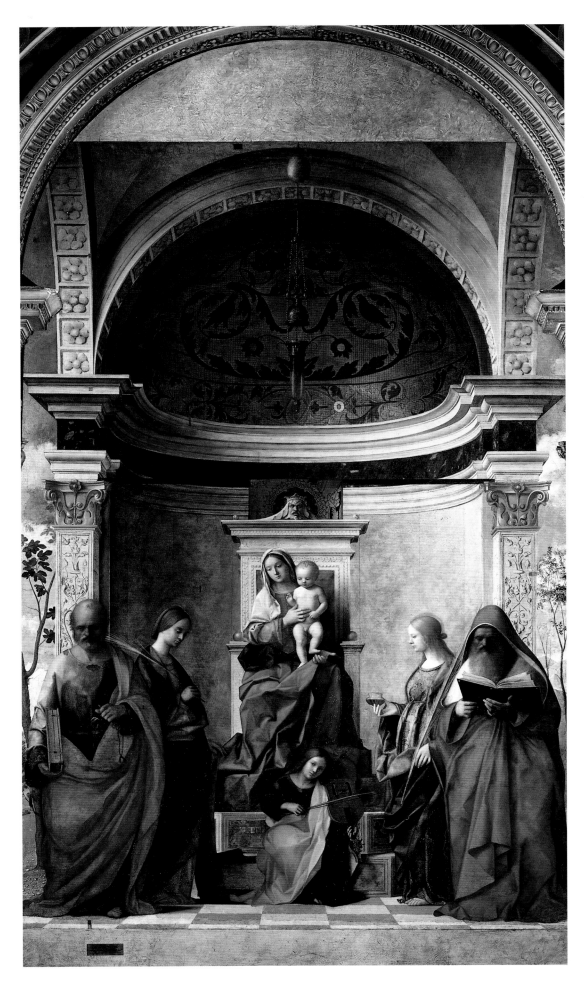

4 (left) Giovanni Bellini
Sacra Conversazione, 1505
Oil? on wood, transferred to canvas, 500 x 235 cm
San Zaccaria, Venice

Painted in beautiful colors, the saints, lost in thought and
wrapped in voluminous robes, are depicted standing
quietly around the Madonna's throne. The male figures in
particular can be compared with St. Peter in *Pope
Alexander VI Presenting Jacopo Pesaro to Saint Peter* (ill. 3).

5, 6 (opposite, top and center) *The Birth of Adonis* and
The Legend of Polydorus, ca. 1505–1510
Oil? on wood, each 35 x 162 cm
Museo Civico, Padua

The attribution of these two works to Titian is disputed.
The panels are so-called *cassone* paintings, made to be set
into wooden chests as a form of decoration. Each work
shows an episode from Ovid's "Metamorphoses", divided
into three scenes. In the center of *The Birth of Adonis*
(ill. 5) is a group of people who are freeing the baby
Adonis from the branches of the tree his mother has been
turned into. The motif of the lovers on the left is a
reference to his conception, and on the right the figure of
Venus, who will fall in love with him, refers to his future.
In *The Legend of Polydorus* (ill. 6), the murder of Polydorus
takes place at the right edge of the picture. On the order of
his father, King Priam, Polydorus brought Troy's gold to
his brother-in-law for safekeeping, but the latter murdered
him out of greed. In the center, the burning Troy is visible.
The female figures on the left are thought to be Hecuba
(his mother), and a servant.

Gentile Bellini's art remained rooted in the
Quattrocento. In contrast, Giovanni was one of the
first in Venice to use the technique of oil painting,
which had developed in the Netherlands. This new
technique enabled artists to work in a freer manner
and use a considerably broader range of colors than
had been possible with the traditional tempera
technique, in which fewer colors were available and
individual layers of colors had to be built up gradually
with very short brushstrokes that dried rapidly.
Giovanni's superb rendering of light and space, and his
beautifully voluminous, colored figures made him the
leading Venetian painter, from an artistic point of view,
of the early 16th century. At the turn of the century,
nearly all Venetian painters based their works on his
style. On his second trip to Venice in 1505, the
German artist Albrecht Dürer (1471–1528) remarked
that though Giovanni was already very old, he was still
the finest artist in Venice.

The early works that we are certain Titian painted
clearly show the influence of Bellini, in particular in
their handling of light and color. It is possible that he
was still employed in Bellini's workshop when he
painted *Pope Alexander VI Presenting Jacopo Pesaro to
Saint Peter* (ill. 3), which is thought to be one of
Titian's earliest works. There are so many similarities in
its composition to those in Giovanni's works that some
scholars feel the work was started by the latter.

According to them, Giovanni painted the composition in two stages, first executing the head of St. Peter and then leaving the work to be completed at a later date by his student, Titian. X-rays of the painting do indeed show that the work was created in two stages.

Other authors believe that Titian painted the picture between 1503 and 1507, possibly with a break, at a time when he was still completely under the influence of Bellini. The example of Giovanni can be seen in the arrangement of the figures, and in the rendering of the folds of the heavy garments, which, emphasized by light and shade, give volume to the figures. The figures can be compared with those in Bellini's altarpiece for the Venetian church of San Zaccaria (ill. 4). The type of head Titian used for St. Peter can also be seen in Bellini's altarpiece. Bellini's way of depicting garments can be seen in many of Titian's early works that he painted long after he left Bellini's workshop, ranging from the altarpiece of St. Mark (ill. 17) to the frescoes in the Scuola del Santo in Padua (ills. 14–16).

There was another young artist besides Bellini who had a major impact on the style of Venetian painting shortly after 1500: Giorgio da Castelfranco, known as Giorgione (1477/78–1510). His main patrons were not the old elite, but young noblemen. Most of his paintings were created for a small circle of connoisseurs. He modified traditional themes to suit their high level

of education and refined tastes and invented new subjects full of mythological, literary and astrological allusions adapted to their preferences and stipulations. The motifs contained in his paintings are frequently so cryptic that it is still not easy to interpret them. Landscape was given a more prominent place in his paintings than had so far been the custom in Venetian art. The movements of his figures are restrained, their features expressionless, or at best melancholy. His works convey a mood that can also be discerned in the literature of the age, in particular in the much-read "Arcadia", a pastoral romance by the poet Jacopo Sannazzaro (1457–1530). It expressed a melancholy nostalgia for a fictitious, idealised classical age and the contemplative life of shepherds, a world Giorgione's contemporaries would have felt could only be achieved in dream, or in literature and painting. In general, melancholy played an important role as the expression of a refined intellectual sensibility. It was mainly young painters who adopted Giorgione's new subjects and forms. Paintings such as *The Birth of Adonis* (ill. 5) and the *Legend of Polydorus* (ill. 6) demonstrate Giorgione's early influence on Titian, though there is some dispute about the attribution of these works.

Titian's relationship with Giorgione, who was only about ten years older than Titian and had also been trained in Bellini's workshop, was different from his relationship with Bellini. Even though Titian's works

7 *Orpheus and Eurydice*, ca. 1510
Oil? on wood, 39 x 53 cm
Accademia Carrara, Bergamo

In this picture the extensive landscape is typical of the early works that Titian painted under the influence of Giorgione. The green of the vegetation, which provides a charming color contrast with the fire in the background on the right and with the yellowish sky, has turned almost completely brown over the course of the years.

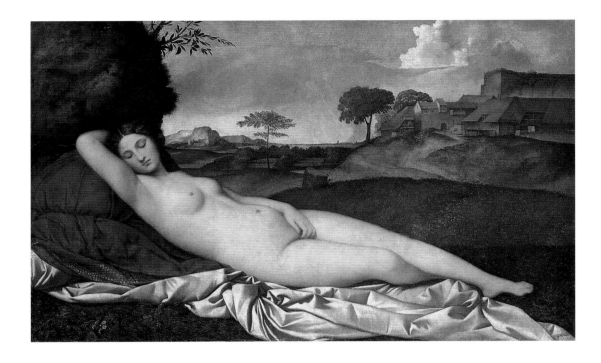

8 (above) Giorgio del Castelfranco, known as Giorgione
Sleeping Venus, ca. 1508–1515
Oil? on canvas, 108.5 x 175 cm
Staatliche Kunstsammlungen, Gemäldegalerie Alte
Meister, Dresden

This is the painting that the Venetian Marco Antonio
Michiel saw in 1525 in the house of Jeronimo Marcello in
Venice. He commented that Titian added the landscape
and a putto to Giorgione's painting, and this has indeed
been confirmed by X-rays. The position of the sleeping
Venus was to become characteristic of Titian's depictions
of Venus.

9 (right) *Concert Champêtre*, ca. 1510–1511
Oil on canvas, 110 x 138 cm
Musée du Louvre, Paris

The significance of the dressed young men and two naked
women is as yet uncertain. Though the painting is now
generally given the title *Concert Champêtre* or country
concert, there continues to be just as much dispute about
its theme as there is about who painted it. It used to be
attributed either to Giorgione alone or to Titian and
Giorgione together. Because of a re-evaluation of Titian's
early style, it is now considered to be his work alone,
though not all authors agree.

clearly show the influence of Bellini, they can always
be clearly distinguished from his master's paintings. It
was a long time before the same could be said of the
works inspired by Giorgione. Many works which are
now thought to have been painted by Giorgione used
to be attributed to Titian, and vice versa. In 1931, it
was possible to prove by the use of X-rays that a small
putto used to exist to the left of the *Sleeping Venus* (ill.
8), a work attributed to Giorgione. This confirmed an
old report that Titian added the landscape and a putto
to Giorgione's figure. It also confirmed the claim that
both artists had collaborated on other works, such as
the *Concert Champêtre* (ill. 9), and that Titian had
entirely adopted the style of the older man. However,
during the last two major Titian exhibitions, in Venice
and Washington in 1990, and in Paris in 1993, a new
interpretation of their relationship was offered. During
the course of the preparations for the 1990 exhibitions,
technical investigations of the paintings made it
possible to distinguish between Titian's broader, more
spontaneous brushstrokes and the finer, more delicate
technique of Giorgione. This was the basis for forming
a clearer conception of Titian's early work. It shows
him to be an artist who, like many other young artists
of the period, followed Giorgione's choice of themes,
but whose use of color and treatment of figures owed
as much to Giovanni Bellini and his inventiveness as it
did to the young master from Castelfranco. Their
relationship is now considered to have been a
reciprocal one, leading them to engage constantly with
each other's art. Titian is now considered to have given
as much as he received.

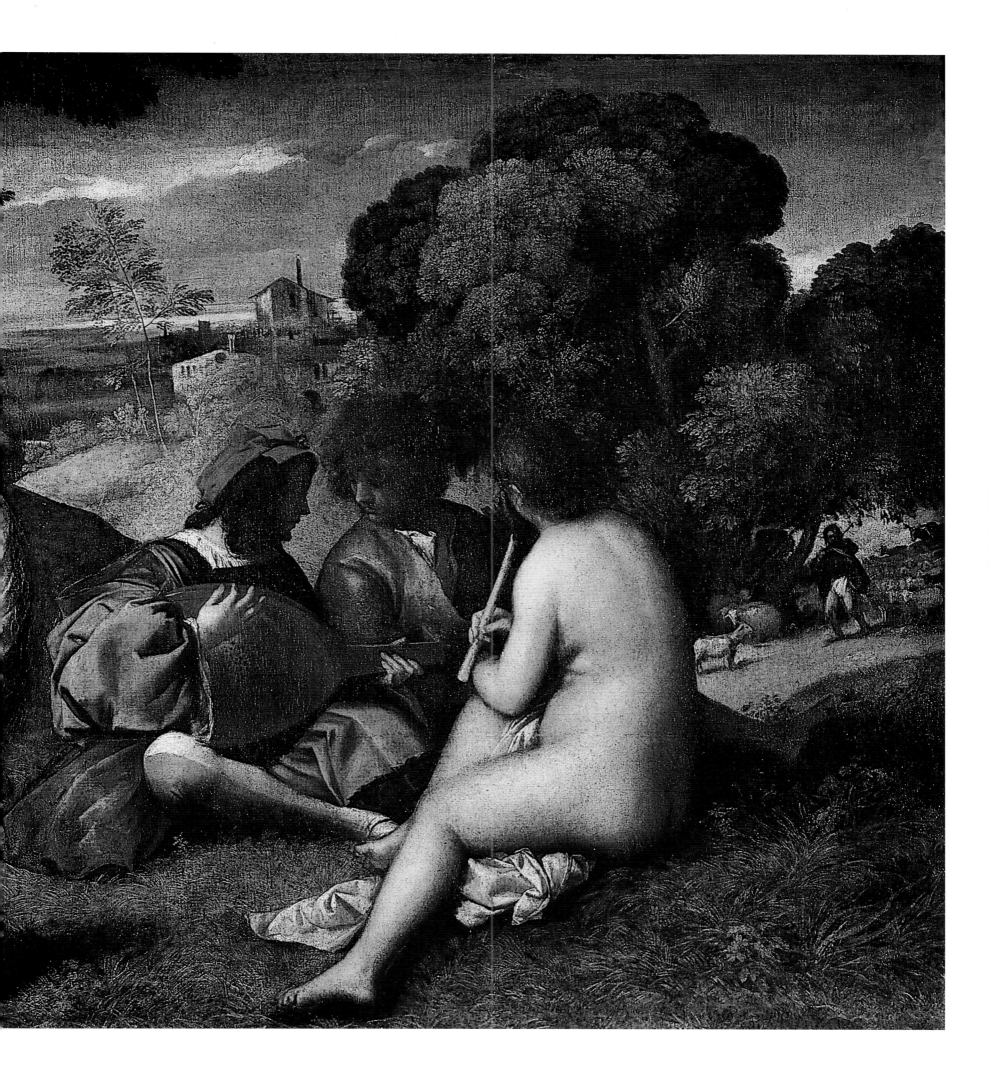

10 *Gypsy Madonna*, ca. 1512
Oil on wood, 65.8 x 83.8 cm
Kunsthistorisches Museum, Vienna

This painting got its name from the black hair and pale face of the Madonna, as well as the charming contrast of colors. This type of Madonna, with very dark eyes, is not found in Titian's later works.

In his earliest works, Titian drew on Bellini as much as he did on Giorgione. Half-length figures such as his *Gypsy Madonna* (ill. 10) and the *Madonna of the Cherries* (ill. 11) are entirely derived from Bellini's type of Madonna. But Titian's own mastery is already evident in the *Gypsy Madonna*. The unusual, delicate combination of pale blue, white and dark red, and the dreamy, contemplative gazes of the Madonna and Child have also reminded many scholars of Giorgione, and the painting has occasionally been attributed to him. The landscape behind the Madonna is closely related to the background in Giorgione's *Sleeping Venus* (ill. 8). However, the closely observed scroll, which seems quite odd in this context, and play of light on

the fabrics, are both clear signs of Titian's authorship. For these are precisely the aspects of Bellini's art that Titian made his own and continued to develop during the following years.

After the fire of 1505, Titian and Giorgione were commissioned to decorate the façades of the Fondaco dei Tedeschi, the German merchants' house in Venice. At first the task gave no indication of the reputation the two artists would gain as a result of their frescoes. For Titian, who as Lodovico Dolce reports, was scarcely twenty years old, these very visible wall paintings were the prelude to an almost unmatched career.

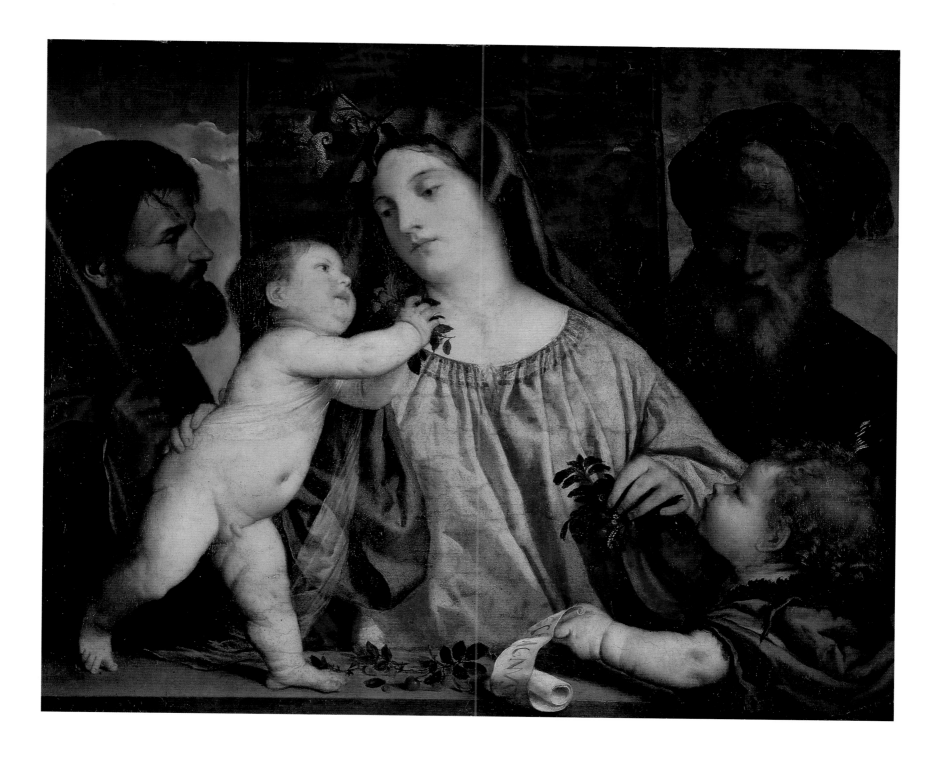

11 *Madonna of the Cherries*, ca. 1515
Oil on wood, transferred to canvas, 81 x 99.5 cm
Kunsthistorisches Museum, Vienna

In this half-length picture of the Madonna, Titian was
still keeping entirely to a pictorial idiom typical of
Giovanni Bellini. St. Joseph is on the left, and Zacharias,
the father of John the Baptist, on the right of the
Madonna. John, depicted as a naked boy, is giving the
Madonna the cherries that give the painting its name.

THE FONDACO DEI TEDESCHI

It is likely that at some stage most visitors to Venice will go into the main post office near the Rialto bridge. Only a few will be aware, however, that this building was the former German merchants' house, the Fondaco dei Tedeschi. The present building is the very one in which Titian first came to the attention of the Venetian public by painting frescoes for it.

The German merchants' house had, according to old reports, been on this site since 1228. The term "Fondaco" is derived from the Arabic "funduk" (store). At first the foreign merchants had to live in the Fondaco and store their goods there as well. By Titian's time, the rule about living in the Fondaco had relaxed. The rooms in the Fondaco were very small, and even large trading businesses often had only one room in which they had to live, store their goods and conduct their business dealings. Here they stored goods such as furs, wax and other items that could be traded with the Venetians for oriental luxuries such as spices, silk and gems. The building was filled with the most varied scents and sounds, the shouts of the packers and customs officials, and the whispers and busy activities of the traders. Not until night fell would there be peace. Women were not normally allowed to enter the Fondaco. Meals were eaten together in two large dining halls. The house had its own customs post, which made things considerably easier for the German merchants, who were always at the disposal of their Venetian trading partners. Many companies had representatives who conducted business there all year. These businessmen were under their own jurisdiction, and the Venetian authorities were not allowed to pursue them into the Fondaco. Given their benefits, only the most important Venetian trading partners were allowed to have such a merchant house.

Apart from the Germans, there were only three other trading partners who had similar facilities, the Turks, the Persians and the Arabs.

Needless to say, this concentration of important trading partners was also decidedly advantageous for the Venetian republic. The Venetian officials who worked in the house were answerable to Venetian authorities, and customs officials, packers and lawyers who came and went here also acted as spies for the Venetian government. Trade could be conducted only through Venetian brokers, so-called *sensali*, who were paid by the Republic. They kept an eye on business, assisted when there were legal and language difficulties, and were constantly at the disposal of the German merchants. By the 16th century, however, this office, known as the *sensaria*, had become largely an honorary position which was given to citizens, including artists, who had served the republic well; they received an annual allowance and did not have to pay taxes.

Given the considerable importance that the Fondaco had for "La Serenissima", it is no surprise that when it burnt down in 1505 the Venetian state paid for it to be rebuilt immediately.

The government made sure that a suitable, but by no means too magnificent building was constructed. It was expressly forbidden to use architectural features to ornament the walls, so they decided in favor of wall paintings, which at that time were common on many Venetian buildings and gave the city a much more colorful appearance than it has today. The artists commissioned to produce the works were two very young and, in the case of Titian, not very well known artists, and there was no way of guessing what a sensation these frescoes would cause.

12 *The Fondaco dei Tedeschi*, 1505–1508
Venice

Following a fire in 1505, the Fondaco dei Tedeschi (German merchants' house), which today houses Venice's main post office, was rebuilt at the city's expense by a German architect called Hieronymus and the Venetians Giorgio Spavento and Scarpagnino.

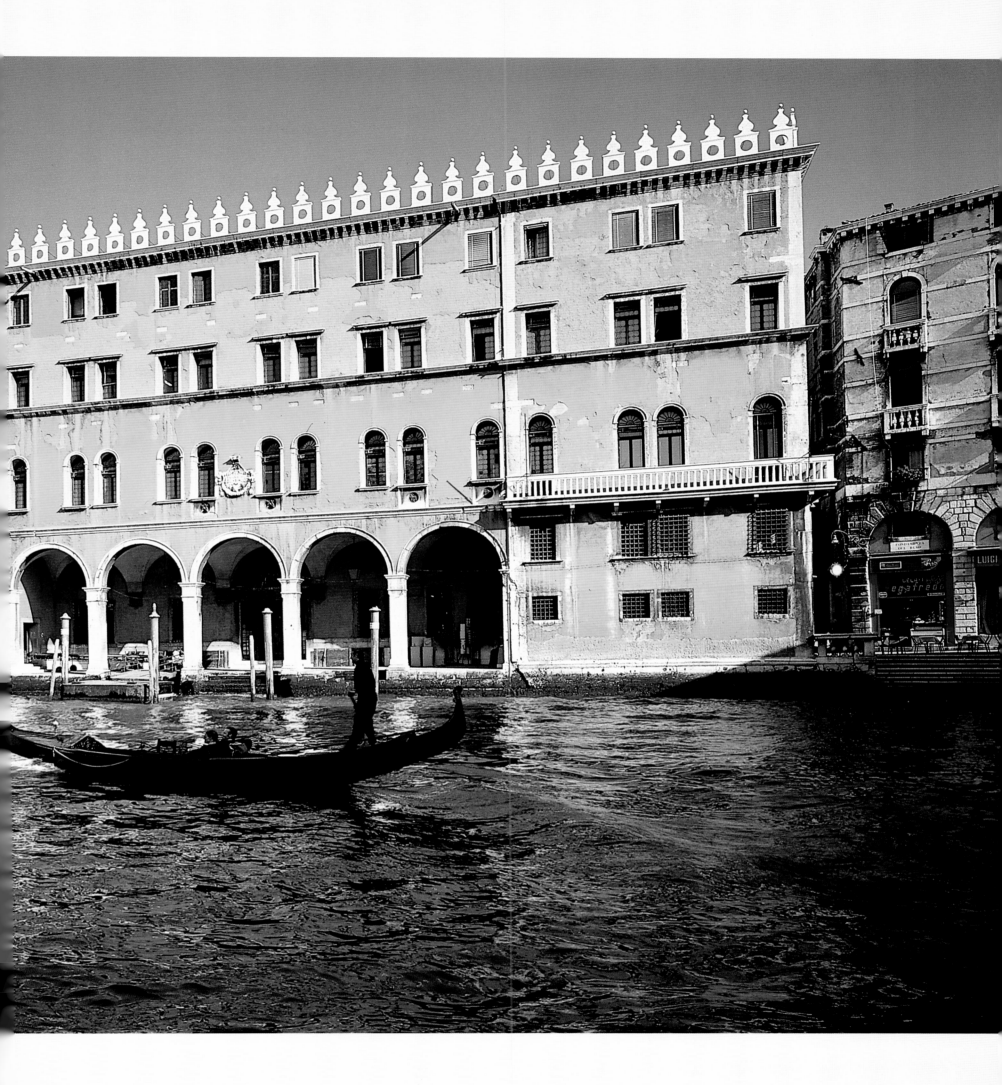

13 *Judith (Justice)*, 1508–1509
Fresco fragment, 213 x 346 cm
Ca' d'Oro, Galleria Franchetti, Venice

This fresco used to be located on the wall of the street
entrance of the Fondaco dei Tedeschi (on what is now the
Calle del Fontego). Only a few fragments still remain of
the powerful, semi-naked figure that once fascinated
visitors. It is Judith, who is simultaneously a
personification of Justice. The head of Holofernes, at her
feet, no longer exists. Because of the damp sea air,
hundreds of other frescoes that once give the façades of
Venetian buildings a bright and colorful appearance, have
suffered the same fate.

FIRST SUCCESSES
THE FIRST COMMISSIONS –
HIS OWN WORKSHOP – THE SENSARIA

14–16 *Scenes from the Life of St. Anthony of Padua*

The Scuola del Santo in Padua, the house where the brotherhood of St. Anthony met, was on the edge of the square in front of the church in which the famous Franciscan saint was buried. In 1510/11 Titian worked alongside other painters to decorate two walls in the upper assembly room with frescoes depicting miracles from the saint's life. They are the first of Titian's works that can be definitely dated and that still exist in their entirety.

14 (opposite) *The Miracle of the Newborn Child*, 1511
Fresco, 340 x 355 cm
Scuola del Santo, Padua

St. Anthony worked a miracle in which a newly born child spoke in defence of his mother, who had been accused of adultery. The closely observed, very individual faces show Titian's mastery of his craft, even at this early stage of his career.

The frescoes were completed by 1508/1509. While Giorgione worked on the more important façade facing the Grand Canal, the younger, less well known Titian had to make do with the façade on the side street. It is now no longer certain that Titian was a member of Giorgione's workshop at this time, something which had long been accepted as a matter of course. The meagre remnants that still exist of the Fondaco frescoes confirm that two quite different artistic personalities were at work. A standing female nude by Giorgione has the same delicacy and daintiness as his *Sleeping Venus* (ill. 8). The stylized elegance of the softly modelled forms belong in a poetic dream world, while Titian's *Judith (Justice)* (ill. 13), despite its ruinous condition, radiates the same powerful physical presence as the frescoes in the Scuola del Santo (ills. 14–16) in Padua, created a year later. The same physical presence is visible in the nudes in the disputed and mysterious *Concert Champêtre* (ill. 9). It has not yet been possible, however, to provide a conclusive interpretation for the presence of men from various social levels together with naked women in a landscape. The attribution of the painting to Titian has also not yet been accepted by all authors. Nonetheless, this painting conveys to the modern observer a strong visual concept of the yearning for Arcadia that prevailed when it was painted. As is the case here, this yearning becomes tangible in numerous Venetian paintings painted under the influence of Giorgione, though it is not possible to express it in a conclusive interpretation.

Giorgione's influence on Titian is clearest in his choice of motifs. Yet even in the first works that can be attributed to him with some certainty, Titian emerges

as an independent artistic personality. Even though the motifs he adopted from Giorgione and Bellini are obvious, he manages to incorporate them into a new, independent form. In addition, he discovered the graphic arts at a very early stage. In 1508 he produced his first large woodcut, the *Triumph of Christ*. Working with various graphic techniques, and producing drafts for paintings in the form of drawings, were features of his entire career. As his fame spread, other artists emerged who distributed his paintings as graphic works, notably the Netherlands artist Cornelis Cort (1533–1578).

In 1510 Titian was commissioned to produce some frescoes in the Scuola del Santo in Padua (ills. 14–16), the place where the brotherhood of St. Anthony met. The grave of this important saint is just a few steps away in the Santo, the church of St. Anthony. Padua had only recently become part of the Venetian state again, after having briefly fallen into the hands of the League of Cambrai, Venice's enemies.

Venice's battles against the League, to which France, the Holy Roman Empire and the Pope had at times belonged, had brought the Republic to the brink of collapse. The end of hostilities did not, however, bring immediate relief to the city. For during 1509 and 1510 there was an outbreak of plague in Venice, one of its victims being Giorgione. It is likely that it was not easy for a young artist to win commissions under these conditions. However, the Augustinians of Santo Spirito in Isola commissioned a votive picture showing St. Mark and the plague saints Roch and Sebastian together with Cosmas and Damian, the patron saints of medical doctors (ill. 17). This painting once again shows a close connection with Giorgione, for he first

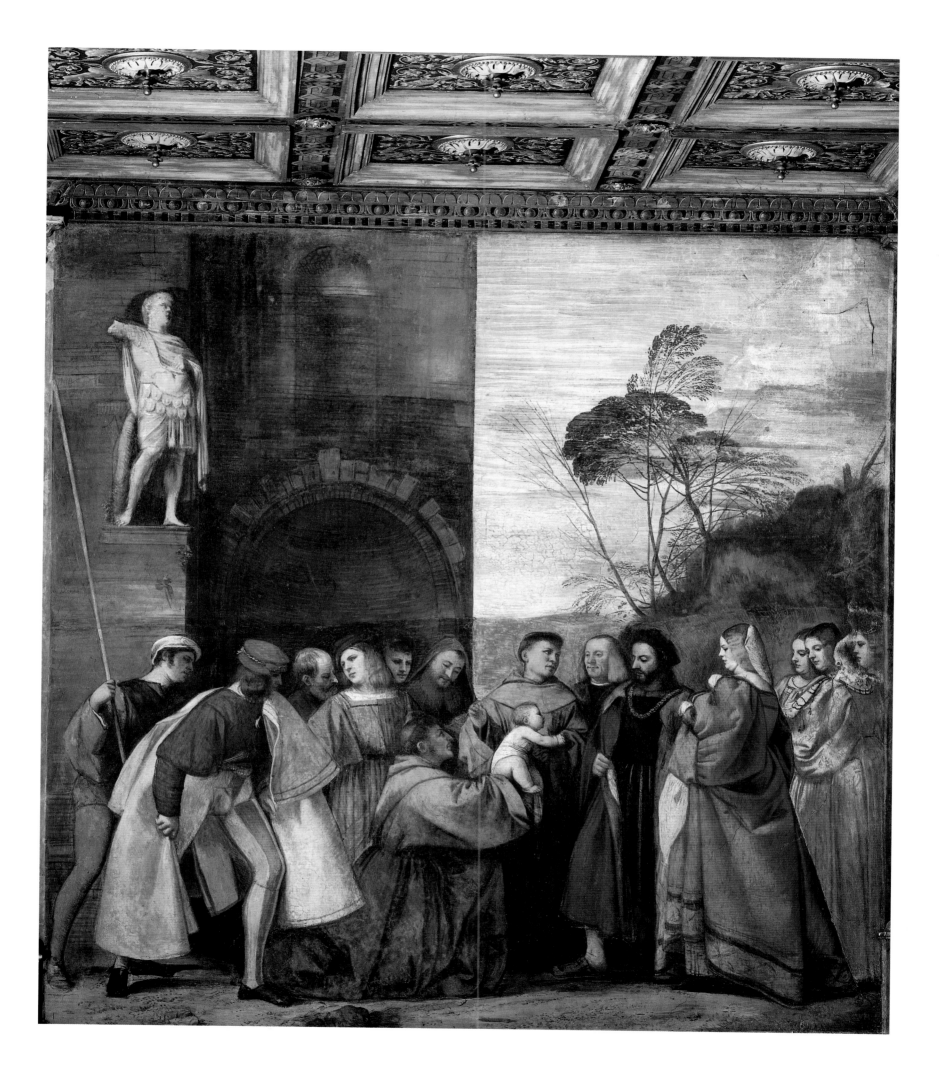

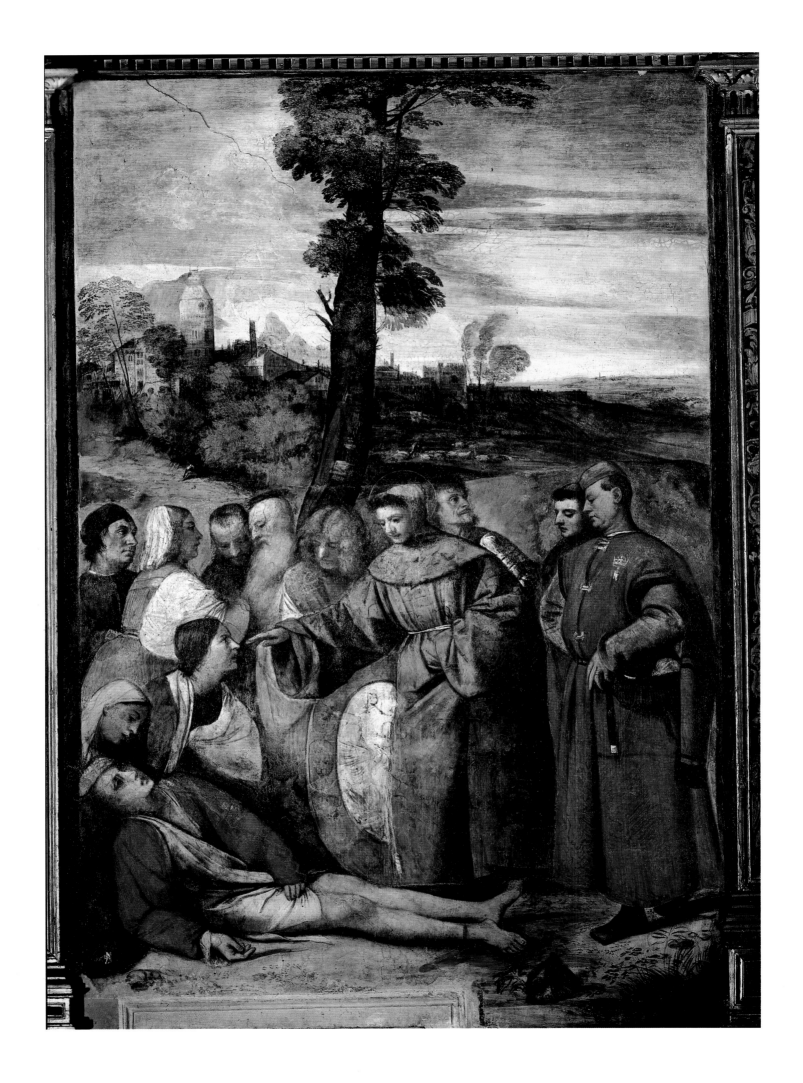

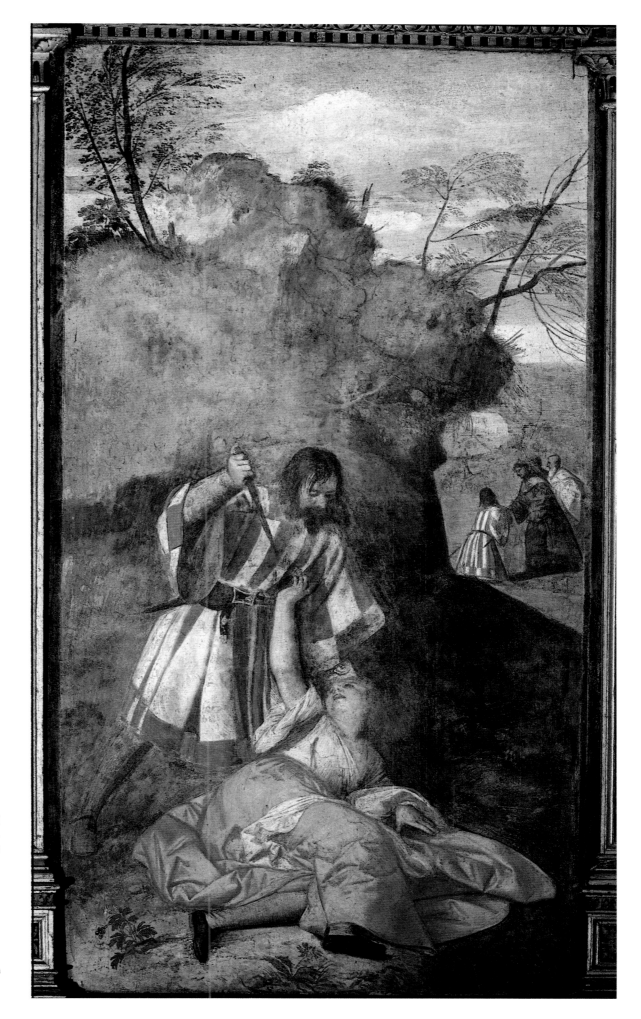

15 (opposite) *The Healing of the Wrathful Son,* 1511
Fresco, 340 x 207 cm
Scuola del Santo, Padua

St. Anthony reattached the foot of a young man who had
cut it off in an outburst of violent temper because he had
hurt his mother with it. Despite the difficulty of working
on frescoes, which demanded great speed on the part of
the artist, Titian succeeded in producing splendid
landscapes.

16 (right) *The Miracle of the Jealous Husband,* 1511
Fresco, 340 x 185 cm
Scuola del Santo, Padua

A jealous husband stabs his wife and then, overcome with
remorse, appeals to St. Anthony, who restores her to
health.

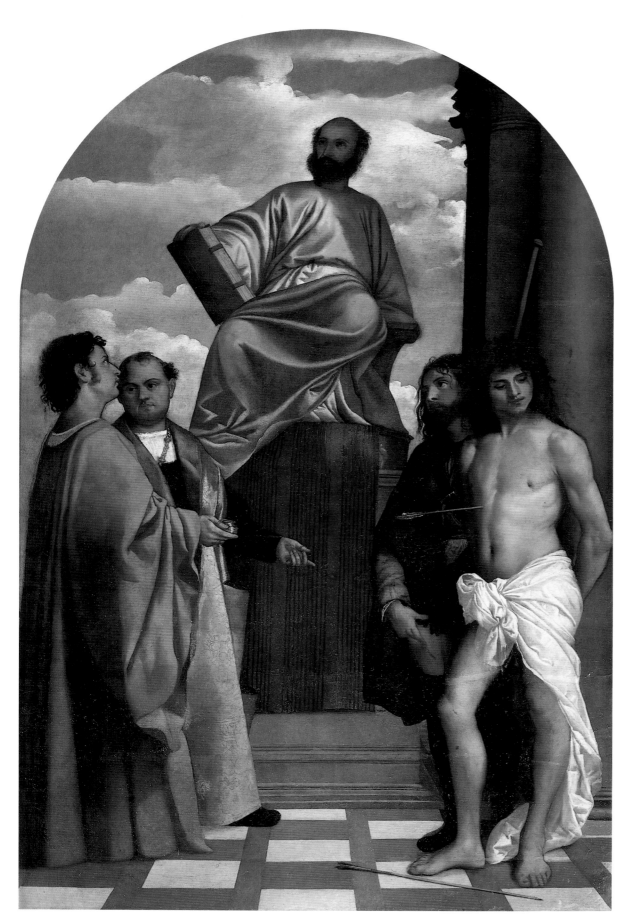

17 (left) *St. Mark Enthroned with Saints*, ca. 1510
Oil on canvas, 218 x 149 cm
Santa Maria della Salute, Venice

This painting was probably created either during or
shortly after the horrific outbreak of the plague in 1510.
St. Mark, Venice's patron saint, is enthroned on high. In
front of him are the plague saints Roch and Sebastian,
and the saintly doctors Cosmas and Damian on the left.
These were the saints to whom pleas for a quick end to
the plague would be addressed, as well as prayers of
gratitude for the protection they give to the city.

18 (opposite) Giorgio da Castelfranco, known as
Giorgione
Castelfranco Madonna, ca. 1506
Oil? on wood, 200 x 152 cm
Duomo, Castelfranco Veneto

With the greatly raised sitting position of the Madonna,
Giorgione introduced a new type of *sacra conversazione*
to Venice that was to become extremely successful.

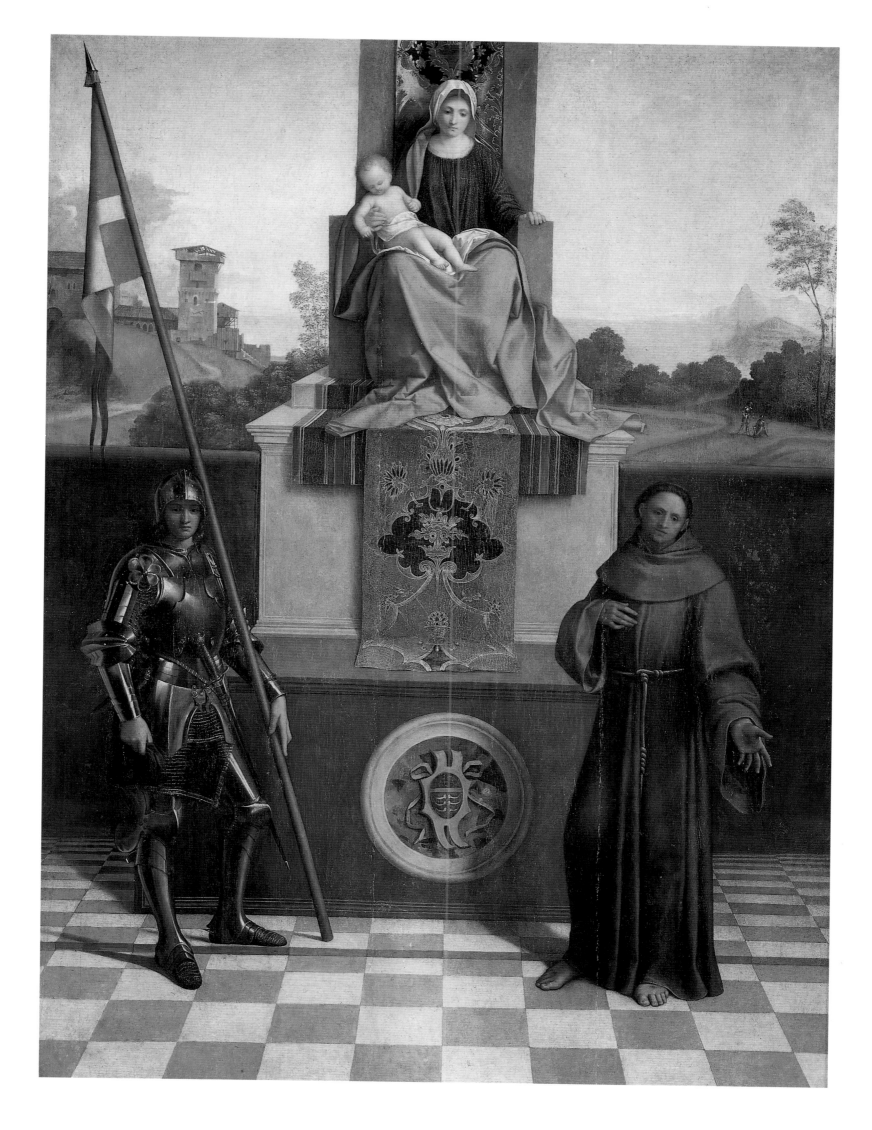

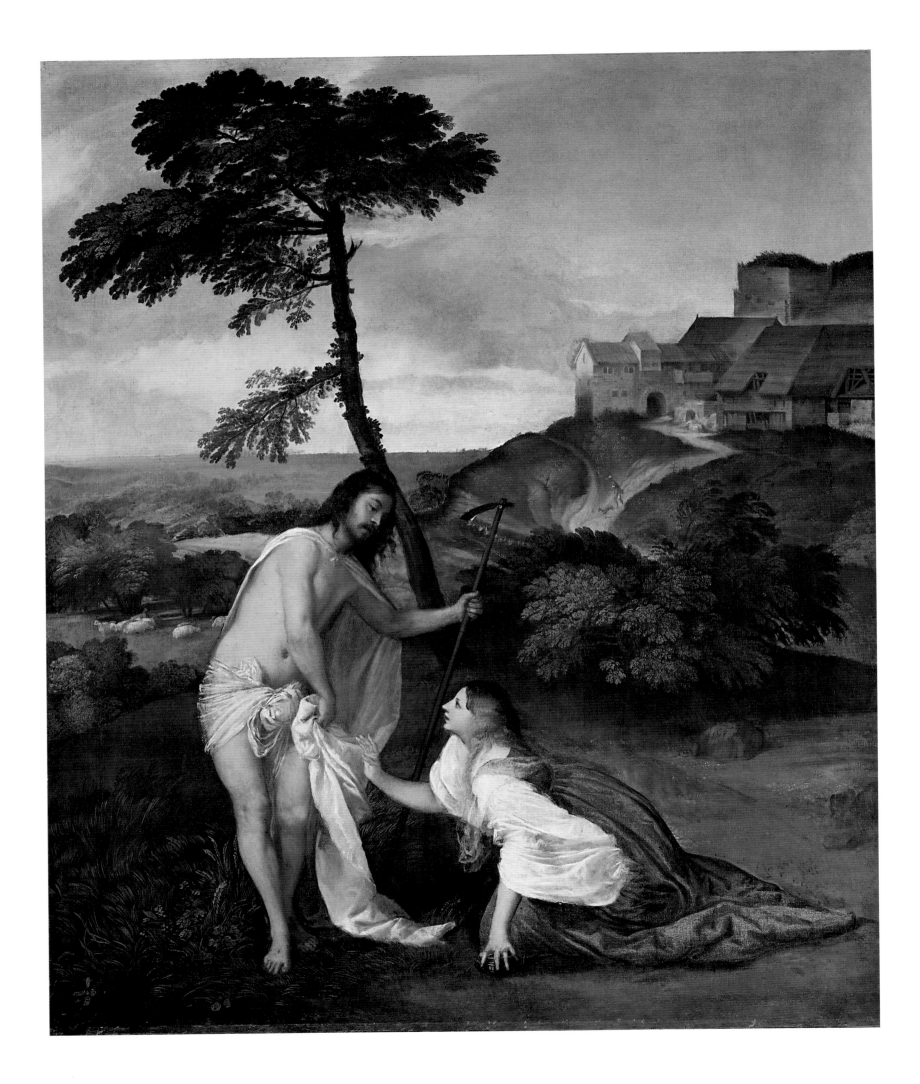

20 (above) *Portrait of a Man*, ca. 1512
Oil on canvas, 81.2 x 66.3 cm
The National Gallery, London

The very affected posture of the sitter is characteristic of Titian's early portraits that were still painted under the influence of Giorgione. The blue sleeve displays a masterly use of color. It is proof both of Titian's ability to depict materials and also of his mastery of color as a means of conveying a picture's meaning.

21 (right) *The Concert*, ca. 1510
Oil on canvas, 86.5 x 123.5 cm
Palazzo Pitti, Galleria Palatina, Florence

This painting has been considered a work by the young Titian only since it was last restored in 1976. The faces of the figures at the sides are badly damaged. Only the center figure and the garment of the figure on the right display his masterful use of color. Pictures of musicians were frequently painted in the 16th century. However, it was very rare for such an intimate relationship between the musicians to be depicted. The youth on the left draws the observer into the scene, thus including him in the web of glances and touches.

19 (opposite) *Noli me tangere*, 1511–1512
Oil on canvas, 109 x 91 cm
The National Gallery, London

"Noli me tangere", do not touch me, is what Christ said to Mary Magdalene in the Gospel of John 20, 14–18, when he met her on the morning of his Resurrection. Despite some awkwardness in the construction of the figures, Christ and Magdalene fit in harmoniously into the wonderful landscape that takes up most of the picture.

used a similar composition for his *Castelfranco Madonna* (ill. 18), and the expression on the face of St. Sebastian is reminiscent of the melancholy appearances of his figures. At the same time, the treatment of the other figures and garments shows the influence of Bellini. The directness with which the figures are related to the subject of the picture – an example being the saintly doctor who is pointing to the wound which St. Roch is displaying on his leg – distinguishes this work from those of Titian's models. Nonetheless, his dependency on Bellini and Giorgione can still be seen in the painting is a strong argument in favor of dating the work to about 1510, as is the fact that this was the year the plague ended, which would have been the reason for commissioning the work. As a result it is, together with the firmly dated frescoes in Padua, one of Titian's earliest independent works.

In about 1510, Titian painted *Noli Me Tangere* (ill. 19) and *The Concert* (ill. 21). Despite the somewhat formless bodies, there is a captivating quality about the depiction of Christ and Magdalene, a result of his use of color, and in particular his treatment of the white materials, which show Titian to be a master of light and color. He is able to give tactile qualities, light and lustre, to colorless material. The white undergarment worn by the clergyman in *The Concert* displays the same use of color.

At the same time, however, *The Concert* has an additional portrait-like dimension. This is another area where both Giorgione and Titian are greatly indebted to Giovanni Bellini. Taking Netherlandish works as a starting point – Hans Memling (ca.1440–1494) was his most important model – Bellini succeeded in creating portraits that did not depend solely on great realism, as many Netherlandish portraits did. Even though he is only depicting the face and shoulders, he succeeds, mainly by means of color, in successfully capturing the character of his subject. His combination of colors enables Bellini to use just a few shades to produce an impression of spiritual anxiety or weariness, festive magnificence or moral humility.

So far it has not been possible clearly to differentiate Titian's and Giorgione's early portraits. Only Titian's broader brushstrokes and greater interest in fabrics that reflect light enable us to attempt carefully to distinguish them. Both Giorgione and Titian chose to depict a larger section of their subjects than Bellini did. This provided them with the opportunity to characterize their sitters by their posture, movements and dress. They replaced the colorful background which had played such an important role in Bellini's works with mainly neutral black or gray ones. Later, Titian introduced curtains or an occasional view opening onto a landscape.

In about 1510, Titian began to win independent commissions and to establish himself as a painter in Venice. In 1513, he opened his own workshop, in which he employed two assistants, one of whom had worked for Giovanni Bellini. During the same year, he wrote a petition asking to be allowed to produce a painting for the Sala del Gran Consiglio, the Senate's large assembly hall in the Doge's Palace. His submission to the *Consiglio dei Dieci*, the Council of Ten, provides us with a fascinating insight into both his artistic self-confidence and also his precise ideas on the way his art should be practised.

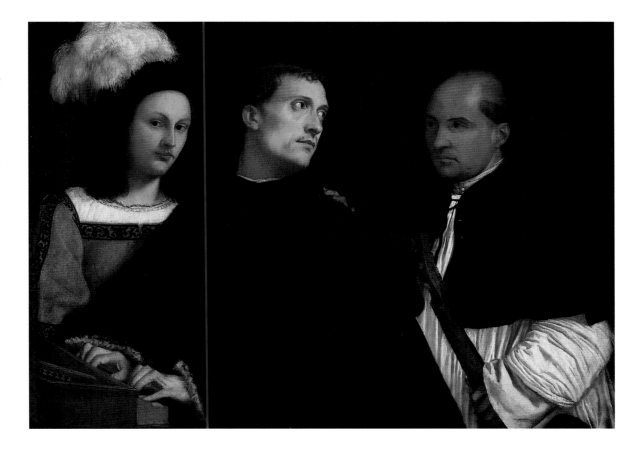

22 *Sacred and Profane Love*, 1514
Oil on canvas, 118 x 279 cm
Galleria Borghese, Rome

During the course of the 20th century numerous authors
have attempted to determine the meaning of this
painting. The two most accepted theories agree in
interpreting the nude woman as Venus. The first theory
sees her as a personification of sacred or heavenly love,
and the clothed figure, also Venus, as a personification of
profane earthly love, fertility and nature. The second
theory is that the clothed figure is Polia, a character in a
Renaissance novel, who at first vows to live a chaste life
but ends up being won over to love.

From the 1470s onwards, the leading Venetian
painters had been restoring the old frescoes in the Sala
del Gran Consiglio and, when this attempt failed,
replacing them with paintings on canvas. The Bellini
workshop carried out the major part of this work.
Other painters employed on this major state
commission were Alvise Vivarini (ca. 1445 – ca. 1505)
and Vittore Carpaccio (1455/65 – 1526). In 1577, all
these paintings were destroyed during a fire in the
Doge's Palace. In his petition, Titian makes a specific
reference to the fact that he would be willing to turn
down numerous invitations to work at Italian courts,
even in Rome, if he was sure of having an opportunity
to prove his abilities in Venice. He says that when he

started training in Venice his aim was not to become
rich, but to make his art famous. He offers to work at
the most difficult location, a wall full of windows. The
only reward he wants for his work is to get the next free
sensaria on the Fondaco dei Tedeschi (cf. p. 14). As was
shown by the historian Charles Hope at the Titian
Congress in Venice in 1976, this position did not
mean that the painter who held the title was also the
official state painter, as was believed for so long.
Rather, the *sensaria* was simply the payment made for
a state commission worthy of a trading republic. The
Venetian government handed out thirty of these more
or less honorary titles, some of them to artists. The
sensaria was an office held for life. If no position was

available, the painter was put on the waiting list or, in cases of particular honor, was moved to the top of the list. The office paid about 120 ducats a year, the holder did not need to pay taxes, but if the offer which led to him being given the office of *sensaria* was not carried out, the title could be revoked. If a position quickly became vacant, an artist who lived a long life would earn more from it than from being paid only once for his paintings. On the other hand, there were financial advantages for the republic if the painter had to wait a long time for a free *sensaria* or died young.

Even though this commission did not have the same status as that of the official position as state painter, the work on the Doge's Palace nonetheless greatly

enhanced his exceptional reputation as an artist. That Titian, scarcely twenty-five, should have applied for and been given such a commission is proof of his considerable artistic self-confidence and the high regard in which he was already held, even though he was not given a *sensaria* until the death of Giovanni Bellini in 1516. However, Titian was extremely slow getting around to painting the work that had gained him this much-desired title.

It is possible that his success in gaining that position played a major part in his being commissioned to produce one of his greatest masterpieces, *Sacred and Profane Love* (ill. 22). The man who commissioned the work, Niccolò Aurelio, was at the time a secretary to

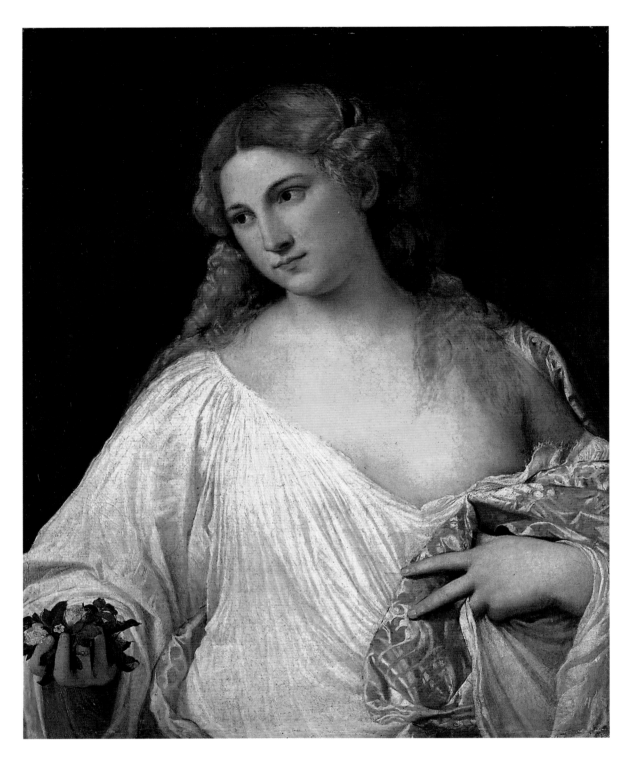

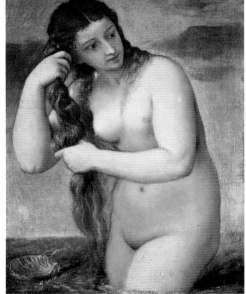

the Council of Ten to which Titian had written. Aurelio ordered the picture in 1514, on the occasion of his wedding to Laura Bagarotto. It has not yet been possible to decipher the subject of the picture. It is certain, however, that the theme is connected to love and marriage. The reason for commissioning such a magnificent painting of high intellectual demands might have been the scandal caused by the wedding. Aurelio was a respected state official, but the bride was already widowed and the daughter of a man executed for high treason. The sensation caused by the marriage was even noted by the city's official historian, Marin Sanudo (1466–1533).

The private allusions in the subject, the theme of love, the references to the classical age, and the beautiful landscape all convey the aura of a distant, lost world of shepherds and gods that was to preoccupy "young" Venetian art, even after Giorgione's death. The movement of materials, which emphasizes the volume of the bodies, the play of light and shadow, the softness, delicacy and colorful beauty of the flesh tones, the harmony of the color composition, the figures in the background, depicted with just a few brushstrokes, the precisely observed buildings gently disappearing into the distant mist – all these factors show that Titian deserves a special position among his

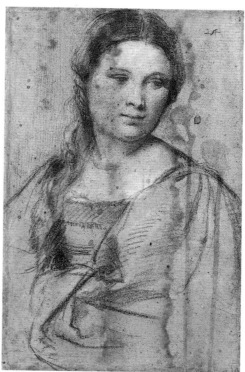

25 (left) *Salome*, ca. 1515
Oil on canvas, 90 x 72 cm
Galleria Doria Pamphilj, Rome

The main focus is on neither the horrific events nor the religious significance of the scene. It is not even clear if this is Salome with the head of the Baptist, or Judith with the head of Holofernes. The former is suggested by the displaying of the head on a platter, the latter by the presence of the female servant who is a feature of the traditional iconography of the Judith story. The painting, with its wonderful color contrasts of red, green, and white, and its delightful female figures, is one of Titian's depictions of an ideal of female beauty. This is why it was frequently copied.

contemporaries. The painting continues to fascinate viewers to this day.

Titian achieved all this through his virtuoso use of color. Technical examinations of his paintings show how revolutionary was the artist's use of the new medium of oil painting. Every detail, in particular the flesh tones and materials, is built up using numerous pigments that were constantly being remixed. This was the way in which he was finally able to achieve his refined use of color, in particular his inimitably delicate changes of color. Especially worthy of note are the carefully harmonized shades of red, purple, yellow, white, and blue on the face of the naked Venus,

contrasted with her strands of her golden hair, which is tied back with a ribbon of delicate purple. Any of the uncertainty that might have been evident in his depiction of figures in *Noli me tangere* (ill. 19) and the Padua frescoes (ill. 14–16) has now completely disappeared. Paintings such as *Salome* (ill. 25) and *Flora* (ill. 23) are closely related to the *Sacred and Profane Love*. The type of woman which Titian now preferred to depict no longer derived from Bellini or Giorgione. Titian himself would now become a model for other artists.

26 *Portrait of a Young Woman*, ca. 1515
Chalk on brown paper, 41.9 x 26.5 cm
Galleria degli Uffizi, Gabinetto dei Disegni e delle Stampe, Florence

It is very difficult to date this drawing. It seems, however, he mainly portrayed women of this type in his early works, such as the frescoes in the Scuola del Santo (cf. ills. 14–16). The tilted position of her head is also reminiscent of portraits painted during the same period.

VENETIAN COMMISSIONS AND WORKS FOR NORTH ITALIAN PRINCES – TITIAN REVOLUTIONIZES VENETIAN ART

27 Assumption of the Virgin (Assunta), 1516–1518
Oil on wood, 690 x 360 cm
Santa Maria Gloriosa dei Frari, Venice

The Italian name "Assunta", by which this painting is also commonly known, derives from the Latin word *assumptio*. It means "to accept", and therefore has a direct bearing on Mary's ascension into heaven. The *Assumption of the Virgin* was the first major official commission that Titian received for an oil painting in Venice. That is probably why he so proudly painted his signature on the right, beneath the seated figure of St. Peter. He seldom signed later paintings that remained in Venice.

On 29 November 1516, Giovanni Bellini died at the age of 84. For as long as he had been alive and in full possession of his creative powers, neither Giorgione nor Titian had ever been able to obtain a public commission for a large-scale oil painting. But now, in 1516, Titian was approached by Germano da Caiole, the prior of the large Franciscan monastery in Venice. He commissioned him to paint a new work for the high altar in the Franciscan church of Santa Maria Gloriosa dei Frari, the *Assumption of the Virgin* (ill. 27). Together with the Dominican church of Santi Giovanni e Paolo, this enormous church was one of the two important churches of the mendicant orders in Venice, and it played an important role in the public life of the city, being used, among other things, as a burial site for the Doges. As Lodovico Dolce records, the unveiling of the *Assumption of the Virgin*, which took place on 19 May 1518, was a shock for the Venetians, and in particular for the other artists in the city. Until then, they had been used to seeing more or less static individual figures which, in older works, even had an entire panel devoted to them. The vivid movements of the figures and the great dramatic quality of the scene broke all Venetian traditions. Only gradually, Dolce wrote, did the initial rejection change to a boundless admiration. He himself praised the altar and made his great admiration for the work clear by comparing it with works by Raphael and Michelangelo. At a time, when central Italian writers such as Vasari were debating who the leading artist of the age was, and narrowing the list of candidates down to Raphael and Michelangelo, Dolce secured Titian a place among the great. At the same time, Dolce's comparison suggests an explanation of Titian's fundamental break with the traditional altarpieces of Venice that has lost none of its validity to this day. Because of the vivid movements of the powerful figures in the *Assumption of the Virgin*, Roman works have repeatedly been cited as the source of Titian's ability to create a greater sense of movement and energy than was usual in Venice up to then. But the works of Raphael and Michelangelo that are used as

comparisons are certainly not direct models. Raphael's Vatican *Transfiguration*, whose dramatic movements are very similar, was not painted until *after* the *Assumption of the Virgin*. The same is true of a fresco on the same theme which, according to Vasari, was created by the Venetian artist Sebastiano del Piombo (ca. 1485–1547) after a design by Michelangelo, for the Borgherini Chapel in San Pietro in Montorio in Rome. Titian himself had not been to Rome yet, though it is possible that he could have received reports about, and possibly even drawings of, the works of Raphael and Michelangelo in the Vatican and the Sistine Chapel.

It must be said, however, that even Titian's earliest works such as the *Judith (Justice)* (ill. 13) and the frescoes in Padua show that he is attempting to depict voluminous figures with complex movements. The spectators who are facing one another, or the young man who is approaching in the scene with the talking new-born child (ill. 14), as well as the twisted and complexly foreshortened body of the wife who has been stabbed to death (ill. 16), all show the same sense for pictorial drama, though the more pronounced gestures of the *Assumption of the Virgin* do suggest there was some Roman influence. In the *Assumption of the Virgin*, Titian also retained the traditional practice of arranging the heads so that they are all at the same level, a device he had already used in Padua. Here, however, the device no longer seems awkward and static. The entire effect of the painting is dominated by the upward movement. Titian achieves this compositionally by means of a triangle of red hues, created by the red garments worn by the Apostles and the Madonna's red dress. The broadening reddish black shape formed by God the Father's cloak seems to open to receive the upward movement. The form and content of the painting coincide completely.

This altarpiece made Titian the most celebrated painter in Venice. At the same time, it drew him to the attention of Bellini's old patrons in the northern Italian ruling houses. From January to March 1516, Titian stayed in Ferrara with Duke Alfonso d'Este, for whose

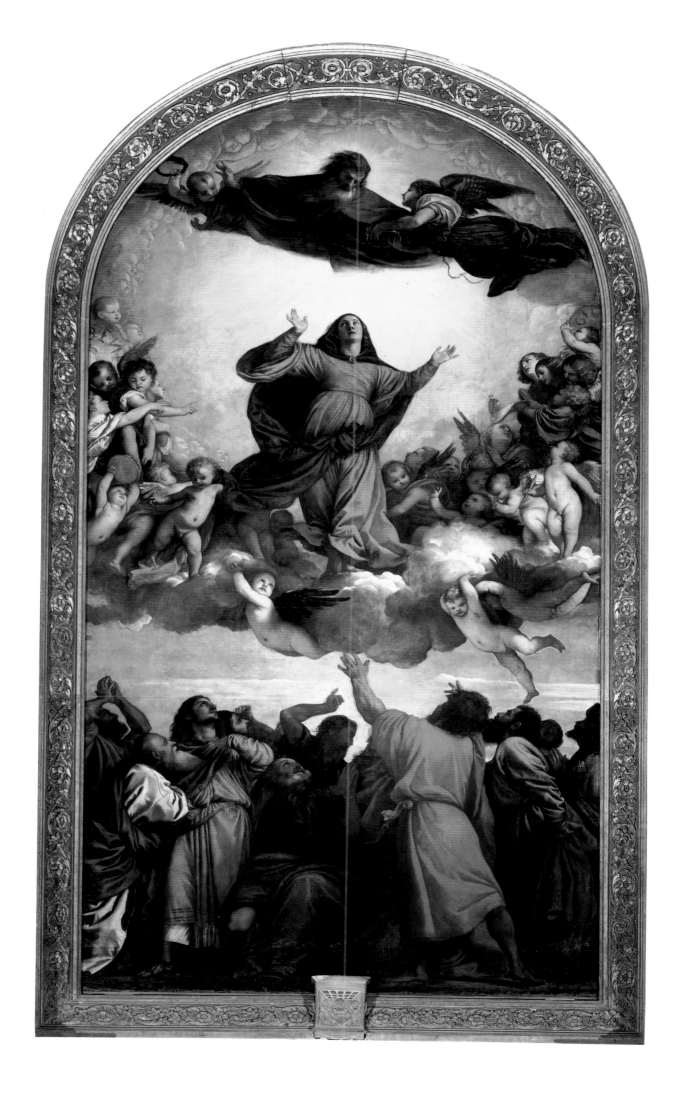

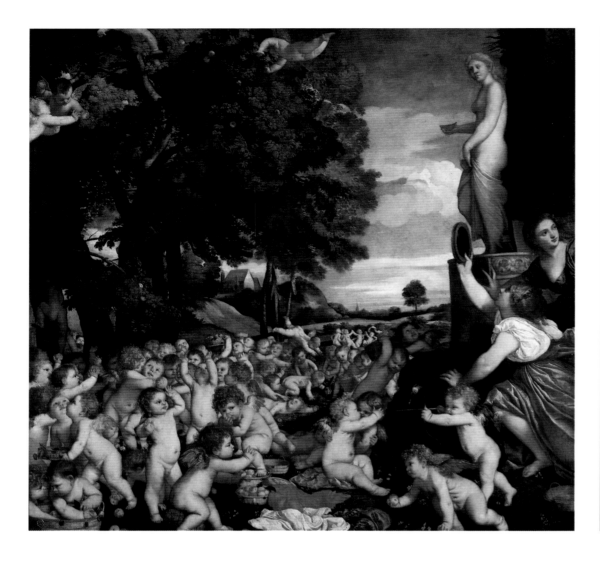

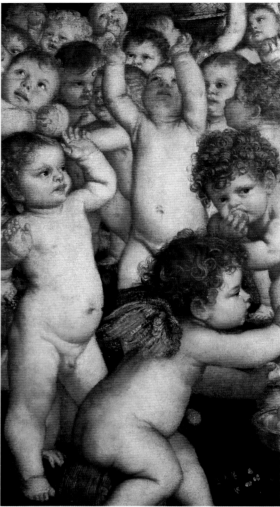

28 (above left) *The Worship of Venus*, 1518
Oil on canvas, 172 x 175 cm
Museo Nacional del Prado, Madrid

The composition of the work is modelled on a classical painting on the same theme, described by the Greek writer Philostratus (beginning of the 3rd century AD) in his "Eikones", in which he writes about the paintings in a classical collection. Nowadays it is disputed whether he was writing about real works or ones he had invented. During the Renaissance, numerous artists attempted to produce paintings that matched the classical models described by Philostratus.

29 (above right) *The Worship of Venus*, (detail ill. 28), 1518

In classical times, Cupids were considered to be the children of nymphs, who were the female nature spirits who were closely linked to Venus. Titian depicted every one with a precise eye for the enchanting freshness and comic gestures of small children.

private study – his Alabaster Room – Bellini had painted *A Banquet of the Gods* in 1514. The background of this painting was later overpainted by Titian, though technical examinations have shown that before he did so another artist had already been at work on it. The overpainting was not, as used to be assumed, carried out during Titian's first stay in 1516. From 1517 until about 1525, Titian was to produce three large mythological paintings for the duke, all of which were hung in his private work and study room. Such a *studiolo* was one of the most important rooms in a Renaissance palace. The place where collections of art works and books were kept, it was a demonstration of one's education and personal taste. Alfonso's sister Isabella d'Este, who was married to the margrave of Mantua, Francesco II Gonzaga, was very proud of the famous art collection in her *studiolo*. It is perfectly conceivable that Alfonso was attempting to create something similar. He commissioned works from Giovanni Bellini and Raphael. However, because of the early death of Raphael in 1520, his paintings for Alfonso were unfinished. If that had not been the case, Titian would have been working in direct competition with him.

The first painting, which Titian completed in 1518, was *The Worship of Venus* (ill. 28). This commission had originally been awarded to a central Italian artist,

Fra Bartolomeo (1475–1517), but he died in 1517. We know from one of Titian's letters to the duke that he was given precise instructions as to the painting's subject. His interpretation of the subject, however, must have been a surprise, particularly in view of Fra Bartolomeo's very conventional design, which is now in the Uffizi. In addition to the masterly depiction of the landscape and materials, which is equally apparent in the enchanting putti (ill. 29) and the shining silk fabrics, Titian uses the art of perspective to give the painting a sense of dynamism that the theme does not actually require. The eyes of the observer are led from the bottom left, along the broad path filled with countless playing putti, diagonally across and into the background. On the left, the ground rises gently, so that we cannot see right into the background. On the right, the statue of Venus, the actual focus of the festivities, blocks our view into the distance.

In December 1522 Titian finished the second painting, *Bacchus and Ariadne* (ill. 30). It is likely that the third painting, the *Bacchanal of the Andrians* (ill. 31), was finished by 1525. In both cases, Titian's feeling for color and the breathtaking energy of the movements are particularly impressive. In the first painting, Ariadne is waving despairingly at the ship disappearing in the distance, on board which is Theseus, who left her behind

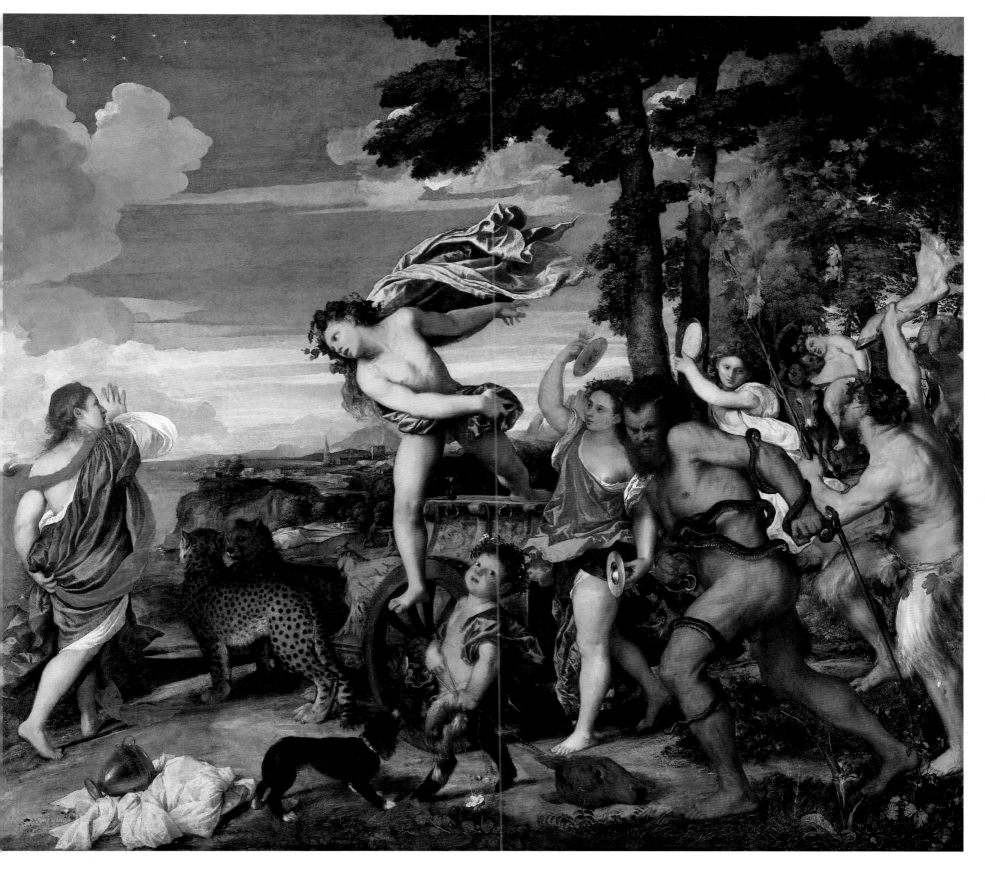

30 *Bacchus and Ariadne*, 1520–1522
Oil on canvas, 175 x 190 cm
The National Gallery, London

This painting is probably based on a variety of classical
texts, all of them concerning Ariadne, the daughter of the
king of Crete. Because of her love for Theseus, she helped
him escape her father's labyrinth by means of a ball of
thread. However, Theseus deserted her on Naxos while
they were returning to Athens. There, she became the lover
of the god Bacchus. Above her, already visible, is a crown
of stars representing the "Corona Borealis", into which she
(or, according to a different tradition, her bridal head-
dress) is eventually transformed.

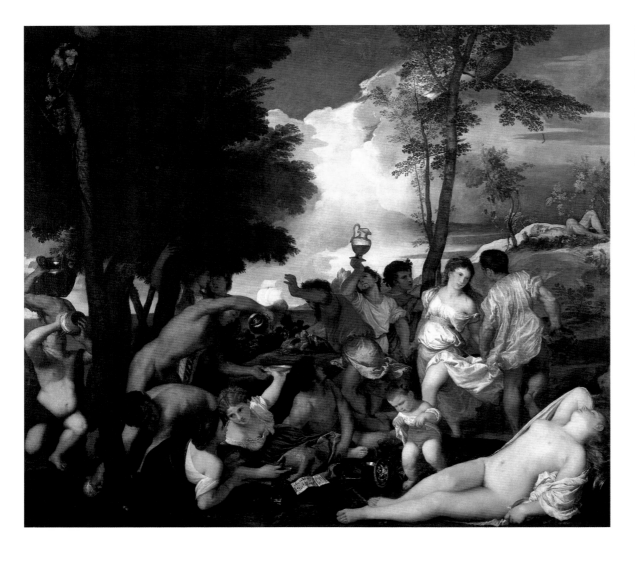

31 (left) *Bacchanal of the Andrians*, 1523–1525, or earlier
Oil on canvas, 175 x 193 cm
Museo Nacional del Prado, Madrid

Like the two previous pictures, this painting was destined to be hung in the Alabaster Room in Ferrara Palace. Like *The Worship of Venus*, it derives from a description written by Philostratus. The inhabitants of the island of Andros are shown taking part in a bacchanal, an orgy for Bacchus, the Roman god of wine. According to classical mythology, Andros was the god's favorite island, where rivers ran with wine instead of water.

32 (below) *Bacchanal of the Andrians* (detail ill. 31), 1523–1525 or earlier

Titian was not afraid to depict humorously the more drastic aspects of the bacchanal.

while she was sleeping. But as she waves, she is already looking at her new lover, Bacchus, who is approaching from the right with a retinue of satyrs and nymphs. While his train does not appear to have come to a standstill yet, Bacchus himself is just about to get down from his chariot. The broad sweeping movement of the length of reddish pink silk – his only clothing apart from a wreath of leaves – underlines the force of his movement. There are no apparent dramatic spatial effects in the third painting in the series, the *Bacchanal of the Andrians* (ill. 31). The elaborate method by which the imaginary space is created, by means of the complex way in which the figures overlap, does not become clear until the painting is looked at more attentively. Much the same is true of the marvellous *Entombment of Christ* (ill. 33), painted at roughly the same time and now in the Louvre.

In his works painted between 1515 and 1530, Titian worked intensively on ways of creating a sense of space. At the same time, he focused the narrative of his pictures on a very precise moment. The figures appear to have been captured at a moment of movement, so that in the very next instant they will change to a new

course of action. By means of these two concerns – unexpected spatial compositions and a dramatic sense of change – Titian frequently succeeded in producing entirely new interpretations of traditional themes.

The Annunciation (ill. 34) was painted for the altar in the Malchiostro Chapel in Treviso Cathedral about 1519. As in *The Worship of Venus*, Titian made use of an unusual perspective. The Archangel Gabriel is rapidly approaching from the back of the picture. Mary is turning her head back. Titian depicted her shock at her heavenly visitor in an inimitable manner: all the Virgin is doing is wrapping her ample garment, full of folds, more tightly around her body as if to protect herself from the swift approach of the angel. In an Annunciation scene, one would traditionally have expected to see the angel approaching Mary on the same picture plane. None of Titian's contemporaries can have been prepared to see such a familiar theme depicted using such a revolutionary spatial composition.

Titian achieved a similar effect in his second large commission for the Frari church, the *Pesaro Altarpiece* (ill. 36) painted for the Pesaro family. The painting is a

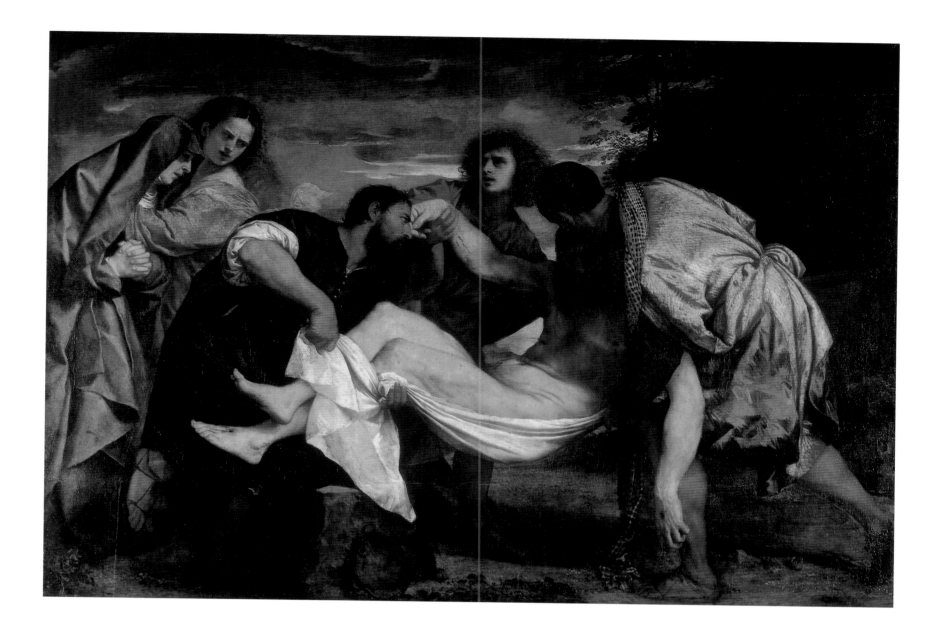

sacra conversazione. This term applies to depictions of the Madonna with various saints, who would be called upon at this altar to intercede on a worshipper's behalf. The central position was normally reserved for the Madonna. Titian, however, moves her from the center to the right of the painting. This means that a visitor to the church, approaching the high altar from the western entrance, would see the Madonna from a long way off. And this indeed makes it possible to show the donor, who is portrayed in profile in the traditional manner, kneeling in front of her instead of beside her. His family, in contrast, kneel on the right and do not meet the eyes of the Madonna or saints. It was very unusual for the donors to appear in a painting for a Venetian altar. However, the painting has a votive character as it is a commemoration of the victory won against the Ottomans by Jacopo Pesaro, the commander of the Papal fleet, together with the Venetians.

By having the Madonna placed to one side, the painting gains a degree of movement that until then would scarcely have seemed possible. Titian's work became the prototype for an unending series of

altarpieces, which repeatedly make use of its dynamic force.

The fresco of St. Christopher in the Doge's Palace (ill. 35) also dates from the early 1520s. Despite the limitations of fresco painting, which requires the artist to work rapidly and confidently because he is painting on wet plaster, Titian succeeded in producing a figure with a monumental physical presence. He used hatching to produce light and shadow, giving an extraordinary three-dimensionality to the saint's muscles. His experience in creating designs for woodcuts was probably of prime importance in helping him to develop this method of representing light and shade.

Between 1520 and 1522, Titian painted the *Polyptych of the Resurrection* (ill. 37) for Venice's papal legate, Altobello Averoldi, who was born in Brescia. The figure of St. Sebastian, on one of the altar's side panels, has much the same physical presence and muscularity as his St. Christopher. Titian does not portray the saint as a delicate, slim youth as the previous generation of Venetian painters had. Instead,

33 *Entombment of Christ*, ca. 1523–1526
Oil on canvas, 148 x 205 cm
Musée du Louvre, Paris

Here Titian skillfully uses the direction of the light to support the dynamics of movement that permeate the entire painting. The greatest contrast of light and shade is present on the body of Christ. The observer's eyes are first drawn to his winding sheet and legs, before moving to his upper body, which is lying in darkness. The shadow in this area treats the subject of Christ's death and entombment in an unusual way, using purely formal means of expression.

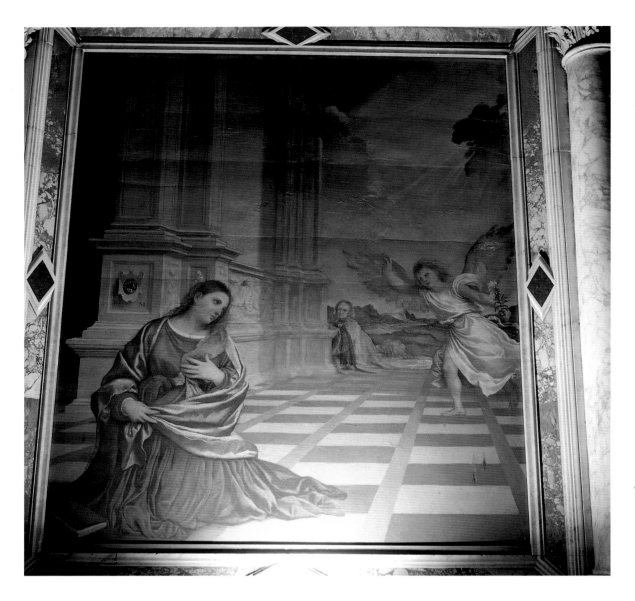

his Sebastian corresponds to the new ideal body as characterized in Rome by Michelangelo. This Sebastian is often compared to Michelangelo's *Slave* for the unfinished tomb of Pope Julius II, now in the Louvre.

In the *Polyptych of the Resurrection*, Titian employs the traditional structure of a polyptych altarpiece which depicts principle subjects on a central panel and less important ones on the side and top panels, a type which was rarely used in the 16th century. The composition of the Averoldi altarpiece clashes with the dramatic effect of the traditional form of altarpiece. The left panel, showing the kneeling donor and saints Nazaro and Celso, is clearly related to the center panel, showing the Resurrection, by means of the gestures and gazes of the figures. In contrast, and despite the ground being at the same level, the right side panel showing St. Sebastian seems to distract from the main panel because of the much lighter, shining blue sky and the muscular body of the naked saint. In an age that was completely shaped by Christianity, it would have been obvious that the two top panels, showing Mary on the right and an angel on the left,

belonged together as an Annunciation. This was also an arrangement found in many other polyptychs. Without knowing this, however, it would be quite conceivable to see both scenes as part of the central scenes, the Resurrection of Christ.

Though the panels do not fit particularly well within a traditional polyptych, the exceptional quality of the individual panels once again clearly shows just how far Titian had moved away from traditional forms by the mid 1520s.

Shortly before the *Pesaro Altarpiece*, Titian painted the altarpiece the *Madonna in Glory with the Christ Child and Saints Francis and Alvise with the Donor Alvise Gozzi* (ill. 38). This panel, which had been commissioned by Alvise Gozzi, shows the Madonna with a number of saints who lived at different times. We can see Venice behind the figure of the donor. Though the conjunction of these figures with a Venetian background is anything but realistic, Titian effortlessly succeeds in creating a much more believable narrative space on a single panel than he does in the Averoldi polyptych.

34 (left) *The Annunciation*, ca. 1519
Oil on wood, 179 x 207 cm
Duomo, Cappella di Malchiostro, Treviso

The interesting spatial composition of this picture was undoubtedly Titian's own idea, as is the treatment of the figure of Mary, who is wearing a wonderfully draped garment with wide folds, made of a heavy lustrous silk. Numerous scholars have expressed their doubts about the figure of the angel and the kneeling donor Broccardo Malchiostro. In 1526, the citizens of Treviso, animated by a strong dislike of Malchiostro and outrage that he should have had himself so obviously portrayed in an altarpiece – something that was not customary in either Venice or Treviso – smeared pitch across the painting, and the work had to be renovated.

35 (above right) *St. Christopher*, ca. 1523
Fresco, 300 x 179 cm
Palazzo Ducale, Venice

This fresco was commissioned by Andrea Gritti (1455–1538), probably shortly after he was elected Doge in May 1523. As in various other paintings by Titian during this period, a view of Venice can be seen in the background. The lofty alpine peaks on the right are a reference to Venice's possessions on the Terra Firma.

36 (opposite) *Pesaro Altarpiece*, 1519–1526
Oil on canvas, 385 x 270 cm
Santa Maria Gloriosa dei Frari, Venice

Until this painting appeared. it was customary to depict the Madonna in the center of an altarpiece. The way Titian moved her from the center of the picture to the edge was a revolutionary modification of the traditional pictorial composition that was frequently copied, especially during the Baroque. The Venetians of the time must also have felt that the prominent position taken up in the painting by the donor of the altarpiece was equally unusual. The most important member of the Pesaro family, Jacopo, the bishop of Paphos, is kneeling directly in front of the Madonna, and his brothers and their sons are opposite him. While pictures of donors were usual in other places, they were normally avoided on altars in Venice, probably for political reasons.

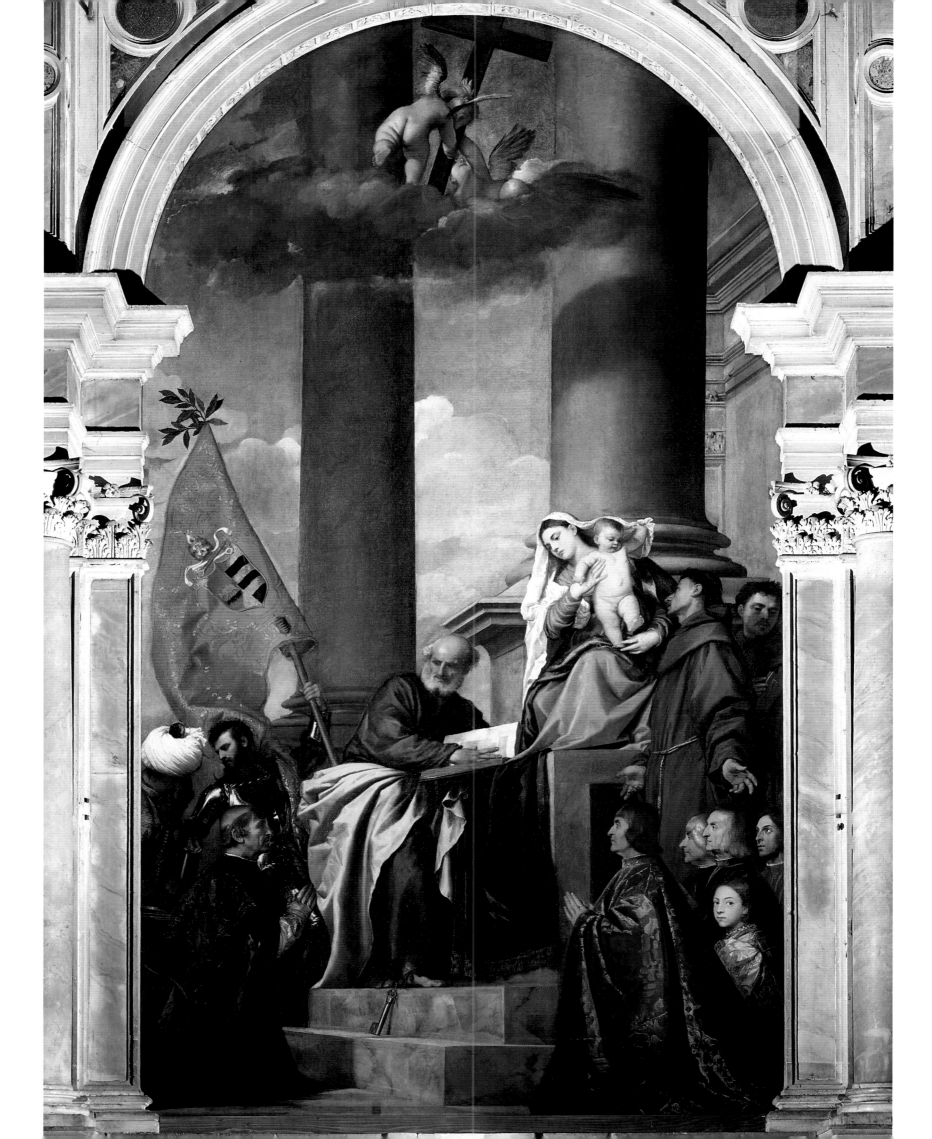

37 Polyptych of the Resurrection, 1520–1522
Oil on wood, 278 x 122 cm
Santi Nazaro e Celso, Brescia

Titian's impulse to capture bold bodily movements is not easily accommodated within the traditional structure of a polyptych, which necessitated depicting different pictorial elements on a number of panels. It is certain that this antiquated form was used the request of the client, the papal legate Altobello Averoldi. He is depicted (bottom left panel) with the patron saints of the church, St. Nazaro and St. Celso, to whom he donated the altar.

The Archangel Gabriel (top left panel) appears to be rushing in from the left, his garments streaming behind him. He spreads his greeting out on a banderole, which he is holding out to Mary on the opposite panel. His right hand, part of the banderole, his wings and the fluttering ends of his belt are all cut off by the edge of the picture. This creates the impression that the almost square panel is much too small to contain the magnificent figure of the angel. This artistic trick enables Titian to intensify the sense of tension and dynamics of the painting.

The bright figure of the ascending Christ (center panel) is surrounded by clouds that are lit up by the red rays of the early morning sun. The light in the upper part of the painting forms a vivid contrast to the darkness of the tomb, where the only flashes of light are reflections from the guards' armor. This dramatic effect of the light supports the theological message of the Resurrection.

The panel showing St. Sebastian (bottom right panel) was finished by 1520. Jacopo Tebaldi, the representative of the Duke of Ferrara, was so impressed by the painting when he saw it in Titian's workshop that he urged his master buy it. Tebaldi offered to pay Titian 60 ducats for this single panel – Averoldi was paying him only 200 ducats for the entire altarpiece. In the end, however, the Duke of Ferrara shied away from making the purchase, probably afraid of annoying the powerful legate Averoldi.

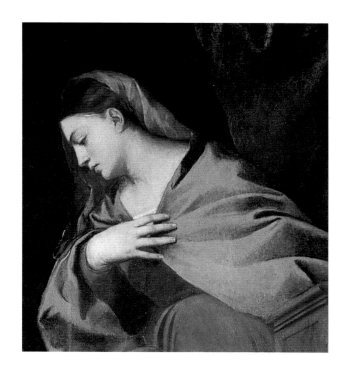
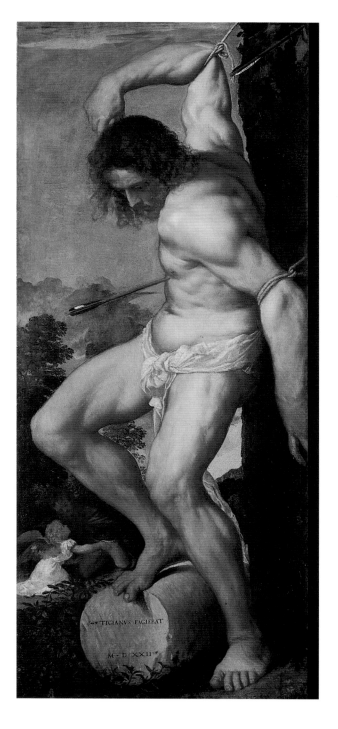

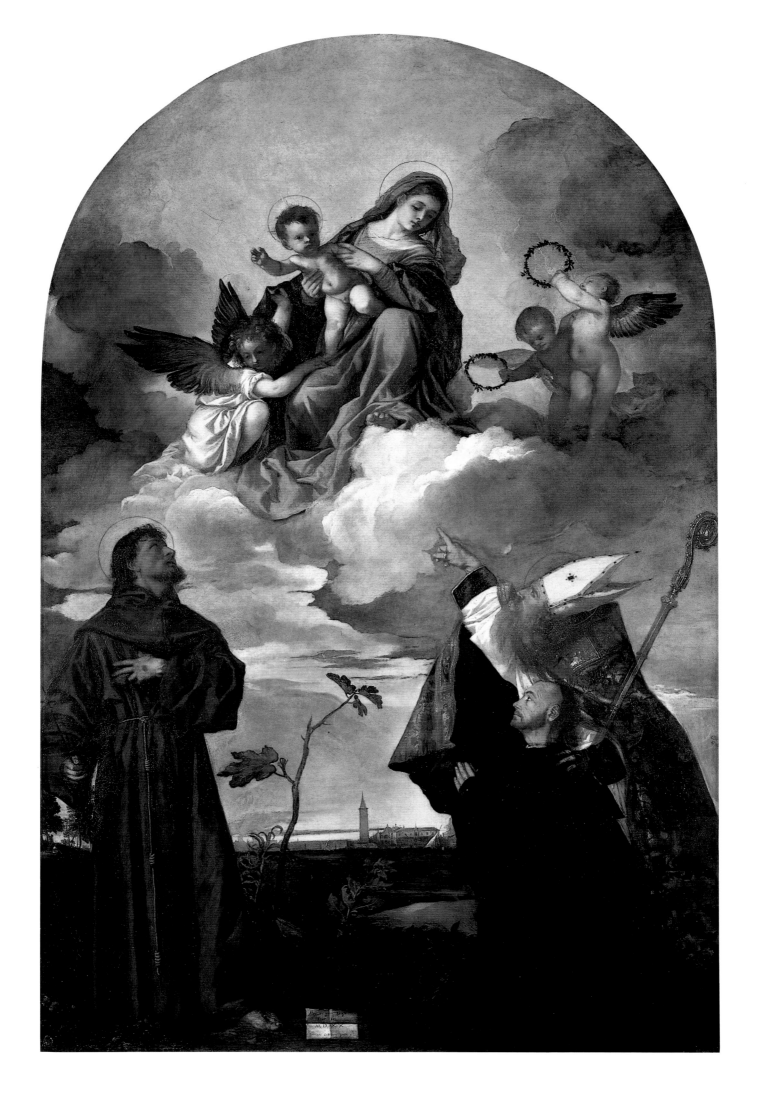

38 (opposite) *Madonna in Glory with the Christ Child and Saints Francis and Alvise with the Donor Alvise Gozzi*, 1520
Oil on wood, 320 x 206 cm
Museo Civico, Ancona

The powerful, animated figures, together with a view of Venice in the background, are typical of Titian's style in the early 1520s. Though it certainly took its inspiration from Raphael's *Madonna da Foligno*, painted about 1511, Titian's figures appear to possess a much higher degree of reality because of their expressive movements and the rich variety of color in which they are painted.

39 (above) *Madonna in Glory with the Christ Child and Saints Francis and Alvise with the Donor Alvise Gozzi* (detail ill. 38), 1520

Titian included a view of the Doge's Palace (Palazzo Ducale) and the church of St. Mark's in Venice, similar to the one he used in the fresco of St. Christopher in the Doge's Palace (ill. 35), which was created a short while later. This gives the work a further dimension of realism, enriching the interrelated levels of reality created by the coexistence within the picture of the Madonna, the donor and the saints.

TITIAN BETWEEN THE REPUBLIC AND EMPEROR – LANDSCAPE AS NARRATIVE ELEMENT

41 (opposite) *Martyrdom of St. Peter Martyr*
Engraving of Titian's altarpiece, destroyed by fire
formerly in Santi Giovanni e Paolo, Venice
Museo Correr, Venice

The painting, which many of his contemporaries
considered to be Titian's finest work, was destroyed on
16 August 1867 by a fire caused by repair work. At its
original location there is now a copy by Niccolò Cassana
(1659–1713). It depicts the martyrdom of St. Peter
Martyr (1203–1252), a Dominican and inquisitor who
was beaten to death on the road between Milan and
Como because of his merciless attitude to those accused
of heresy.

40 (right) *The Stigmata of St. Francis*, ca. 1530 or
1545–1550
Oil on canvas, 281 x 195 cm
Museo Pepoli, Trapani, Sicily

Because it appears of poor quality, this severely damaged
painting was long thought to be by someone other than
Titian. After cleaning and restoration in 1953, however, it
is now considered a genuine Titian. The dramatic lighting
of the heavens, the lack of breadth in the background,
and the trees and cloud formations used as compositional
elements of the events depicted, are all features that bear
comparison with the *Martyrdom of St. Peter Martyr*. There
is much uncertainty about the dating, however, varying
from the 1530s to the 1550s, as his treatment of color
suggests a later date than 1530.

The artistically lit clouds of the Averoldi polyptych (ill.
37) and the threatening clouds, shot through with
sharp yellow bolts of lightning, of the *Entombment of
Christ* (ill. 33) are indicators of an aspect of Titian's
work to which he increasingly devoted his attention
from about 1530 – the use of landscape not just as the
scene of the events, but as a feature that plays a role in
determining the picture's meaning. The most
important example of this new conception, the
Martyrdom of St. Peter Martyr (ill. 41), has since been
lost. Titian painted it between 1526 and 1530 for the
Dominican church of Santi Giovanni e Paolo in
Venice. Vasari wrote of the painting that "of all the
pictures painted so far by Titian this is the most
finished, the most celebrated, the greatest and the best
conceived and executed." Countless copies were made
of the altarpiece, which was destroyed by fire in 1867.
The painting was the summation of a series of pictorial
solutions Titian reached in the 1520s. Powerful,
monumental figures making dramatic, emotional
gestures focused the story on its climax. The saint is
lying on the ground. The murderer is swinging his
sword in order to kill him in the next instant. Two
angels are already on their way from Heaven with a
martyr's palm. St. Peter Martyr appears to have already
seen them, for he is looking towards them, not his
attacker. His fleeing companion is also looking back
towards the angels. The climax of the story will take
place in the next instant. The attacker will split Peter's
skull, making him a martyr for which he receives the
palm. The continuation of the scene would be clear to
anyone who knew the story of this saint. That the
events are not depicted, that instead they take place in
the observer's mind, creates the particular tension of
this altarpiece. A sense of mounting tension is created
in much the same way in numerous works painted
before this one, such as the *Assumption of the Virgin* (ill.
27), and *The Annunciation* (ill. 34) in Treviso.
However, Titian achieves a new quality in this painting
by linking more of the landscape, and not just the
light, to the dramatic events that are unfolding. The
trees appear to be sharing the movements of the
protagonists: they are effectively a paraphrase of the
main lines of movement of the figures.

A comparable interest in movement can be observed
in the Madonna paintings of the 1530s, though they
are much more reserved in their gestures and action.
Instead of stirring drama, they convey quiet
contemplation, the harmony of the colors playing an
important role in this. An impressive example is the
*Madonna and Child with the Young St. John the Baptist
and St. Catherine* (ill. 42). Titian makes technically
difficult aspects, such as the intertwined movements,
appear easy, and here too the action, though it has
been captured on canvas, is clearly about to continue.
The colors in the foreground are repeated in the
background, giving an impression of harmonious
unity. The same can be said of the *Madonna and
Child with St. Catherine and a Rabbit* (ill. 43), which
Titian probably painted for Federico II Gonzaga
(1500–1540), the young marquis who became the
Duke of Mantua.

The court of Mantua was the nearest place where

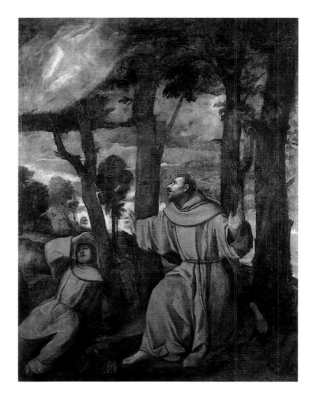

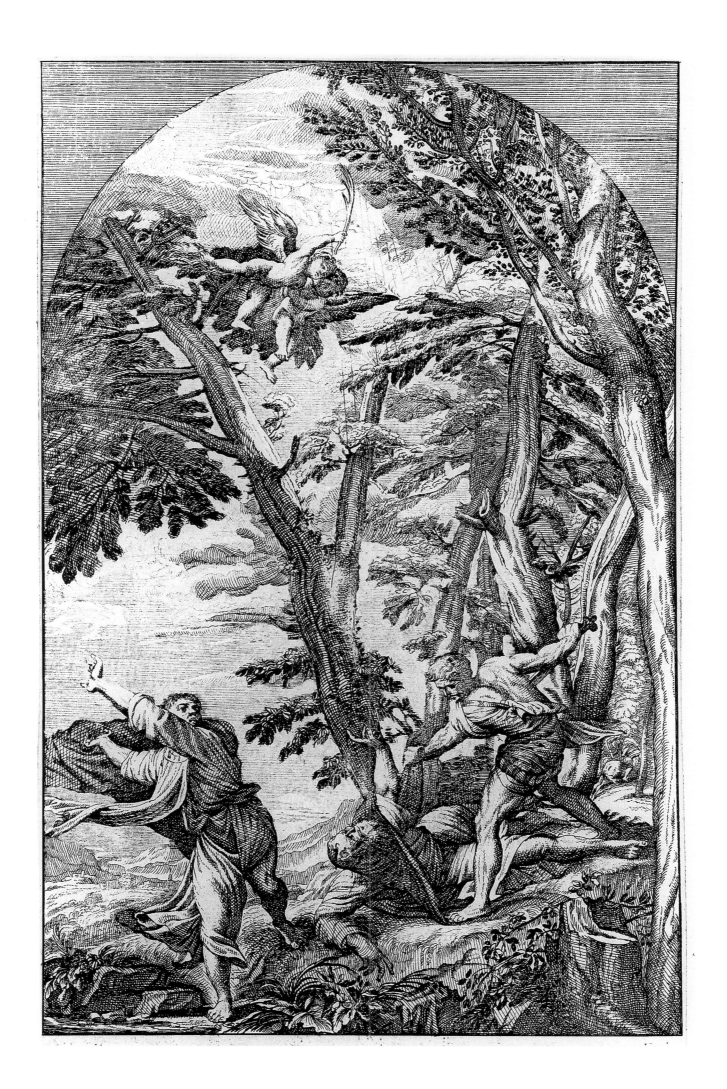

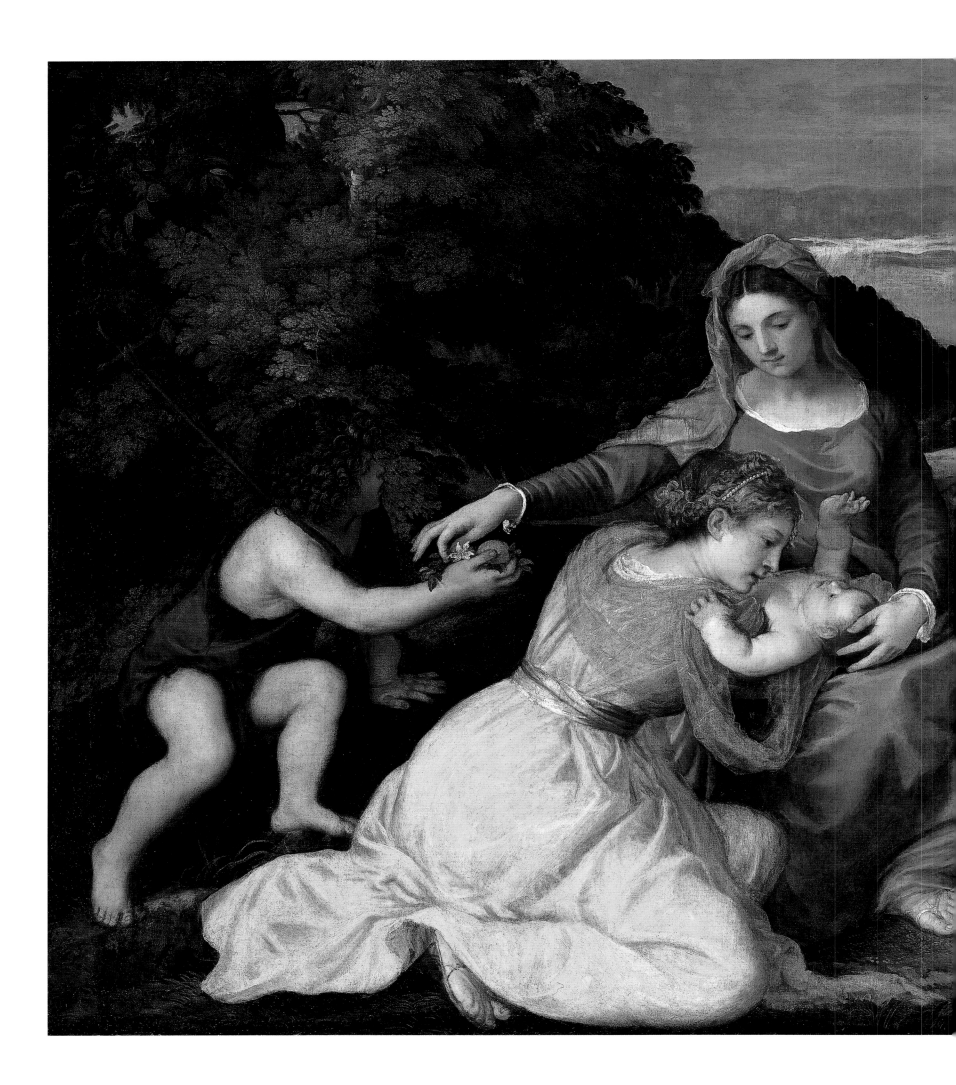

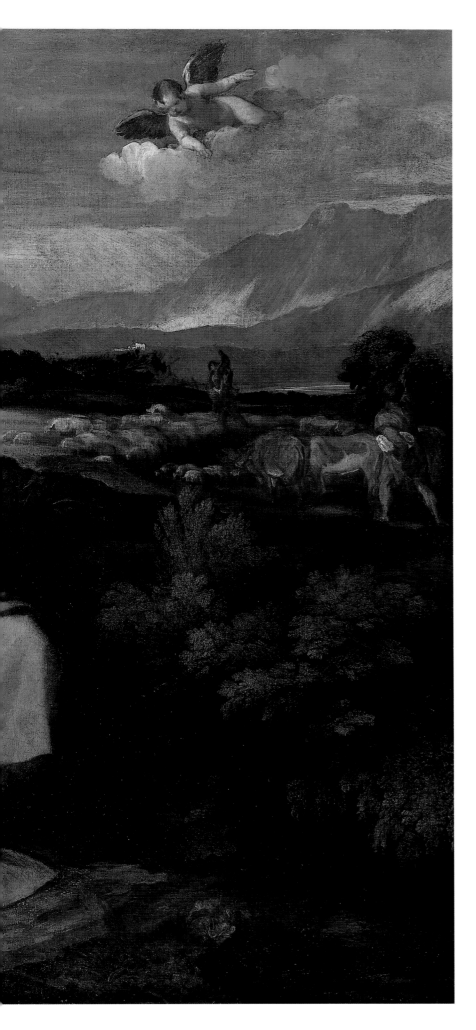

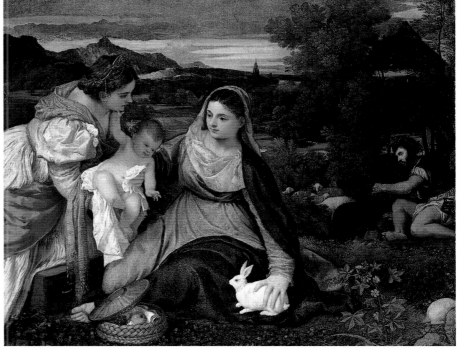

43 (above) *Madonna and Child with St. Catherine and a Rabbit*, 1530
Oil on canvas, 74 x 84 cm
Musée du Louvre, Paris

This painting mainly captivates through the beauty of its colors and the marvellous landscape. The small format is a sign that this was a private devotional picture. It was almost certainly painted for Federico II Gonzaga, who some researchers have identified as the shepherd on the right (compare his portrait in ill. 40). What at first sight appears to be a normal picture of the Madonna gains an additional, very private dimension as a result.

42 (left) *Madonna and Child with the Young St. John the Baptist and St. Catherine*, ca. 1530
Oil on canvas, 101 x 142 cm
The National Gallery, London

In his pictures of the Madonna dating from the early 1530s, Titian avoided large, emphatic gestures. The figures are nonetheless interconnected by a series of complicated overlapping movements that form a compositional whole – for example, St. Catherine carefully holding the Christ Child above Mary's lap, clearly about to either lift him up or lay him down. Thanks to Titian's superb mastery of such difficult movement motifs, the observer becomes aware of this only when analyzing the work more closely. We can only guess at the original color composition of the painting. It was detrimentally affected by a cleaning procedure that was too harsh.

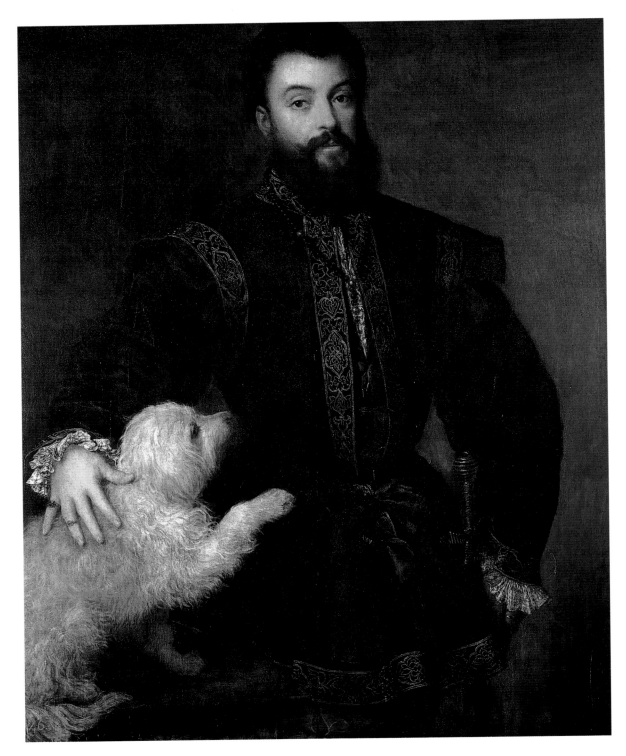

45 (above) *Portrait of Ippolito de' Medici*, 1533
Oil on canvas, 139 x 107 cm
Palazzo Pitti, Galleria Palatina, Florence

Ippolito dei Medici (1511–1535) was the natural son of
Giuliano, Duke of Nemours. While still a baby, he was
given into the care of his uncle, Pope Leo X (Giovanni
Medici). The pope's cousin, who succeeded him to
become Pope Clement VII, made Ippolito a cardinal in
1529. His unusual attire is a reference to the part he
played in the defence of Hungary against the Turks,
shortly before this portrait was created.

44 (left) *Portrait of Federico II Gonzaga*, 1523–1529
Oil on wood, 125 x 99 cm
Museo Nacional del Prado, Madrid

Federico II Gonzaga (1500–1540) was the son of the
margrave of Mantua, Francesco II and Isabella d'Este,
who was widely celebrated for her beauty and love of art.
He spent his childhood as a hostage at the courts of the
German emperor Maximilian I, the French king Francis I
and the Pope. In 1529, he succeeded his father as the
ruler of Mantua. One year later he was made a duke by
Emperor Charles V. Like his mother, he was a
knowledgeable and cultivated patron of the arts.

many Venetians could study the new directions that art
was taking in Rome. Works by Raphael could be found
here, and since 1524 Raphael's most important student
Giulio Romano (ca. 1499–1546) had been working
here. Federico II Gonzaga (ill. 44) was the nephew of
Alfonso d'Este, Titian's most important patron during
the 1520s. It is likely that Alfonso had brought Titian
to Federico's attention. But from 1527 there was
another herald spreading Titian's fame throughout
Italy, the writer Pietro Aretino (1492–1556) (ills. 58,
94), who was also in close contact with Federico. It was
Federico II Gonzaga who would finally introduce
Titian to his most important client during the

following decades. It was in the winter of 1529 that
Titian met Emperor Charles V for the first time, in
Parma, and in 1530 he painted his first portrait of him,
which has since been lost. The earliest of his surviving
portraits of the emperor is *Portrait of Charles V* (ill. 46),
which was painted either in 1532 or, more likely, in
1533. In the autumn of 1529, Charles had come to
Italy in order to resume the custom, which had lapsed
since the mid 14th century, of being crowned emperor
by the pope. It was no more than a symbolic act aimed
at bringing a temporary halt to the hostilities between
the emperor and pope. The emperor did not travel as
far as Rome, but was crowned by Pope Clement VII in

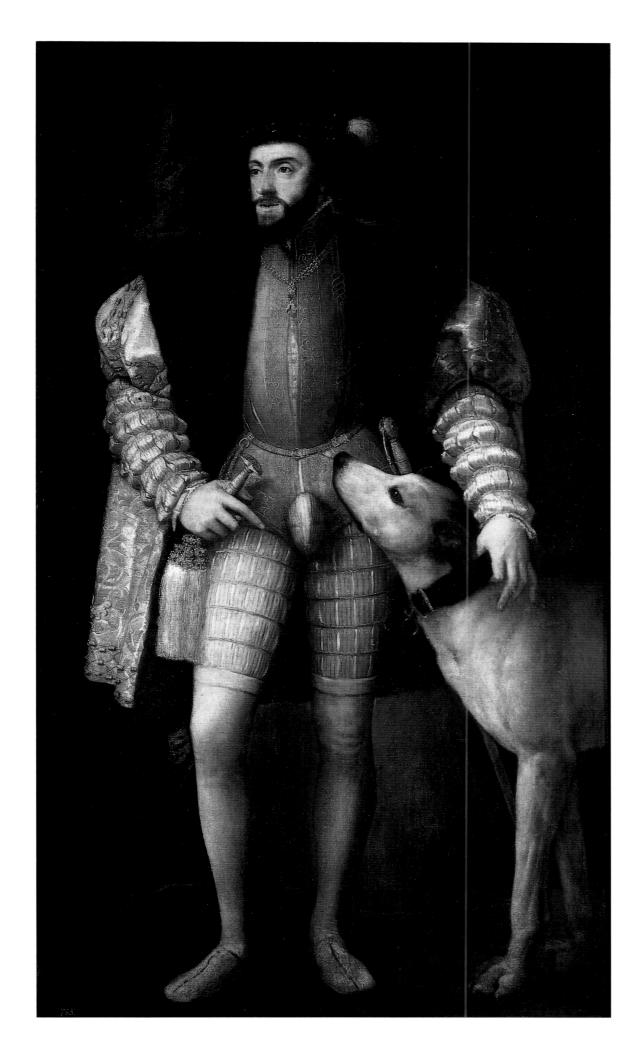

46 *Portrait of Charles V*, 1533
Oil on canvas, 192 x 111 cm
Museo Nacional del Prado, Madrid

This portrait is the earliest surviving example of a series of
portraits Titian painted of Emperor Charles V. It was
almost certainly painted in Bologna in 1533, for
numerous sources describe the emperor's clothing at this
time as being very similar to what he is shown wearing in
the painting. It is generally accepted that in this picture
Titian was copying a portrait made by the Austrian artist
Jakob Seisenegger (1505–1567), though there have also
been suggestions that the opposite is the case.

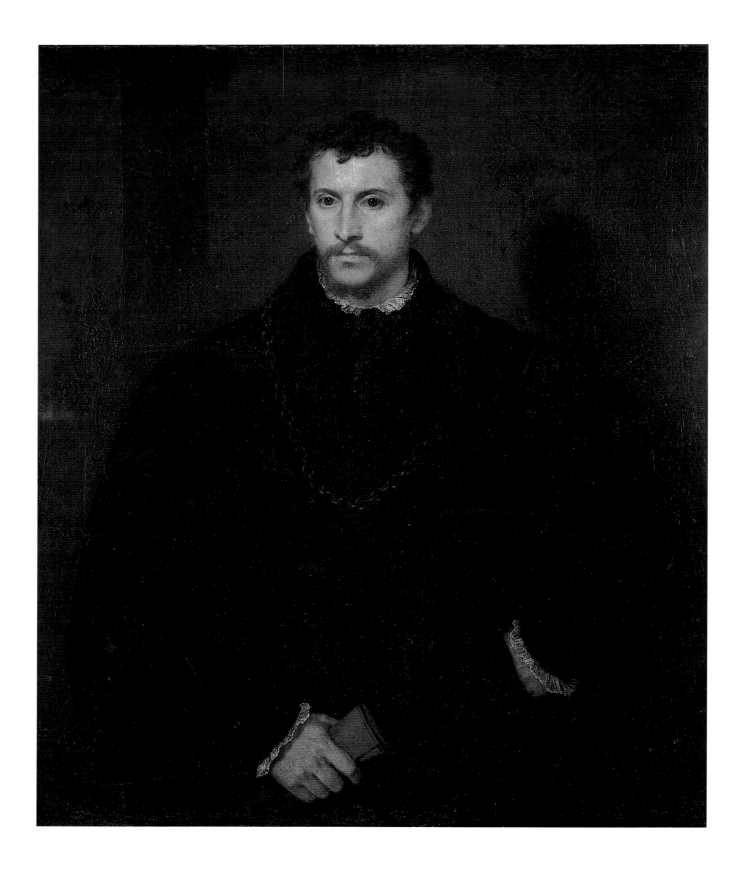

47 (above) *The Young Englishman*, ca. 1540–1545
Oil on canvas, 111 x 93 cm
Palazzo Pitti, Galleria Palatina, Florence

The light color of the portrayed man's hair and eyes, and
the elegance of his pose, led earlier interpreters to think
he was a young Englishman, though there is no evidence
to confirm this suggestion. The portrait is, however,
undisputedly one of Titian's most masterly portraits.

48 (opposite) *The Young Englishman* (detail ill. 47),
ca. 1540–1545

Titian skillfully used the man's blue-green eyes as a
colorist effect. They give the picture a particularly intense
expression, as they harmonize with the coloring of the
background.

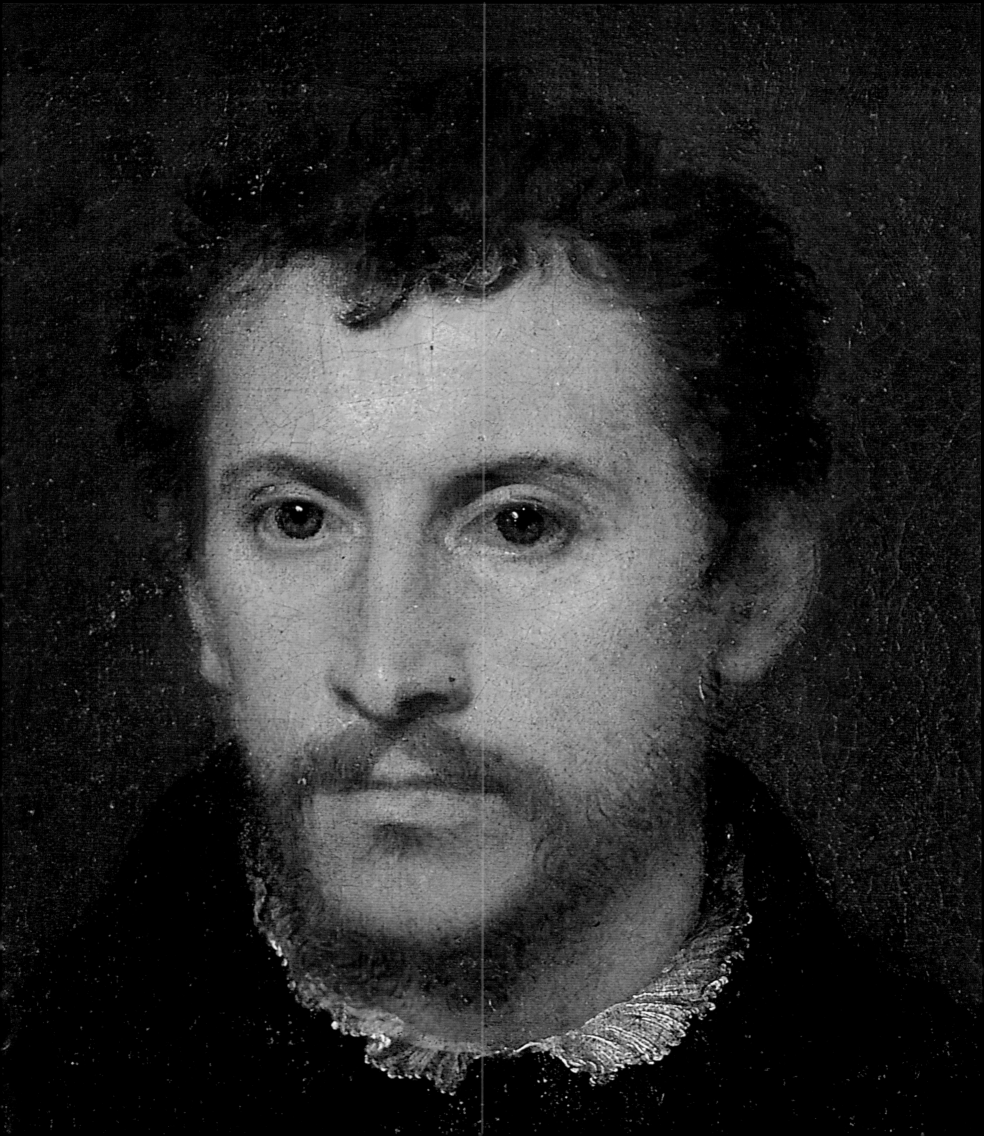

49 (below) *Portrait of a Musician*, ca. 1515 or ca. 1544–1546
Oil on canvas, 99 x 81 cm
Galleria Spada, Rome

In his monograph on Titian, Harold E. Wethey gives this picture a
very late date and excludes the possibility that it was one of Titian's
works. More recent Italian research has, however, defended the
work's attribution to Titian, though at a much earlier date. The pose
reminds us of his early works painted under the influence of
Giorgione. Wethey's date is based on the manner of painting, which
he feels to be typical of the 1540s.

Bologna in February 1530. An entire range of
diplomatic activities went hand in hand with the
coronation. The representatives of a number of Italian
aristocratic families went to Bologna in order to wait
upon the emperor, make new contacts, or even acquire
new titles or properties for their families.

The commission which Federico II Gonzaga gave to
Titian must also be seen in this context. Federico,
whose family enjoyed a long-standing relationship
with the German emperors, was made the duke of
Mantua. His portrait (ill. 44), which Titian may have
painted as early as 1523, or not until 1529, is
considered – along with his *Portrait of Ippolito de'
Medici* (ill. 45) and *The Young Englishman* (ill. 47) – to
be one of the finest male portraits he painted.

Works such as the *A Knight of Malta* (ill. 50), the
Man with a Glove (ill. 51) and *Portrait of Tomaso or
Vincenzo Mosti* (ill. 53) illustrate Titian's style of
portraiture. In contrast with his earlier portraits, Titian
was now faced with the task of portraying an
important dignitary. Federico's proud, erect posture
contrasts with his dreamy gaze; his face is framed by
thick, short curls and he is gently laying his hand on a
small dog who is pawing at him for attention. Titian
succeeds in simultaneously conveying an impression of
strength, eagerness and a sensitive, self-confident
calmness, corresponding to the Renaissance's ideal
courtier as described in "The Book of the Courtier" by
Baldassare Castiglione (1478–1529). However the
clothing, the velvety bluish-purple jerkin with gold

50 (above) *A Knight of Malta*, ca. 1510–1515
Oil on canvas, 80 x 64 cm
Galleria degli Uffizi, Florence

The cross on the man's cloak clearly identifies him as a
Knight of Malta. The portrait is typical of Titian's early
work, in which he was still strongly influenced by
Giorgione. The latter's influence can be seen clearly in
the way the portrayed man is positioned in the picture, and
Titian's choice of picture format.

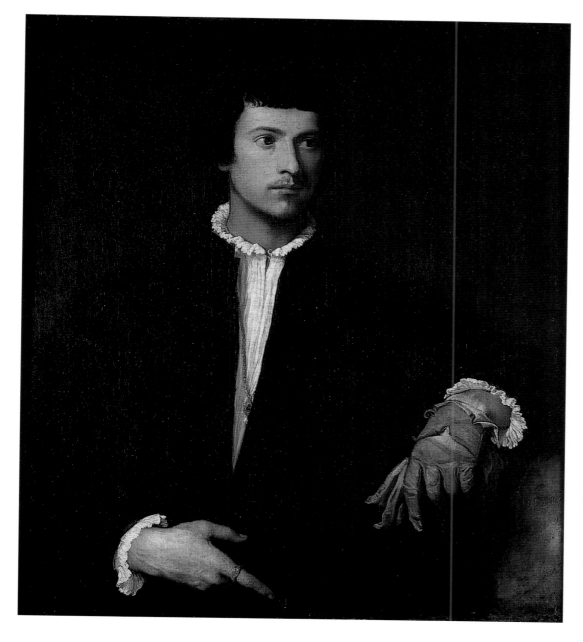

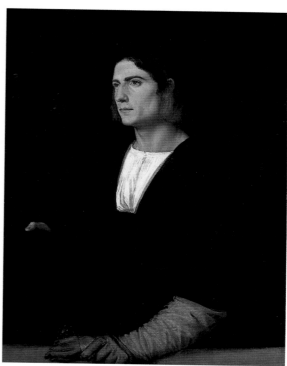

52 (below) *Young Man with Cap and Gloves*, ca. 1512–1515
Oil on canvas, 100 x 84 cm
Garrowby Hall, Earl of Halifax Collection, London

In this portrait the dark costume is enlivened by colorful touches such as the pink sleeves, shining white shirt, and slightly yellow gloves. As in all his paintings of this period, Titian delights in clearly displaying different materials and the way light falls on them. The stone balustrade in the foreground separates the portrayed young man from the observer. At the same time, Titian is playing with the levels of reality, for the young man, by the way he is leaning on the balustrade, seems capable of stepping beyond the confines of the picture.

51 (above) *Man with a Glove*, ca. 1520–1522
Oil on canvas, 100 x 89 cm
Musée du Louvre, Paris

Here the muted grays, blacks and whites make individual highlights of color – such as the sitter's blue eyes, red lips, and flushed ear lobes, and the chain around his neck – all the more prominent. The casual though clearly contrived pose, emphasized by the signet ring on his right hand, together with the unified use of color, clearly differentiate this portrait from Titian's portraits of rulers, which are characterized by stiff poses and a colorful splendor.

trim, the magnificent sword and jewels, creates a delicate, festive character in keeping with the duke's particular position. Titian had learnt Giovanni Bellini's lessons: his portraits create an impression through posture, color, and the play of light, all of which clearly reflect the position and personality of the sitter.

During Titian's lifetime, he was mainly admired for the verisimilitude of his portraits. But on closer observation it becomes apparent that he did not attempt to depict every feature or aspects of a person. He restricted himself to essentials, which he expressed not merely through depiction, but also through his choice of colors and forms, and his ability to convey the tactile properties of the clothing. It is precisely this skillful concentration on essentials, rather than an

exact realism, that make his portraits so easy for the observer to understand. Titian succeeded brilliantly in capturing certain aspects of a personality, ranging from a sitter's social status to his individual characteristics. In some cases it is to be doubted whether they were always historically accurate: social conventions and expectations will probably have played an equally important, if not greater, part.

In the 1530s, Titian reached the pinnacle of his career. He was working for Venetian patrons, for the most important northern Italian princely houses, and for the Emperor. In contrast to his friend Giulio Romano, though, he had always carefully avoided becoming the court painter for just one patron. Titian always remained an independent artist.

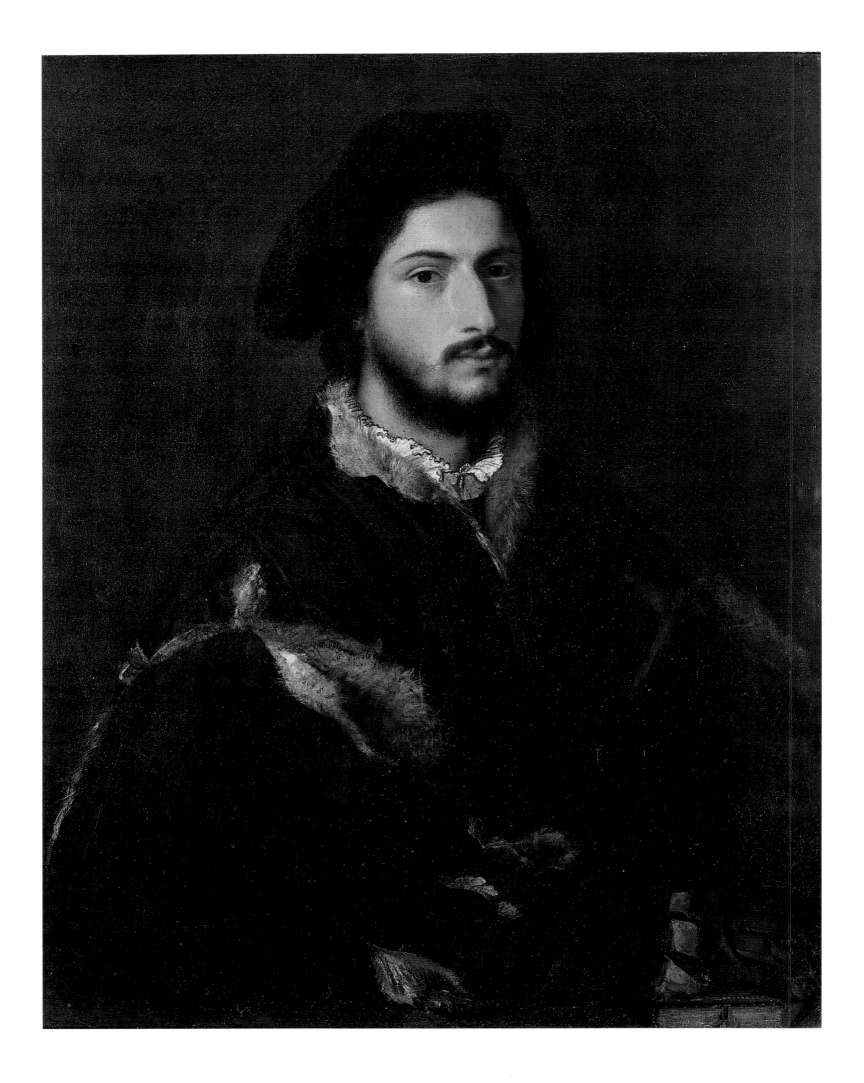

54 (above) *Portrait of Ippolito Riminaldi*, ca. 1528
Oil on canvas, 116 x 93 cm
Accademia di San Lucca, Rome

Many scholars believe that Titian did not paint this
portrait. The body of Riminaldi appears too flat, and the
use of the table in the foreground to separate the figure
from the observer is not skillful enough. When carefully
compared to portraits painted by Titian, it becomes clear
how masterful was his ability to give his portraits a three-
dimensional quality, even against a neutral background.

55 (right) *Portrait of Francis I*, 1539
Oil on canvas, 109 x 89 cm
Musée du Louvre, Paris

Titian never saw Francis I, the king of France
(1494–1547). He nonetheless succeeded in painting an
impressive portrait of a ruler. The model for his portrait
was a medal made by Benvenuto Cellini (1500–1571),
showing the king in profile. The erect posture, broad
torso and magnificent garments give the portrait a regal
air. The flat hat with its delicate feathers, together with
his fine hair, which is brushed across his face in a similarly
feathery way, give a certain lightness to the otherwise very
proud royal portrait.

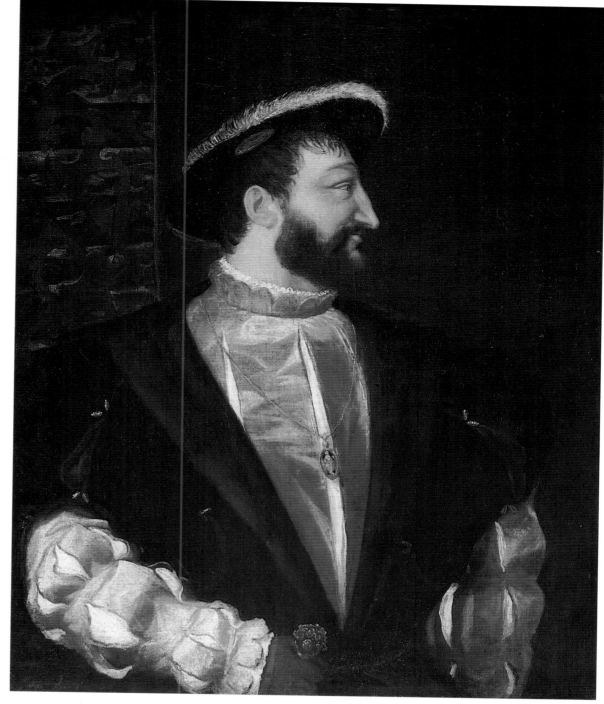

53 (opposite) *Portrait of Tomaso or Vincenzo Mosti*,
ca. 1526

Oil on wood, transferred to canvas, 85 x 66 cm
Palazzo Pitti, Galleria Palatina, Florence

There is an inimitable elegance in the way Titian links the
various shades of gray in the garment to those in the
background. Gray silk, fur and a lace shirt all become
tactile sensations. An inscription which used to be on the
back of the portrait identified the figure as Tomaso Mosti.
Some authors, however, think it more likely that this is
his brother Vincenzo. The reason is that Tomaso was a
priest, while Vincenzo, in contrast, was a favorite of
Alfonso d'Este at the court of Ferrara.

Though he was awarded the title of Count Palatine
and Knight of the Golden Spur by Charles V in
1533, and was repeatedly invited to visit his court in
Spain, Titian left Venice only for short trips. Some may
feel it to be astonishing that he preferred the
comparatively modest position of a Venetian craftsman
to the role of artist at a brilliant court. But even if his
foreign title meant nothing in Venice, this was where
he was sure to have both a regular income and the
security and freedom that no court could offer him. As
an adroit businessman, he will also have been quite
happy to be able to play various clients off against each
other.

The rising number of important commissions
enabled him to move into a new house on the edge of
Venice in 1531. It was both his workshop and
dwelling. While it was no palace, it was large enough
to be known as the Ca' Grande, the Grand House.

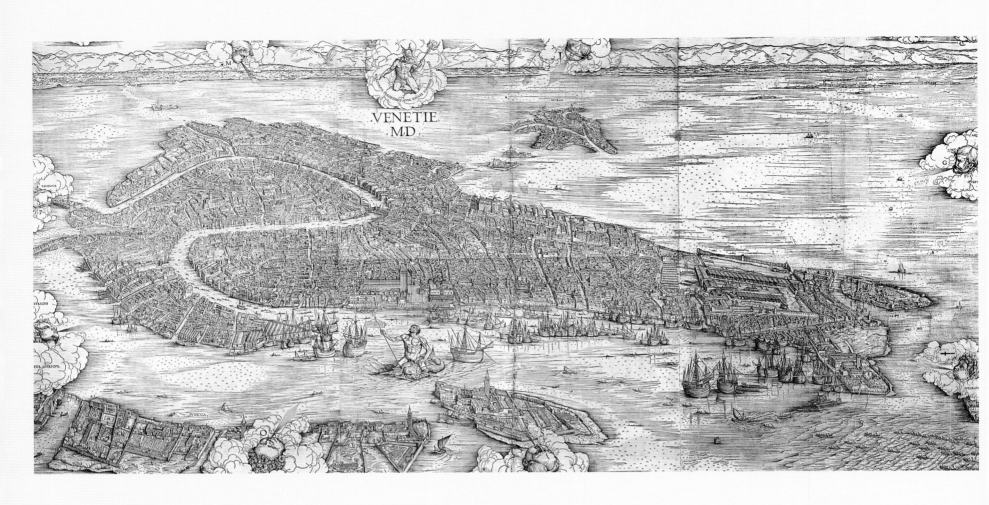

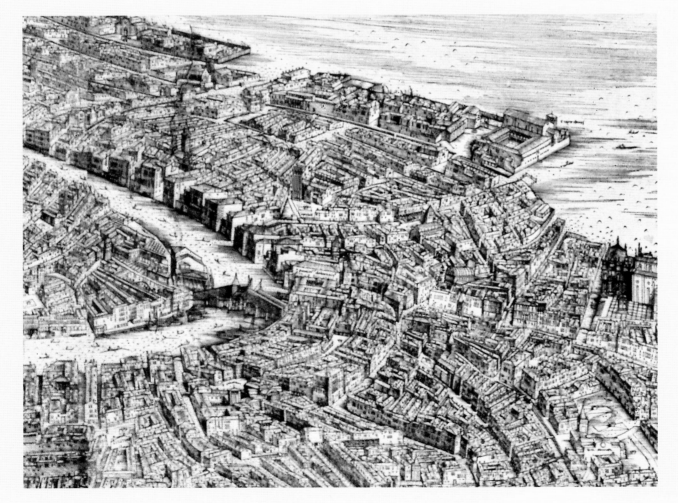

56 (above) Jacopo de Barbari
Plan of Venice, 1500
Woodcut produced with six blocks, 135 x 282 cm

In 1500, the Venetian artist and printer Jacopo de Barbari (ca. 1440–1516) had Anton Koberger of Nuremberg print a woodcut of Venice in which he had depicted all the buildings, gardens and islands of Venice at that time in minute detail. As a result, Barbari's plan gives us a precise idea of the appearance of Venice in about 1500.

57 (left) *Plan of Venice* (detail ill. 56), 1500

The region at the northern edge of the city of Venice, where Titian's house stood, was not yet built on at the time Barbari produced his plan. Titian's house was not built until 1527. At first he only rented the top floor. It is probably in about 1537–39 that he moved into the other floors. In 1549 he extended his property further by leasing a bordering, unused piece of land.

SVEGLIANDO GLI ANIMALI

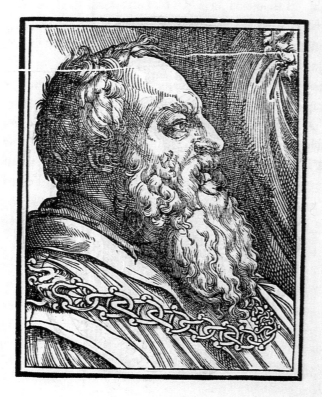

IN OGNI SELVA.

IACOPO SANSOVINO SCVL.
FIORENTINO.

Descrizione dell' opere di Iacopo Sansauino Scultore Fiorentino.

ENTRE, che Andrea Contucci scultore dal monte Sansauino hauendo gia acquistato in Italia, & in Ispagna nome, dopo il Buonarruoto, del piu eccellente scultore, & architetto, che fosse nell'arte, si staua in Firenze, per fare le due figure di marmo che doueuano porsi sopra la porta, che uolta alla Misericordia del Tempio di san Giouanni; gli fu dato a imparare l'arte della scultura vn giouanetto figliuolo di Antonio di Iacopo Tatti, il quale haueua la natura dotato di grande ingegno, & di molta gratia nelle cose, che faceua di rilieuo, perche conosciuto Andrea quanto nella scultura douesse il giouane uenire eccellente, non mancò con ogni accuratezza insegnarli tutte quelle co se

TITIAN'S HOUSE IN BIRI GRANDE

In 1531 Titian moved into his new house in Biri Grande in the parish of San Canciano. At that time, it lay on the north-eastern edge of the city amid gardens, and had an unspoilt view over the lagoon to Murano and the mainland. On particularly clear days, one could even see the Alps from here. The foundations of the house still stand, but the interior has long been changed and the garden has disappeared. It is now separated from the lagoon by the Fondamente Nuove, a bank of earth constructed in 1595. Titian's house was much more magnificent than any of the dwellings of other Venetian artists, and it was known as Ca' Grande, the Grand House. Vasari reports that it became an attraction in its own right. According to this biographer, his house at Venice had been visited by all the princes, men of letters and distinguished people

58 (above left) Giovanni Britto? after a drawing by Titian
Pietro Aretino, ca. 1538
Woodcut, 13.4 x 9.3 mm
Biblioteca Nazionale Centrale, Florence

Pietro Aretino (1492–1556) was born in Arezzo, the son of not particularly wealthy parents. He started writing from an early age and began his career at the papal court under Pope Leo X. Apart from both sacred and profane texts and plays, he mainly wrote letters which quickly spread his fame throughout Europe, but also won him many enemies. They earned him the nickname "flagello dei principe" ("scourge of princes"). In 1526 he moved to Venice and became one of Titian's most important friends. Giovanni Britto was a German artist active in Venice 1530–1550.

59 (above right) *Jacopo Tatti*, called Sansovino, 1568
Woodcut from: Giorgio Vasari, "Le Vite de' più eccellenti pittori, scultori architettori …", Florence 1568, vol. 2 of part 3, p. 822
Biblioteca Nazionale Centrale, Florence

Jacopo Tatti (1486–1570) became a member of Andrea Sansovino's workshop in Florence in 1502. Tatti adopted the name of Sansovino and followed his master to Rome in 1505. He fled to Venice before the Sack of Rome in 1527, and was welcomed by Aretino, with whom he had struck up a friendship in Rome. It is likely that Aretino introduced him to Titian. In the mid 16th century, Sansovino was Venice's leading architect. He built the major part of the Library, the Mint and the Logetta, which to this day give St. Mark's Square much of its distinctive character.

60 Dirck Barendsz
Venetian Ball, 1583–1584
Washed ink drawing on paper, 40 x 74 cm
Rijksmuseum, Rijksprentenkabinett, Amsterdam

Dirck Barendsz (1534–1592), an Amsterdam painter,
probably spent some time working in Titian's workshop
from about 1555. Though a ball in Titian's house would
scarcely have been as magnificent as the one in this
drawing, it is nonetheless assumed that Barendsz used the
view from Titian's garden for the background, which
shows a view over the lagoon. There, in the distance, one
can see the island of San Cristoforo della Pace, a view that
would have been possible from Titian's property.

staying or living in Venice in his time; for, apart from his
eminence as a painter, Titian was a gentleman of most
courteous ways and manners. There was probably no
distinguished visitor to Venice who would have wished to
fail to make the acquaintance of the famous artist. On
their return home, such an encounter would be a source
of pride, and would at the same time spread the artist's
reputation. Agents and messengers from his noble clients
came and went from Titian's house. In letters they sent
reports of the paintings he was working on, and wrote of
his hospitality. In 1574 even Henri de Valois, the future
king Henri III of France, visited Titian's workshop.

His house was also a meeting place for a circle of friends
drawn from Venice's artists and scholars. The most
important members of this circle were Pietro Aretino (ills.
58, 94) and Jacopo Sansovino (ill. 59). Aretino had lived in

Venice since 1526. He was famed and feared for his
letters, which he published. His vicious satire either
brought fame to princes, writers and artists, or destroyed
their reputations. Being favorably mentioned in his letters
was felt to be extremely desirable, and most were
prepared to reward Aretino with princely sums for the
opportunity. In addition, he played an important role in
the circle of Italian humanists.

The architect Jacopo Tatti, called Sansovino, had fled to
Venice in 1527, when Rome was sacked by the mer-
cenaries of Emperor Charles V. He immediately received
considerable recognition and during the 1530s advanced
to become one of the republic's leading architects. The
composition of St. Mark's Square, its Library and the
Logetta by the Campanile, are all derived from his designs.
The three friends formed a triumvirate which made its

influence felt in all areas of Venice's cultural life. They were frequently used, either singly or together, as experts in artistic matters. Their conversations and modest festivities in Titian's hospitable house are mentioned in many of Aretino's letters. The writer describes Titian as a friendly and generous host, who was gifted at using good food and music to create a particularly stimulating atmosphere for artistic and intellectual interchanges.

As reported by numerous visitors, the appearance of the great artist corresponded to that of an educated craftsman who was well situated financially rather than to that of a prince of painting who was famed throughout Europe. In addition, he was extremely eager to learn and interested in all the issues relating to the art of his era.

Around the friends there was a group of Venetian and foreign scholars and artists, such as Lodovico Dolce, who wrote a biography of Titian and was an art theoretician and translator of classical works, Sebastiano Serlio (1475–1554), who was an architect and architectural theorist and had also come to Venice from Rome in 1527 and had been working on his theoretical treatises since the end of the Thirties, and the publisher Francesco Marcolini, well-known chiefly because of Aretino's writings. Francesco Priscianese (ill. 61), an important Tuscan humanist who lived in Rome, spent some time in Venice in 1540 in order to have his most important work, a Latin grammar, printed. In a letter to friends he wrote a fascinating description of an evening spent in Titian's house and garden. Titian's horizons were undoubtedly considerably broadened by the learned conversations which took place there, and by the news which his guests brought him from all over the known world.

61 Giovanni Britto? after a drawing by Titian
Francesco Priscianese, ca. 1540
Woodcut from "La Lingua Romana", Venice 1540

Francesco Priscianese was born in the small town of Pieve di Presciano in the diocese of Arezzo. At first he remained in his native area as a priest. Then, in the 1530s, he came to Rome. There he mainly occupied himself with the Latin language and quickly made a name for himself as a philologist. Before 1540 he wrote a Latin grammar book, and Aretino helped him find a Venetian publisher for it. His portrait is taken from this work. This was also the book in which he printed a letter to his friends Lodovico Becci and Luigi del Riccio, in which he describes spending an evening with Titian.

62 *Adoration of the Shepherds*, 1533
Oil on wood, 93 x 112 cm
Palazzo Pitti, Galleria Palatina, Florence

Because of its small format, this is not an altarpiece but a
private devotional picture. Letters written by Francesco
Maria della Rovere, the Duke of Urbino. fix the date at
1533. Despite the severe damage, it is still possible to get
a sense of the wonderful night landscape and the
fascinating reflections of light in this night-time scene.

Apart from the Emperor and various Venetian clients, Titian painted the finest works of the 1530s for the ducal della Rovere family in Urbino. The duchess, Eleonora Gonzaga (1493–1555) (ill. 63), was the sister of Federico II Gonzaga.

One of the first paintings that Titian created for the della Roveres is the badly damaged *Adoration of the Shepherds* (ill. 62). A few years later he painted the mysterious *La Bella* (ill. 64), a portrait of a beautiful young woman that was also ordered by Duke Francesco Maria della Rovere (1490–1538). It is very likely that this painting, as well as *Flora* (ill. 23) and other paintings of this sort, was not a simple portrait but the depiction of an ideal of female beauty, though many authors have pointed out the subject's similarity

to Eleonora Gonzaga. Its interpretation as a portrait is based on inventories which always name the painting together with a portrait of Eleonora's mother Isabella d'Este (1474–1539). The latter painting is an idealised portrait of the young Isabella, painted by Titian when the margravine of Mantua was already more than sixty years old. Is it possible that her daughter had the same idea, to have a youthful portrait of herself painted when she was already in her forties? It is more likely, however, that Titian also applied a certain ideal type to the portrait of Eleonora (ill. 63) that was painted between 1536 and 1538, and that it was simply possible to express this type in a purer form in the *La Bella* than in the portrait of a real person.

64 (right) *La Bella*, 1536
Oil on canvas, 89 x 75.5 cm
Palazzo Pitti, Galleria Palatina, Florence

Like so many of Titian's other works, it is likely that this portrait is an idealized portrait of female beauty, and not a precise depiction of any one person. This is corroborated by the Duke of Urbino, who, in a letter he wrote on May 2nd 1536, simply described it as the "lady in the blue dress". The painting gains its opulent, sensuous appeal mainly from its masterful combination of color values, from the blue dress with red sleeves, through to the flesh tones and the golden brown, skillfully plaited hair.

63 (above) *Portrait of Eleonora Gonzaga, Duchess of Urbino*, ca. 1536–1538
Oil on canvas, 114 x 103 cm
Galleria degli Uffizi, Florence

In 1509, aged 16, Eleonora Gonzaga (1493–1555) married the Duke of Urbino, Francesco Maria della Rovere. The portrait corresponds completely to the Renaissance ideal of virtue. It displays nothing of Eleonora's powerful personality, which came to the fore when she actively supported her husband in his attempt to regain his territory, repeatedly ruling in his stead when he was away on campaigns.

In the portrait, Eleonora is wearing a magnificent dress in the colors of the house of Montefeltre, the rulers of Urbino until Francesco Maria della Rovere, who was made the heir of the last Montefeltre. She is sitting in front of an open window. We see out onto one of the most beautiful landscapes that Titian ever created. Today the top layer of color has been destroyed in some places, but it is still possible to make out the wonderful blue shades in the distance and the golden flashes of the trees, fields and rooftops in the sunlight. It is mainly the opulent dress and valuable jewelry that give the rather gentle woman an air of grandeur. Her lowered eyes and fine narrow mouth, in contrast, convey an impression of modesty. Only the firm chin, softened by the hint of a double chin and

firmly pressed lips, suggests something of the power and determination that were indeed characteristic of Eleonora. The entire intention of the portrait is to depict a beautiful, demure and modest Renaissance lady. It is lavishly praised as such by Pietro Aretino in one of his letters. Ten years later Titian painted a similar female portrait that conveys the character of the subject solely by means of her modest expression and her sumptuous clothes, which he makes all too obvious. This is his *Portrait of Isabella of Portugal* (ill. 66), which he painted without ever seeing her.

The counterpart to the portrait of Eleonora was that of her husband Francesco Maria della Rovere (ill. 65). He is characterized predominantly as a military leader. As if the magnificent shining armor and gleaming

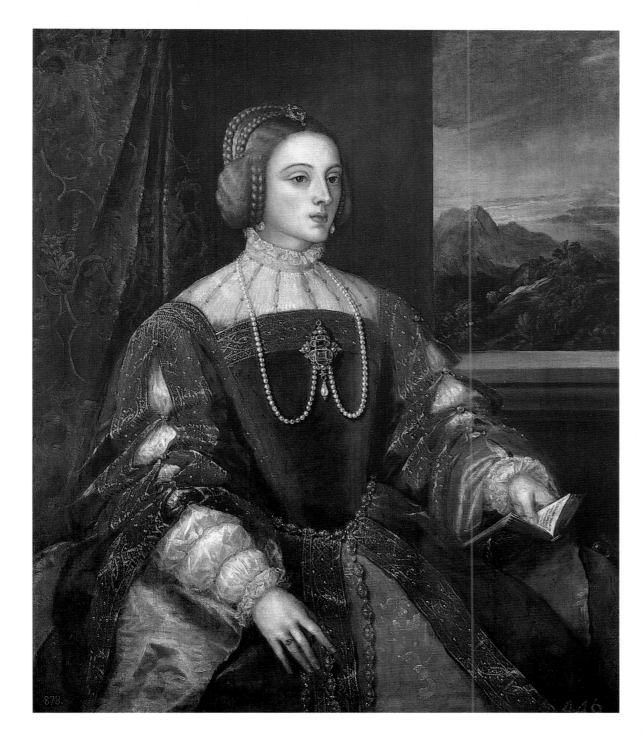

67 (above) *Portrait study of Francesco Maria della Rovere*,
ca. 1536–1538
Ink on white paper, 33.7 x 14.2 cm
Galleria degli Uffizi, Gabinetto dei Disegni e delle
Stampe, Florence

This drawing is not a proper study for the portrait of the
Duke of Urbino. Sources tell us that Titian had the duke's
armor brought to Venice so that he could depict it
faithfully – this study was probably drawn in connection
with that event.

68 (below) *Study of a Helmet*, 1537 or 1555–1560
Charcoal and white chalk on blue paper, 45.2 x 35.8 cm
Galleria degli Uffizi, Gabinetto dei Disegni e delle
Stampe, Florence

Compared with the shining helmet in the portrait of
Francesco Maria della Rovere (ill. 65), this work gives a
very good demonstration of Titian's ability to work with
charcoal. The various soft, richly shaded tones of black,
which he interspersed with white chalk to create the
stronger light effects, almost look as if painted with a
brush. He succeeds in creating a perfect imitation of a
polished metal surface.

65 (opposite) *Portrait of Francesco Maria della Rovere,
Duke of Urbino*, ca. 1536–1538
Oil on canvas, 114 x 103 cm
Galleria degli Uffizi, Florence

Francesco Maria della Rovere (1490–1538) succeeded his
uncle Guidobaldo da Montefeltre as ruler of Urbino.
Though at first protected by his uncle Pope Julius II
(Giuliano della Rovere), he lost power under the Medici
Pope Leo X, but was able to regain his territories after his
death. He was one of Italy's most important military
leaders and frequently served the Republic of Venice.

66 (above) *Portrait of Isabella of Portugal*, 1548
Oil on canvas, 117 x 93 cm
Museo Nacional del Prado, Madrid

Isabella of Portugal (1503–1539) married Emperor
Charles V in 1526. She died very young, when she was
only 36, and long before Charles V commissioned Titian
to paint her portrait. Her pale face emphasizes her
gentleness, which is also visible in the slender fingers of
her hands. The entire portrait is centered around a superb
color harmony of the red, white and gold. A charming
color contrast is provided by the blue and green tints of
the landscape, and the eyes of the empress.

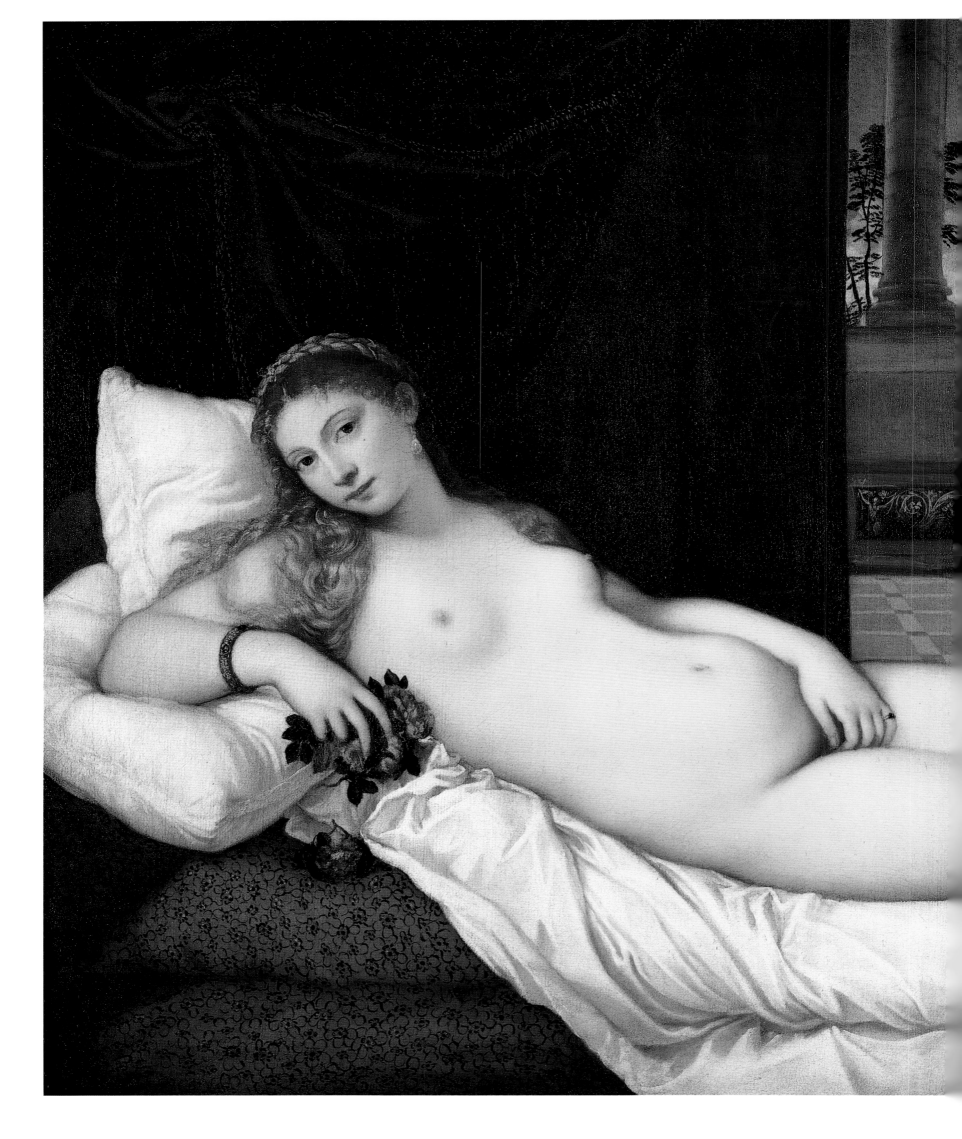

69 *Venus of Urbino*, 1538
Oil on canvas, 120 x 165 cm
Galleria degli Uffizi, Florence

The motif of the reclining figure is reminiscent of
Giorgione's *Sleeping Venus* (ill. 18) in Dresden. Nowadays,
the painting is normally interpreted as an allegory of
marital love and fidelity; there have been some
suggestions that there might be a connection with the
wedding of Guidobaldo della Rovere and Giuliana
Varano in 1534. There is an inimitable mastery in the
way Titian modelled the skin tones of the naked woman,
using a variety of colors from yellow through blue to dark
red, all of which blend to form a soft, peach-colored hue.

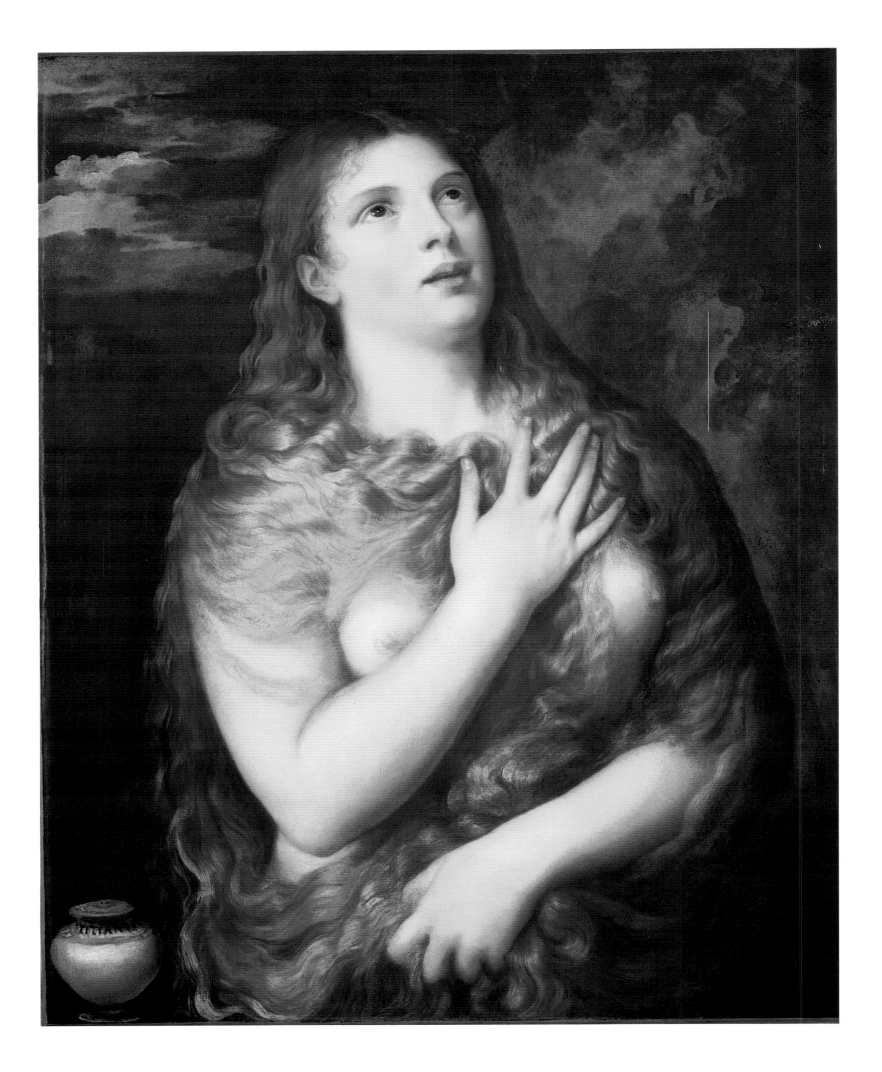

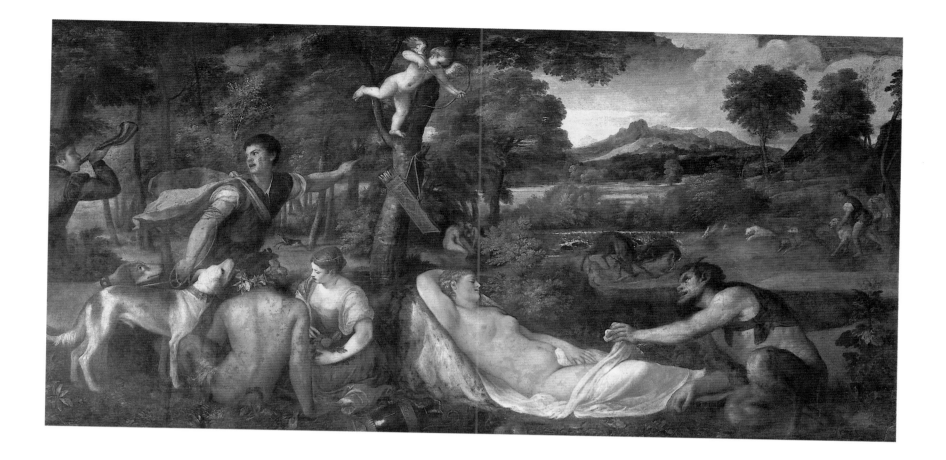

helmet were not enough, he is also leaning on the command staff of the Republic of Venice, and on the velvet cloth behind him we see the command staffs awarded to him by Florence and the Pope. Between them is an oak branch with his personal motto. He is gazing directly at us with pride and determination. Nonetheless one cannot help feeling that a small delicate man is being crushed by the burden of his duties, for Francesco does not fill the entire picture.

As in his other portraits, Titian depicted only a few aspects clearly. He still managed, however, to convey the impression of an individual personality. In contrast to his earlier portraits, it is mainly the air of authority that is being expressed here in the stiff posture of the subject and the splendor of his armor. This masterly ability to combine the expression of authority with an individual likeness meant that he was very much in demand as a portrait painter for the ruling classes.

He painted another masterpiece of the 1530s for the son of Eleonora Gonzaga and Francesco Maria della Rovere, Guidobaldo della Rovere (1514–1574), who succeeded to his father's title in 1538 – the *Venus of Urbino* (ill. 69). In a letter to his agent in Venice, Guidobaldo simply described the subject as "the naked woman". The strong erotic aura and portrait-like character of the painting led many early authors to consider it to be a portrait of a courtesan. Though this interpretation is no longer considered very plausible, no satisfactory explanation of the subject has yet been offered. It is very clear in all the paintings of this type, from the *Flora* (ill. 23) and *La Bella* (ill. 64) to the later pictures of Danaë and Venus, and even to the *St. Mary*

Magdalene (ill. 70) commissioned by Federico Maria della Rovere, that the main objective was the depiction of feminine beauty. Moreover Titian, like his client, frequently described such a female nude simply as "the naked woman". This, for example, was the term he used for the *Pardo Venus* (ill. 71) in a late letter to Philip II. The highly erotic depiction of the female body and the unexpected similarity to many other figures of women is very confusing for modern viewers. Scholars have only just begun to examine this aspect of Renaissance art seriously. Titian provides many examples of artistically challenging works that explore this erotic tension. While early research on these works was frequently characterized by prudishness or male voyeurism, the very different position of women in the Renaissance is now an integral part of scholarly attention. It is precisely in this field that the most interesting developments are to be expected during the next few years.

However, Titian did not work only for the court of Urbino during the 1530s. Federico II Gonzaga also continued to feature as one of his patrons. One of his commissions for his palace in Mantua was for a series of portraits of twelve Roman emperors for the palace in Mantua. These works have been lost.

At the same time, the Venetians were insisting that Titian should keep the promise he made in 1513 and produce the large battle painting for the Sala del Gran Consiglio for which he had been awarded the *sensaria*. In 1537 the Great Council underlined its demands by threatening to ask for the return of all the funds he had received until then. Titian fulfilled his obligation, but

71 (above) *Pardo Venus (Jupiter and Antiope)*, 1535–1540, reworked ca. 1560
Oil on canvas, 196 x 385 cm
Musée du Louvre, Paris

In 1574, Titian described this painting in a letter to the secretary of Philip II as being "the naked woman with the landscape and satyr". Its present name, *Pardo Venus*, derived from the Spanish palace of El Pardo, where the painting was for a long time kept. The reclining naked figure was interpreted as a Venus. In fact, the painting depicts the moment when Jupiter, in the form of a satyr, approached Antiope, a king's daughter, who will give birth to twins.

70 (opposite) *St. Mary Magdalene*, ca. 1530–1535
Oil on wood, 84 x 69 cm
Palazzo Pitti, Galleria Palatina, Florence

The sensuous quality of this saint, which is emphasized rather than subdued by the long, shining hair that fails to cover her bare breasts, was almost certainly the main reason why this type of painting was so successful, for countless copies and variants were produced by the Titian workshop. (cf. ills. 115, 116).

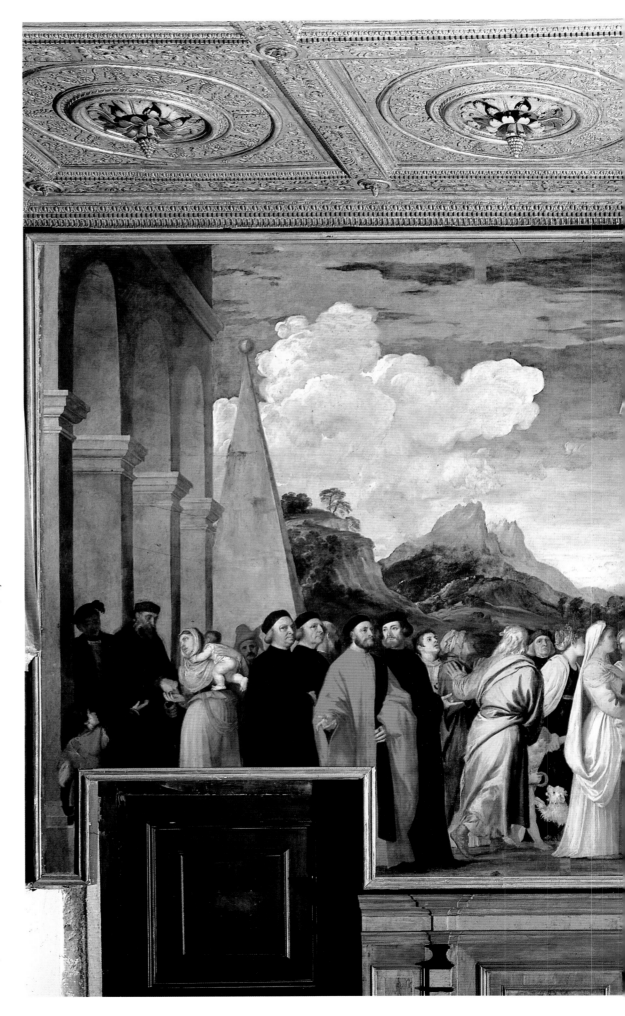

72 *Presentation of the Virgin at the Temple*, 1534–1538
Oil on canvas, 335 x 775 cm
Gallerie dell'Accademia, Venice

The various architectural elements, the portraits, the beautiful landscape in the background, and the variety of realistically painted details make this painting look as if it is the precise reflection of a very diverse reality. In fact, these are individual set pieces in which Titian was attempting to demonstrate the virtuosity of his painting technique and prove his ability to depict the world more precisely than any writer or sculptor could. This competition with other arts, known as *Paragone*, was a central feature in Renaissance art theory.

this large painting was destroyed in 1577 by a fire in the Doge's Palace.

Another work which was commissioned in Venice between 1534 and 1538 still exists: the *Presentation of the Virgin at the Temple* (ill. 72) in the assembly hall of the Scuola Grande di Santa Maria della Carità. The Scuola's building is now part of the Venetian art gallery, the Gallerie dell' Accademia, so it is still possible to admire Titian's masterpiece in its original setting.

This is an incomparable combination of large group portrait and religious painting. All the leading members of the Scuola are depicted in the large group of onlookers. Behind them there extends a marvellous alpine landscape. In contrast, there is a wall behind Mary and she stands completely alone on the steps of the temple. It is an important part of the legend that Mary climbs the steps on her own, without help. Titian emphasizes her solitude, in contrast to the group of onlookers, by setting her against a different background and by painting her dress in the same color as the sky. So he creates two pictorial zones: that of the group portrait and that of the religious picture, which, though closely interrelated, can be contemplated either together or individually.

As in all Titian's paintings of the late 1530s, the special characteristics of this picture are its quieter composition and the great realism of its details. Even though the protagonists appear to be connected to

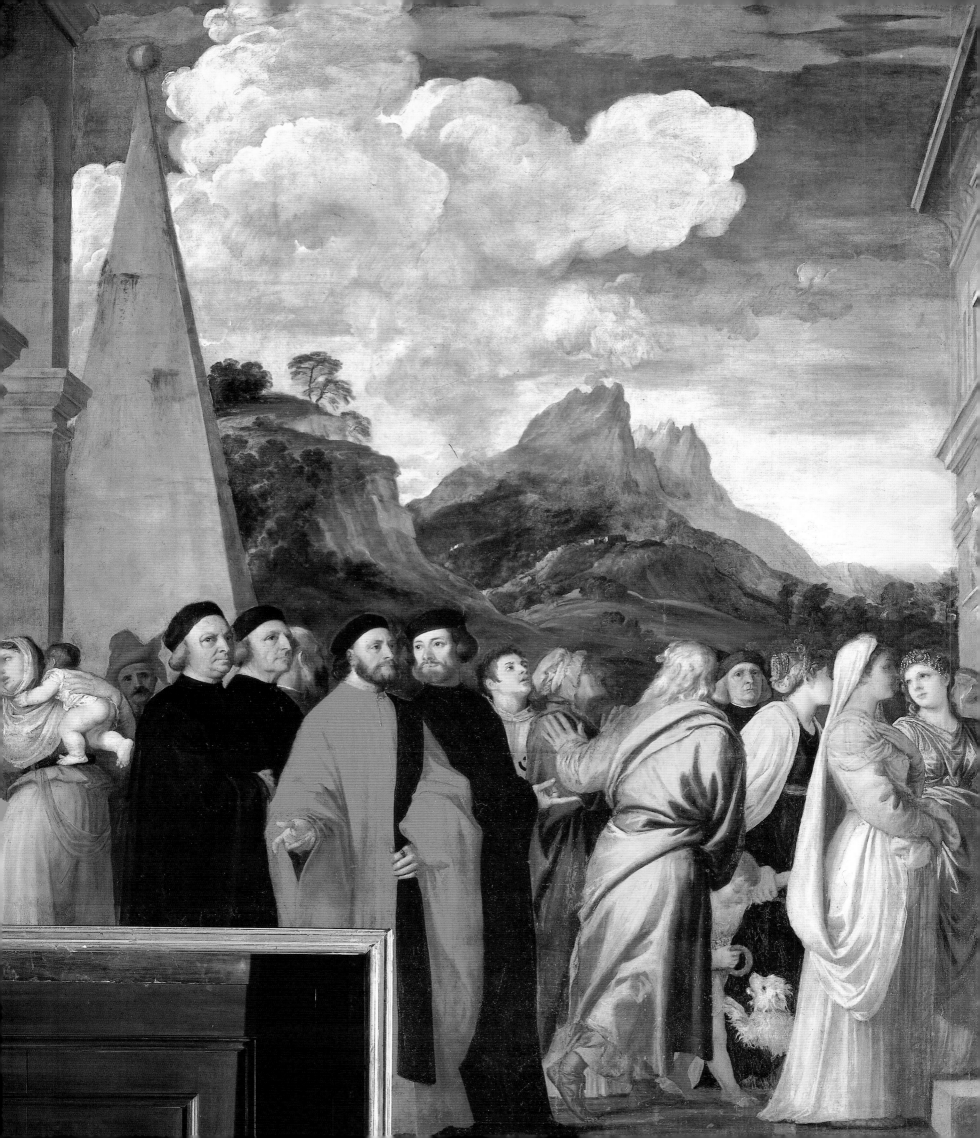

each other by glances and gestures, these are in fact less complicated, dramatic and contrived than those of the pictures from the 1520s and early 1530s. The egg basket in the foreground, the hens and the little black pig, the veined marble columns behind Mary and the mossy front edge of the steps – all these are depicted in a more lifelike manner than at any other point in Titian's creative work. Something similar is true of many pictures created during the 1530s, such as the enchanting fruit basket in the *Madonna and Child with St. Catherine and a Rabbit* (ill. 43), the valuable clock on the Duchess of Urbino's table (ill. 63) and the Duke's shining armor (ill. 65).

This method of depiction continued to characterize some of his paintings into the early 1540s, including the *Pardo Venus* (ill. 71), *St. John the Baptist* (ill. 75) and *Alfonso d'Avalos Addressing his Troops* (ill. 76). By this time, however, there are already signs of a change in Titian's manner of painting, a change that in art history has come be known as the period of his "Mannerist crisis".

73 (opposite) *Presentation of the Virgin at the Temple* (detail ill. 72), 1534–1538

All the leading members of the Scuola Grande di Santa Maria della Carità, which commissioned the painting, were portrayed by Titian among the spectators. The scuole were unions of Venetian citizens whose original purpose was to make sure that its members had appropriate funeral ceremonies. During the course of the years, the six wealthiest ones, the Scuole Grande of which the Scuola della Carità was one, became important charitable institutions that also played a leading political role in the life of the city.

74 (right) *Presentation of the Virgin at the Temple* (detail ill. 72), 1534–1538

The young Mary is dressed in a shining blue silk dress and is surrounded by a golden aureole as she climbs the steps of the temple, unaided, in an erect, dignified way that indicates, even at the age of three, what her future role will be. The gleaming dress, the golden light surrounding her, and the opulent marble columns behind her give the figure of Mary an aura of preciousness that is further emphasized by the sharp contrast with the ugly old farmer's wife in the foreground.

75 (opposite) *St. John the Baptist*, ca. 1540
Oil on canvas, 201 x 134 cm
Gallerie dell'Accademia, Venice

The view of the cliffs on the left emphasizes the powerful, muscular body of
St. John the Baptist. The arched shape of the grayish brown surface makes it
seem as if nature is shying away from him. On the right, we can see out onto
a brightly shining river, a reference to John the Baptist's mission. In this
painting too, the landscape not only sets the scene, but also plays a major
role in communicating the painting's meaning.

76 (above) *Alfonso di'Avalos Addressing his Troops*, 1539–1541
Oil on canvas, 223 x 165 cm
Museo Nacional del Prado, Madrid

A military commander addressing his troops is a classical motif that was
revived during the Renaissance. There is a specific model for the painting
when, in the war against the Turks in Hungary in 1532, Avalos spurred on
his faltering troops with an address. However, it is likely that there is a more
general allegorical meaning beyond that. For the small boy carrying the
duke's helmet is his son Francesco Ferrante, who would only have been one
year old in 1532.

Emperor and Pope
The "Mannerist Crisis" – Titian's Trip to Rome

77 *The Last Supper*, 1542–1544
Oil on canvas, 163 x 104 cm
Palazzo Ducale, Urbino

Titian's workshop carried out less of the work on this section of the processional banner than on its companion piece (ill. 78). Although it is clear that Titian did not take any great pains over the painting and left parts of it for his workshop to do, we can accept that the particularly skillful, rapidly painted areas of color, such as the bottle of wine on the table, were painted by the Titian himself. Typical of Titian is the confident and masterful organization of a composition which would normally require a horizontal format into an upright one.

78 (opposite) *The Resurrection*, 1542–1544
Oil on canvas, 163 x 104 cm
Palazzo Ducale, Urbino

Like illustration 77, this painting was originally part of a single processional banner for the Corpus Domini brotherhood in Urbino. Documents relating to payments made in 1542 and 1544 still exist. As early as 1546, the banner was split. Here, Titian is repeating the composition of the *Polyptych of the Resurrection* (ill. 37). The greater range of colors, however, is typical of his work shortly after 1540, even though both sections of the banner would have been produced with the assistance of his workshop.

The term "Mannerism" is used in very different ways in art history. By now, just as much space has been devoted to its definition as to the question of whether (and when) one should use it in order to define a style. The common denominator of the various interpretations is that Mannerism refers to a turning away from a precise depiction of reality in favor of an artificial style that is clearly based on the artist's own concerns. From one case to the next, Mannerist works are characterized by an intriguing artificiality. The leading exponents of Mannerism included artistic personalities as differing as Michelangelo, Giulio Romano (and other pupils of Raphael), Correggio (1494–1534) and Parmigianino (1503–1540).

During the course of the 1530s, a powerful competitor for Titian's Venetian clients emerged in the form of Giovanni Antonio Pordenone (1484–1539), who outdid Titian both by selling his works at a lower price and by painting mighty figures modelled on those of Michelangelo and Giulio Romano, much to the delight of his patrons. Even Titian's friend Pietro Aretino once described him as the only one who could equal Michelangelo.

At the end of the 1530s, Cardinal Giovanni Grimani invited the Roman artists Francesco Salviati (1510–1563), Giovanni da Udine (1487–1564) and Giuseppe Porta (ca. 1520–1575) to Venice in order to decorate his palace near Santa Maria Formosa in the Roman manner. In 1541 Giorgio Vasari also arrived at the invitation of his fellow Tuscan Pietro Aretino (they were both from Arezzo) in order to produce the stage scenery for Aretino's comedy "La Talanta". All these artists introduced Mannerist ideas to Venice. One of the artists working in Venice itself was Andrea Schiavone (ca.1510/15–1563), who modelled himself on artists from northern Italy, such as Parmigianino (1503–1540) and Correggio (ca. 1494–1534) rather than Roman ones. Works by all these artists, as well as the many engravings of works by Raphael, Michelangelo and Correggio, must have made an impact on Titian's art. He again began to experiment with color and space. In this sense one can certainly talk of a creative crisis in his life; during this time, there was little uniformity in his works. But it was a creative crisis in which he was trying out new means of depiction, and from which he was to emerge, now almost sixty years old, with an entirely new style.

He needed numerous assistants to carry out the countless commissions of those years. His works are not always the ones that have survived. Many of the works we now possess are merely adaptations of his designs by more or less talented assistants, some of whom worked for him for a very short period. He occasionally added a few brushstrokes to works produced by his assistants in order to make them his own. That is why many of the paintings which left his workshop from the 1540s onwards are much more difficult to classify and date than his early works. This is reflected in the literature on the subject, with a wide range of dates being suggested for some works.

His processional banner for the brotherhood of Corpus Domini in Urbino (ills. 77, 78) displays stylistic characteristics of both the 1530s and the 1540s, as well as those of his workshop. As in the *Presentation of the Virgin at the Temple* (ill. 72), he now shows a greater interest in architectural motifs. He frequently pays far less attention to the recording of the subject than to working out color values. Alongside this, however, there are passages that are almost still lifes, such as the bottle of wine on the supper table. He did not achieve these perfectly convincing illusions through a painstaking skill in painting details, as did the Netherlandish artists of the 15th century, but solely through a knowledge of the effects of colors. For example, in the case of the wine bottle, he creates the illusion of a transparent glass bottle filled with wine by means of a patch of red that deepens towards the left, and a couple of white lines.

The ceiling paintings for the Augustinians in Santo Spirito in Isola clearly show the way in which Titian approached the new forms created by the Mannerists (ills. 79, 80). Both Pordenone and Vasari, as well as the artists working for Cardinal Grimani, had created ceiling paintings before him. But Titian's ceiling paintings were like a thunderbolt. Their monumentality and foreshortened view from below (the so-called *sotto in sù*) went beyond anything that had existed in Venice until then, even though some of the forms he used are modelled on Correggio and the frescoes by Pordenone in the cloister of Santo Stefano in Venice. Vasari, who may originally have been commissioned to produce the work by the Augustinians, emphatically praised Titian's mastery of *sotto in sù*. In the powerful, muscular figures with

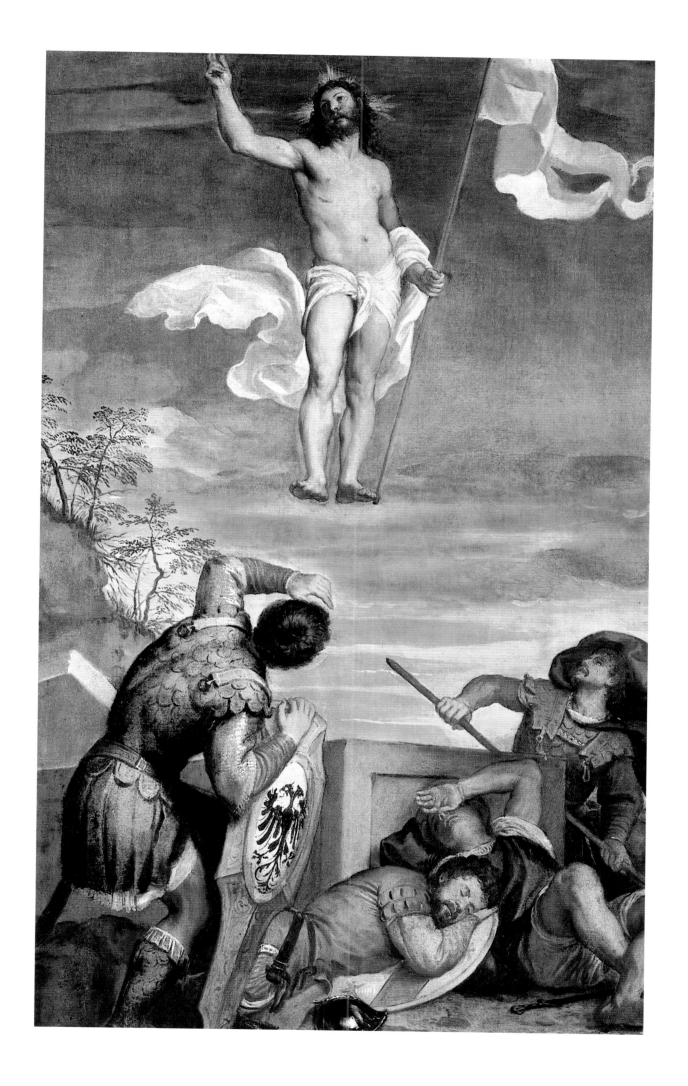

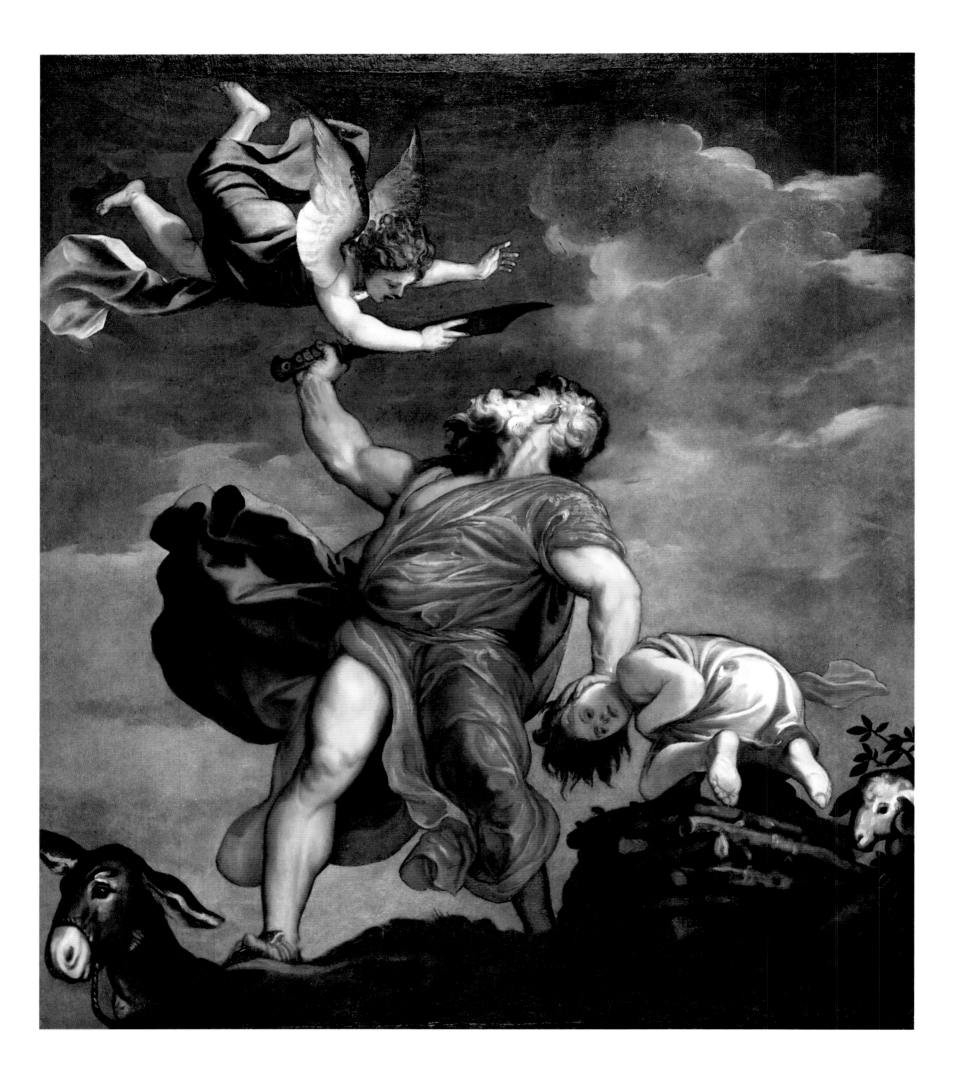

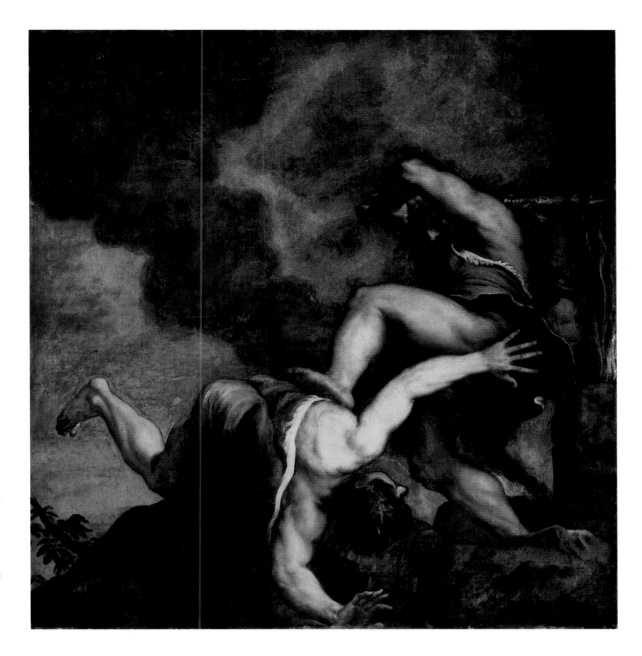

80 (right) *Cain and Abel*, 1542–1544
Oil on canvas, 292 x 280 cm
Santa Maria della Salute, Venice

This painting, like illustration 79, was originally part of a ceiling decoration for the monastery of Santo Spirito in Isola. The carved ceiling into which the paintings were set, and which no longer exists, was designed by Jacopo Sansovino. In 1656, the paintings were transferred to the church of Santa Maria della Salute. The powerful muscular bodies and the clouds streaked with bright light are elements which can be seen in Titian's art since the 1520s. By now, however, he is no longer interested in rendering space and the different textures of objects – skin, fur, clouds and stone appear primarily as color.

79 (opposite) *The Sacrifice of Isaac*, 1542–1544
Oil on canvas, 328 x 282 cm
Santa Maria della Salute, Venice

This, the largest of the paintings for Santo Spirito, was painted for the central section of the ceiling. The entire picture surface is dominated by the heavily foreshortened, muscular figure of Abraham, whose outstretched arms link the dramatic centers of the painting. At the bottom right, he is firmly bending down the head of Isaac, his only son and heir. To prove his faith, Abraham is prepared to sacrifice his son accordance with God's will. At the top left, the angel of God appears, seizing the sword in order to save faithful Abraham's son.

incredibly strong, confident movements, Titian proved that he was far superior to Pordenone and Vasari. This once again confirmed his leading artistic position in Venice. He did, though, increasingly turn to more important patrons outside Venice. The 1540s, even more than the previous decade, are characterized by works painted for the emperor and his immediate entourage. Even Pope Paul III, whose predecessor had made a vain attempt to lure Titian to Rome, also received some paintings.

In about 1540, Titian painted two works for the imperial governor of Milan, Alfonso di Avalos, the Duke of Vasto (ill. 76). In 1978, it was possible to prove that Titian received a further commission in connection with this Milan task, to paint *Christ Crowned with Thorns* (ill. 81) for the Milan church of Santa Maria della Grazie, a work that displays his reaction to the works of Giulio Romano.

Shortly afterwards, he created the enchanting portrait of the Pope's twelve year old grandson,

Ranuccio Farnese (ill. 82). It is the first of a series of pictures which Titian painted for the Pope's Farnese family from then until 1546. At the same time he painted another charming child's portrait, that of Clarissa Strozzi (ill. 83). In these two portraits Titian shows himself a master in depicting childhood in all its freshness – adding a light sheen to the eyes and lips, reproducing the play of the light on hair, and conveying a sense of imminent movement. In the portrait of Clarissa Strozzi he added attributes such as the little dog and the putti playing in the relief. In that of Ranuccio Farnese he relied solely on formal means, such as the fresh coloring of his cheeks, the reflections in his eyes, and his shining lips. Titian's portraits of children always seem particularly authentic, while his portraits of adults always seem to be modified by various contemporary ideals. A direct comparison with the works of his contemporaries reveals Titian's mastery in both areas. His copy of Raphael's 1512 portrait of Pope Julius II (ills. 85, 86) also dates from

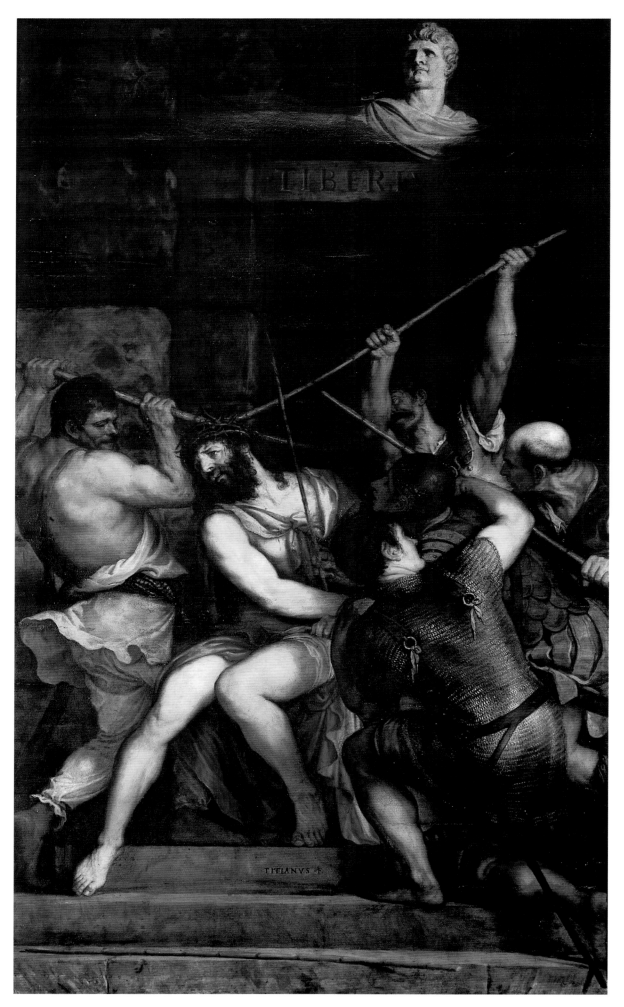

81 (left) *Christ Crowned with Thorns*, 1540
Oil on wood, 303 x 180 cm
Musée du Louvre, Paris

The muscular bodies and the heavy rustication in the
background of this painting clearly show Titian's interest
in the vocabulary of forms developed by Giulio Romano
in Mantua. The varied arrangement of colors, with areas
of powerful, almost cornflower blue contrasting with
yellow, green, and pink, is typical of Titian's palette in the
early 1540s and harmonizes much more delicately than
the colors in the Urbino processional banner (ills. 77, 78).
Despite this new use of color, there are still exceptionally
realistic details in the painting, such as the crown of
thorns, the tormentors' sticks, and the tormentor's chain
mail in the foreground.

82 (opposite) *Portrait of Ranuccio Farnese*, 1542
Oil on canvas, 89.7 x 73.6 cm
National Gallery of Art, Kress Collection, Washington

Ranuccio Farnese (1530–1565) was the son of Pier Luigi
Farnese, the son of Pope Paul III. He came to Venice in
1542 to be the prior of San Giovanni dei Forlani, which
belonged to the Knights of Malta. The white cross on his
cloak clearly shows that he is a member of the order. The
way he is looking out to the left of the picture, and the
slight turning of his body, makes him look as if he is
about to move from the place where the artist has
captured him on canvas. This movement contributes
considerably to the impression of childlike freshness
which the painting radiates.

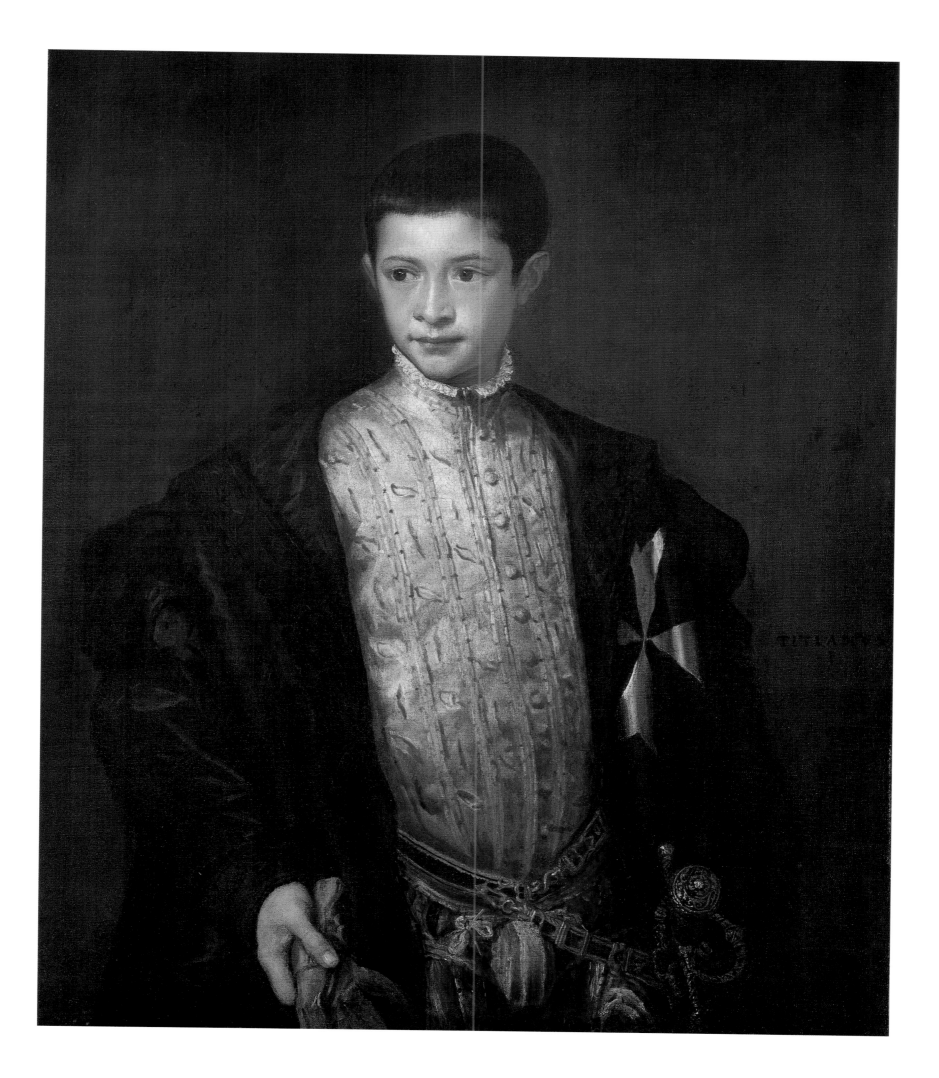

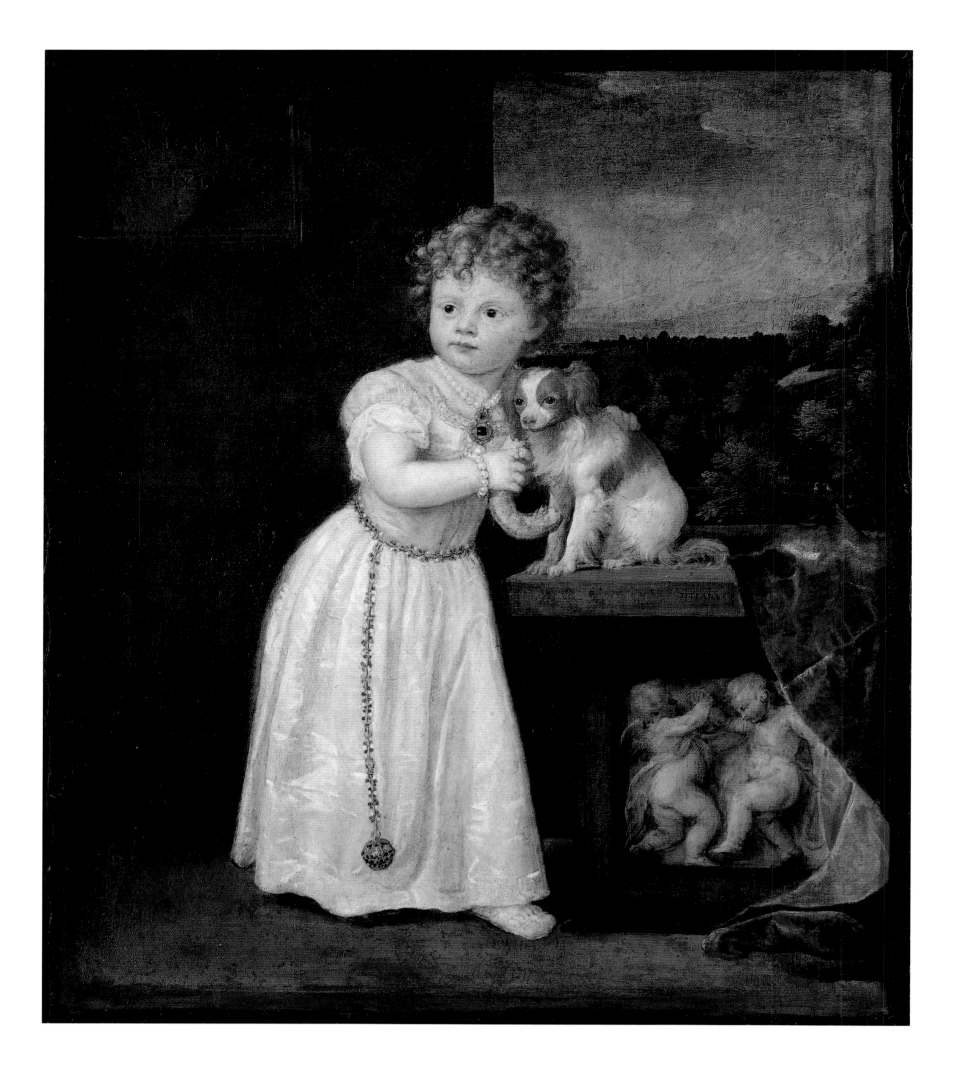

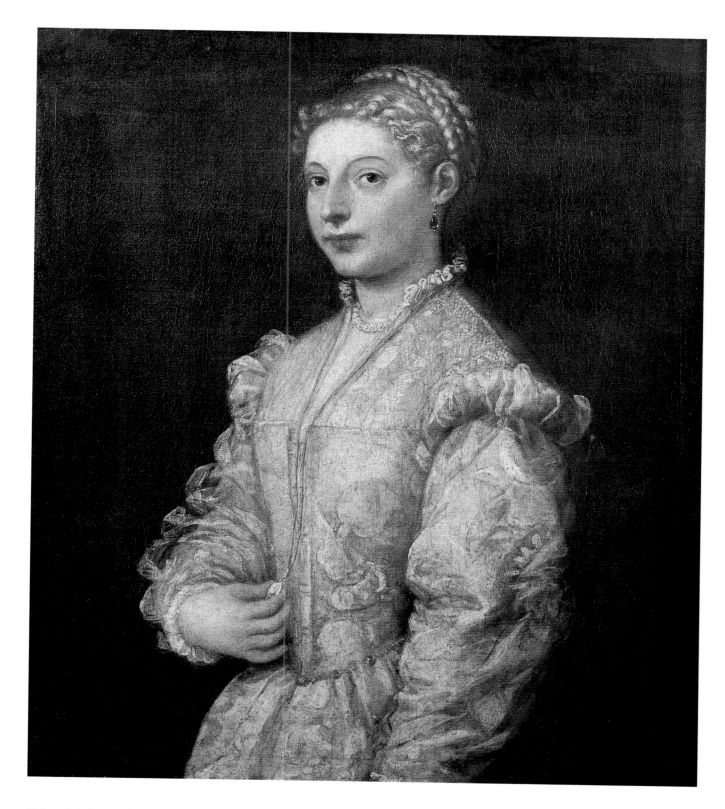

83 (opposite) *Portrait of Clarissa Strozzi*, 1542
Oil on canvas, 115 x 98 cm
Staatliche Museen zu Berlin – Preußischer Kulturbesitz,
Gemäldegalerie, Berlin

Clarissa Strozzi was the daughter of Roberto Strozzi and
Maddalena dei Medici, who lived in exile in Venice from
1540 to 1542. Along with the portrait of *Ranuccio Farnese*
(ill. 82), this painting is the second enchanting child's
portrait Titian painted in 1542. Clarissa is feeding her
little dog, but, like Ranuccio, is looking at something
taking place outside the picture. This again creates a vivid
sense of movement. The putti on the relief emphasize
Clarissa's childlike vitality.

84 (above) *Portrait of a Girl (Lavinia)*, ca. 1545
Oil on canvas, 85 x 75 cm
Museo Nazionale di Capodimonte, Naples

The young girl in this small painting has frequently been
identified as Titian's daughter, Lavinia. But there is little
to support this claim apart from the blonde hair. Its
interpretation as Clelia Farnese, which would mean that
the painting was commissioned by a member of Pope
Paul III's family, is given little credence by scholars. It has
even been disputed whether this is an original work by
Titian, or whether it is an imitation painted by another
talented artist. What is certain is that the painting, with
the delightful play of pale pink and light golds, would
have been painted by a member of Titian's circle.

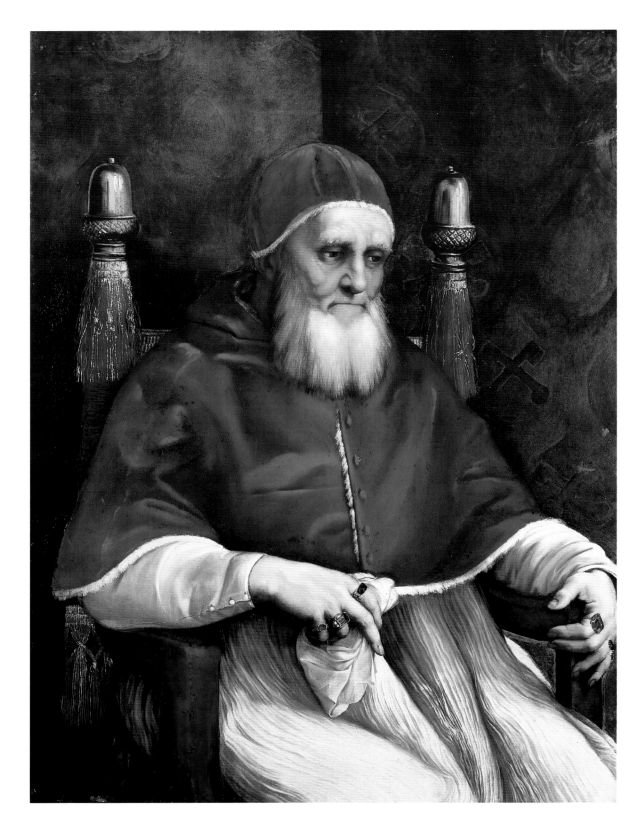

85 (left) *Portrait of Pope Julius II*, 1512
Raphael Sanzio
Oil on wood, 108 x 80.7 cm
The National Gallery, London

This painting, which is now in London, was the prototype for an entire series of copies and variants. The motif of the corner of the room and the colorful wall coverings in Raphael's portrait suggest a more concrete space than Titian's portrait, in which the background is a neutral dark color. As a result, Raphael's portrait seems to be less timeless than Titian's copy.

the 1540s, and it is now in London. So far it is unknown whether Titian copied that picture, or a replica of it which might have been in Urbino at the time, or perhaps a third version of the same prototype. A comparison with Raphael's portrait of Julius (ills. 85, 86) shows Titian's impressive ability to create an idealized yet completely accurate image of a sitter. In Raphael's version, the Pope is sitting in the corner of a room in front of a green silk wall covering. Though Titian depicts Julius in the same setting, he chose a closer viewpoint. He does not bother to depict the room, instead concentrating solely on the figure of the Pope. He treats the garments in a much more summary manner than Raphael, while overemphasizing the effects of light on the fabrics. The sum of these changes is a portrait with greater presence. Though Titian copied the old man's face down to the last wrinkle, the Pope's face appears to be more powerful and less melancholy than in Raphael's original. Titian achieved this by means of a little trick

86 (opposite) *Portrait of Pope Julius II* (after Raphael), 1545–1546
Oil on wood, 99 x 82 cm
Palazzo Pitti, Galleria Palatina, Florence

It is quite likely that Titian was commissioned to copy Raphael's portrait of Julius II by the della Rovere family in Urbino, as the pope was one of their forebears. So far it is not certain which of the numerous versions and copies of Raphael's portrait that already existed during the Renaissance was used as a model by Titian.

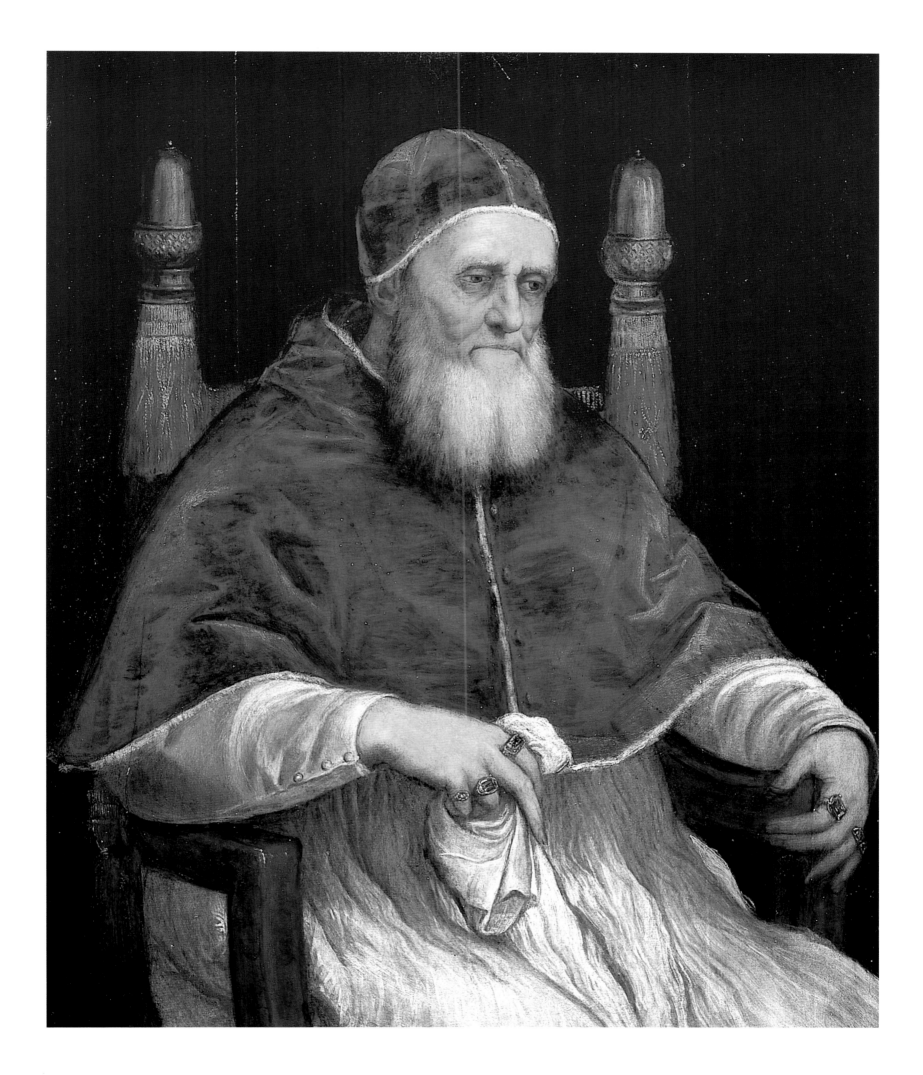

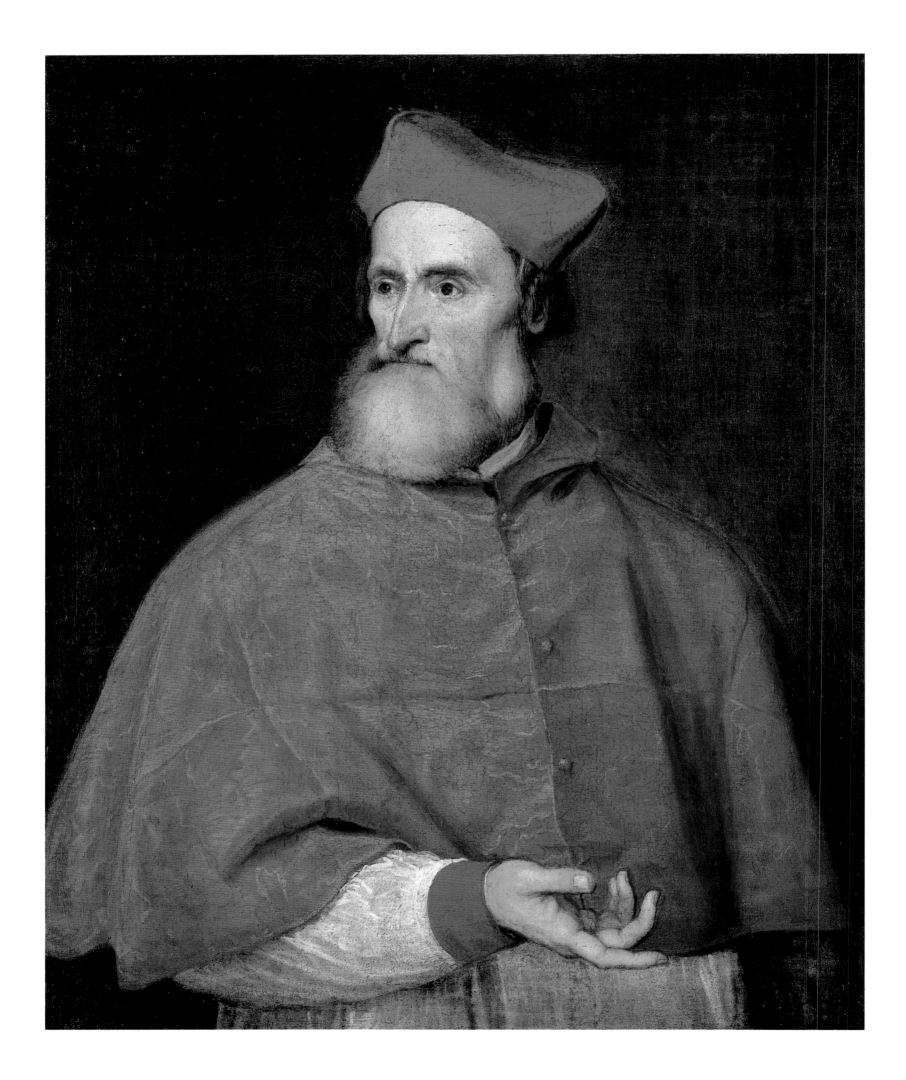

which had a decisive influence on the entire expression of the painting. While the corners of Leo's mouth are drawn down in Raphael's painting and his lips are scarcely visible, in Titian's version the lips are soft and slightly curved. The corners of his mouth have been softened to form wrinkles that defined the edges of his cheeks. He also gives the Pope an almost unnoticeably more erect sitting posture. These small changes may seem trivial, but they are actually made with a clear awareness of the effect of minor details, and give the portrait a more powerful personality.

The portrait of Ranuccio Farnese was the first occasion on which Titian made contact with Pope Paul III Farnese. Though Cardinal Pietro Bembo (ill. 87) and others had repeatedly invited him to Rome, Titian had refused every invitation. In 1543, when the Pope came to northern Italy in order to negotiate with the emperor, Titian finally agreed to paint his portrait. He not only painted the famous *Portrait of Pope Paul III without Cap* (ill. 91), which has frequently been copied. Titian also painted a version in which the Pope does wear a cap, perhaps painted for the Pope's grandson, Cardinal Alessandro Farnese (ill. 88). The latter introduced Titian to the Farnese family and, as an important patron of the arts, had commissioned other paintings from Titian.

It is possible that at this stage Titian had already been promised a church living for his son Pomponio, who had decided to become a clergyman, as a reward for his portraits; his other son, Orazio, worked in his workshop. Titian asked that Pomponio be given the wealthy abbey of San Pietro in Colle, whose properties bordered those owned by the artist himself in Ceneda.

The promise that his son would be given this living was what finally persuaded Titian to visit the Eternal City. On 20 September 1544, the papal ambassador in Venice wrote to tell Cardinal Alessandro Farnese that the artist was prepared to come to Rome to "paint Your Honor's illustrious household down to the last cat". But Titian did not get to Rome until October 1545, accompanied by an escort which Guidobaldo della Rovere had placed at his disposal. He was given quarters in the Belvedere, which was frequently used to accommodate guests of the Pope. Here, as he wrote in a letter to Charles V, he started studying those classical works he had never seen. Vasari claims to have guided Titian on these trips, although he was not even in the city during the first part of Titian's stay in Rome. It is certain that Titian will have seen the great works of Raphael and Michelangelo and other contemporary Roman artists, just as, in turn, his workshop in the Belvedere became an attraction for Roman painters. In the same letter in which he wrote that Titian would be coming to Rome, the papal ambassador also wrote of a "naked woman" that the artist had started work on at Alessandro's request, and which he would be bringing

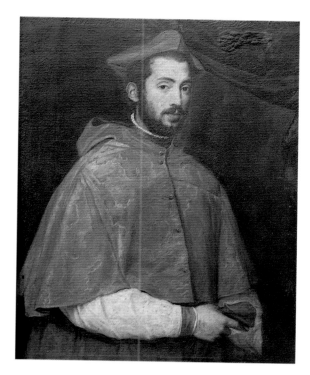

88 *Portrait of Cardinal Alessandro Farnese*, 1545–1546
Oil on canvas, 99 x 79 cm
Museo Nazionale di Capodimonte, Naples

Alessandro Farnese (1520–1589) was the son of Pier Luigi Farnese and the grandson of Pope Paul III. Though he was showered with ecclesiastical honors by his grandfather, he did not succeed in becoming pope when Paul died in 1549. Nonetheless, he continued to exert considerable influence on Roman politics until his death, and was in addition, a particularly important patron of the arts.

to Rome. This nude, the ambassador wrote, would make the *Venus of Urbino* (ill. 69) look like a nun, if only Titian finally got the living he wanted for his son. The painting which Titian brought to Rome was the *Danaë and Cupid* (ill. 89). According to Vasari's report, even the great Michelangelo saw this painting in Titian's studio in the Belvedere. He took obvious pleasure in pronouncing his verdict, though it is not certain that Michelangelo expressed himself in those terms; it is possible that Vasari put words in his mouth. Michelangelo apparently commended it highly, saying that his coloring and his style pleased him very much but that it was a shame that in Venice they did not learn to draw well from the beginning and that those painters did not pursue their studies [of ancient and modern works] with more method. One could not learn from nature alone. Whether this is really what Michelangelo said, or an invention of Vasari's, it nonetheless reflects the debate on art that raged in the mid 16th century. Vasari and Michelangelo represented the Tuscan and Roman view which valued the inventive powers of the artist and his knowledge of other art, in particular classical and contemporary works, far more highly than his simple ability to imitate nature. Venetian theorists, such as Lodovico Dolce, influenced by Titian's style felt that color and the ability to imitate nature were just as important. From Dolce's point of view, the perfect artist, indeed the god amongst artists, would be the painter who was able to combine Michelangelo's drawing with Titian's color.

87 (opposite) *Portrait of Cardinal Pietro Bembo*, ca. 1540
Oil on canvas, 94.4 x 76.5 cm
National Gallery of Art, Kress Collection, Washington

The pointed nose and prominent cheekbones in the cardinal's lean face do nothing to conceal the advanced age of the seventy year old. But his firm gaze and eloquent gestures clearly emphasize the mental vigor of this great humanist. The fine pleats and rich iridescence of the silk underline the impression of gentle vivacity created by the face.

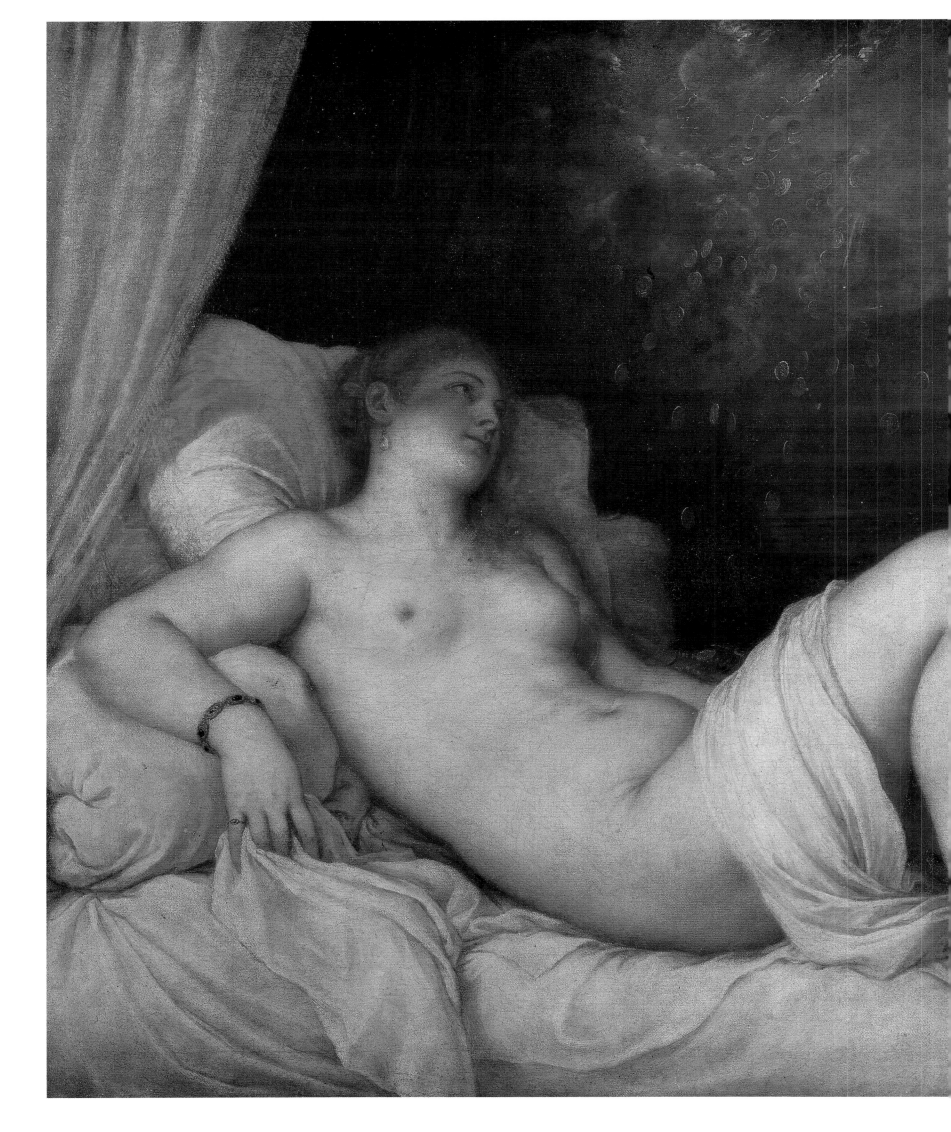

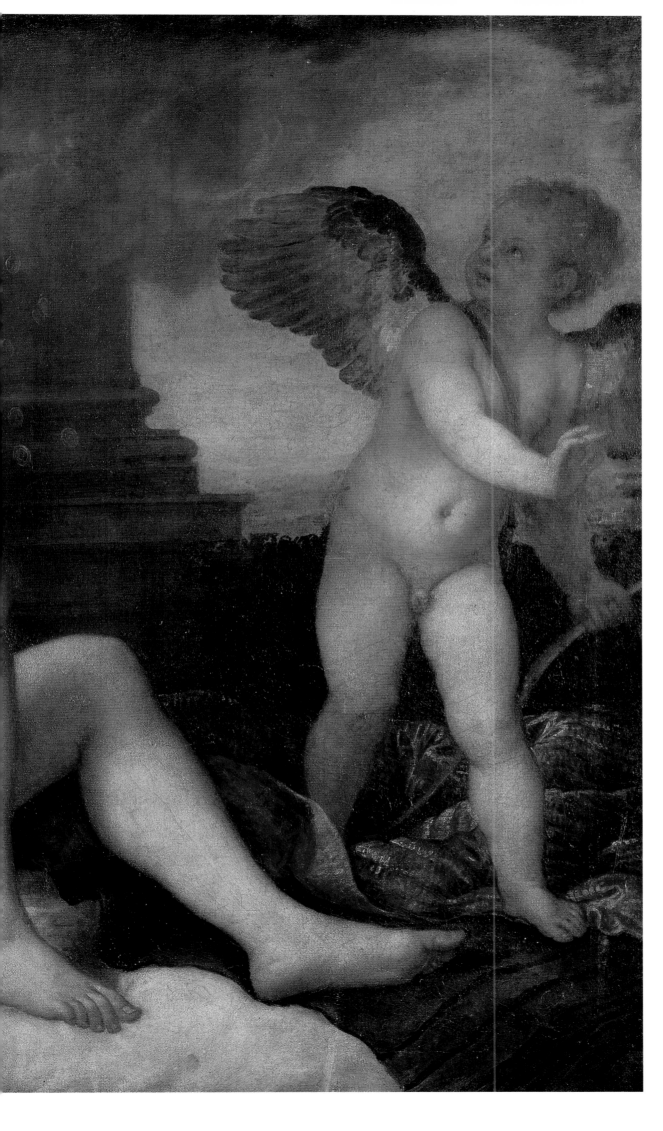

89 *Danaë and Cupid*, 1544–1546
Oil on canvas, 120 x 172 cm
Museo Nazionale di Capodimonte, Naples

The story of Danaë deals with one of the amorous
escapades of Jupiter, the most powerful god in classical
mythology. He visited Danaë, the daughter of the king of
Argos, while in the form of a golden shower because her
father, Acrisius, had locked her up in a bronze tower after
it was prophesied that a son of Danaë would kill him.

POPE PAUL III AND HIS GRANDSONS – TITIAN'S PORTRAITS OF THE POPE

The most important work that Titian created for the papal family in Rome was the portrait of *Pope Paul III and His Grandsons Ottavio and Cardinal Alessandro Farnese* (ill. 90). It was not, however, completed, and disappeared into the Farnese family's palace. The triple portrait, which mirrors the dramatic and conflict-ridden story of the Farnese family and the pope's artful tactics, is now considered to be a masterpiece of psychological art.

Before he stayed in Rome, Titian had produced two other portraits of Paul III. In the *Portrait of Pope Paul III Without Cap* (ill. 91), Titian presents us with an image of an old but still powerful pope. This impression is created by the fact that the figure is shown looking down on us slightly. The dark red of the chair and robes blends with the white of his pleated surplice to produce a magnificent mountain of color, at the top of which sits the old man's small head. In contrast to the robes, which are painted in broad brushstrokes, his head appears framed by finely painted hairs. The dark eyes which are gazing at the beholder piercingly are given additional vitality by means of gentle highlights. Just as fine, and extremely unusual in Titian's works, are the hands with the conspicuous Ring of the Fisherman. The painting is the complete expression of papal power and greatness, even though the pope himself is a very old man. In this portrait, all the viewer might know about the Pope's sinful life has to be set aside. The portrait with his grandsons, however, is frequently interpreted as a clear psychological profile that would be worthy of a Shakespeare – that, at any rate, is the view of Rodolfo Pallucchini and Harold Wethey in their monographs on Titian. In complete contrast to the two previous portraits, it positively invites one to include everything one knows about the enigmatic character of the pope and the power struggles among his successors.

Whatever the case, this triple portrait was surely one of the most difficult tasks Titian was faced with during his career, as he had to take matters of protocol and politics into account. The very fact that the Farnese family chose Titian, the emperor's favorite portrait painter, was a political signal. The presence in the painting of only two of the pope's five male descendants is also part of the context of the contemporary political events.

It was possible for the newly elected pope to give two of his relations, normally nephews, the positions of cardinals, and they carried out the important business of papal government. In the case of Paul III, however, they were his actual direct grandsons, the sons of his son Pier Luigi, Alessandro and Ranuccio. But in this portrait Cardinal Alessandro appears with his secular brother, Ottavio. The latter had been married to Margaret of Austria, a natural daughter of Charles V, since 1538. During the period in which the portrait was begun, the emperor was in close diplomatic contact with the pope, and Cardinal Alessandro, who frequently spent time at the imperial court as the papal legate, was their intermediary. Charles' main goal was financial support for a war against the Protestant princes in Germany. In return, the emperor let the pope, who was always keen to increase his family's

properties and gain important titles for members of his family, know that he would be prepared to hand over the duchies of Parma and Piacenza to his son-in-law Ottavio. Both territories had fallen to Charles V with Milan. On 26 August 1545, the pope gave these duchies to his son Pier Luigi although the emperor had made it quite clear through diplomatic channels that he would be happy to see them ruled by Ottavio and Margaret but not Pier Luigi. Surprisingly Charles did not react immediately.

It was at this rather awkward moment during the winter of 1545/46 that the pope, who no doubt felt it to be a quite hopeful political situation, had himself portrayed by the emperor's favorite artist together with those grandsons of his with whom the emperor had the most contact.

Cardinal Alessandro is standing behind the pope's chair and is holding the knob on the backrest, a sure sign of his future ambitions. Clement VII, Paul III's predecessor, makes the same gesture in the portrait of Leo X and his nephews (ill. 92) that was painted by Raphael. Paul III, who is bent by age, is however turning with a friendly look on his face towards his secular grandson Ottavio, the emperor's son-in-law. His left hand is tightly gripping the armrest of his chair. It creates the impression that he is needing to make a great effort in order to turn his stiff upper body. His evident age contrast vividly with the erect, upright posture of Alessandro behind him, and this too may be a subtle reference to his plans of succession.

Ottavio, in contrast, is about to bow to the Pope. This is a formal part of the ceremony of greeting the pope. It starts with three bows and ends with the pope's foot being kissed as a sign of total submission. Titian moved Paul III's shoe, embroidered with a golden cross, clearly into the picture as a sign of Ottavio's next movement. Every visitor to the pope, even members of the clergy, were obliged to bow in this way. Titian, however, depicts only Ottavio in this posture, while Alessandro (perhaps aspiring to be the next pope) is standing erect behind his grandfather. Only the emperor's own relative has to carry out the ceremonial greeting; every aspect of the picture indicates his submissive attitude. Though it must remain speculation, it is difficult to imagine who apart from the emperor or his representative in Rome this painting could be addressing.

The claim to power of the pope and his hopes for the continuing rise to power of his family are laid bare in this painting in a most extraordinary manner, and Titian as usual presented these aspects in a masterly manner. It is extremely unlikely that it was Titian's intention in this portrait, as has so frequently been written, to make a silent criticism of the Pope's way of life. Though Martin Luther may have called the pope an Epicurean sow or devil, squandering the church's possessions for the benefit of himself and his successors, one cannot attribute the same opinion to Titian. As an Italian, he would have considered these practices to be entirely normal. Moreover, he himself was in Rome in order to obtain an abbey for his son Pomponio.

The pope's confidence that he would be able to prevail against the emperor without any trouble turned out to be false. At the time when the painting was begun, it must

90 *Pope Paul III and His Grandsons Ottavio and Cardinal Alessandro Farnese*, 1545–1546
Oil on canvas, 200 x 173 cm
Museo Nazionale di Capodimonte, Naples

Paul III was born Alessandro Farnese in 1468 and became pope in 1534. He began his career in the ecclesiastical hierarchy under Pope Alexander VI. Despite this, he fathered four children. His only surviving son, Pier Luigi, in turn had four sons, Alessandro, Orazio, Ottavio and Ranuccio. Two of his grandsons, Cardinal Alessandro and Ottavio, appear with their grandfather in this painting.

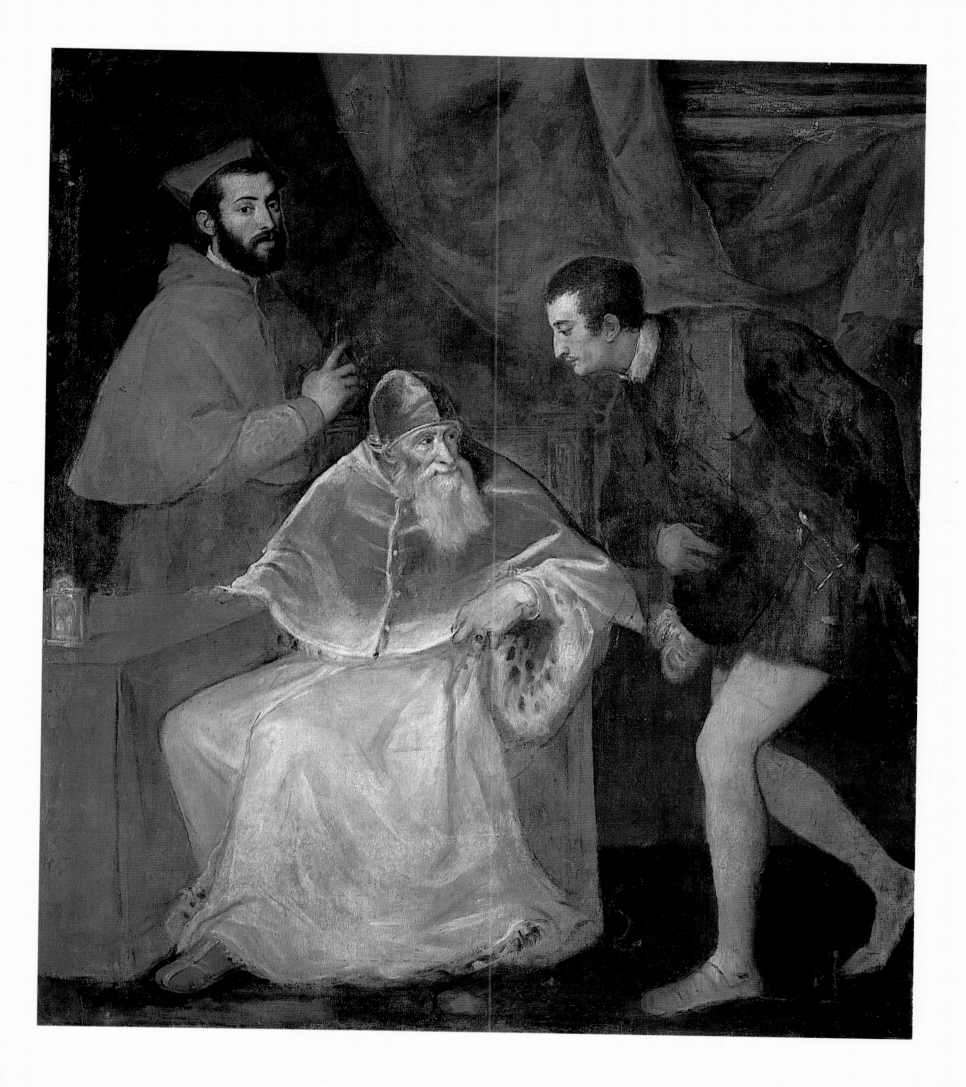

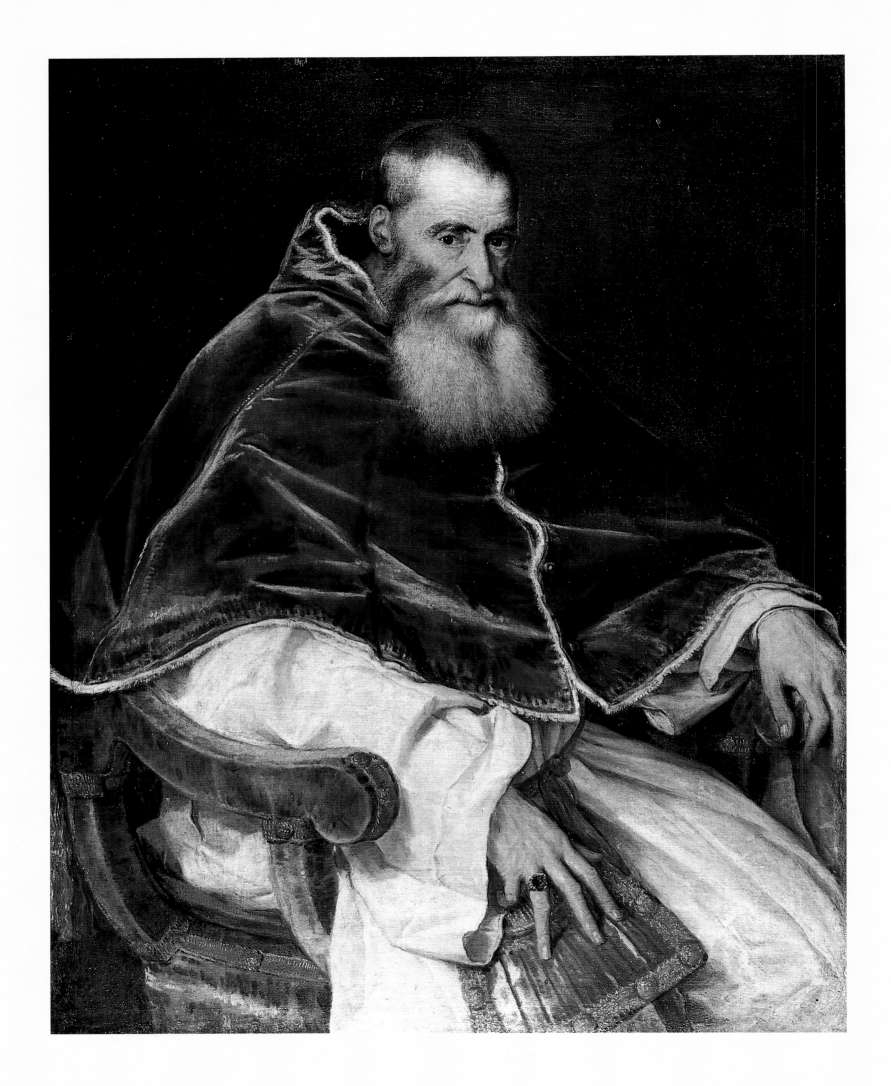

91 (opposite) *Portrait of Pope Paul III Without Cap*, 1543
Oil on canvas, 106 x 85 cm
Museo Nazionale di Capodimonte, Naples

Painted in Bologna in 1543, this portrait was the first
work Titian painted for Paul III. Paul III was typical of
those Renaissance popes who aroused the fury of the
Protestants. Neither chaste nor poor, he used the political
and financial power of his office to act as the third power
between the Habsburgs and France. For political rather
than religious reasons, however, he recognized the need to
renew the Catholic Church. In 1545 he convened the
Council of Trent, which played a decisive role in
introducing reforms.

92 (right) Raphael
Portrait of Leo X with Two Cardinals, 1518/1519
Oil on canvas, 154 x 147 cm
Galleria degli Uffizi, Florence

Pope Leo X (1475–1521), who was a great patron of
Pope Paul III, was also portrayed with two of his relatives,
his nephews Giulio de' Medici and Luigi de Rossi. Giulio
later became Pope Clement VII. The political allusion to
this painting is clear in Paul III's decision to be portrayed
with two of his younger relatives. In terms of
composition, though, Titian is scarcely influenced by
Raphael. He finds his own subtle means of expressing the
political claims of Paul III.

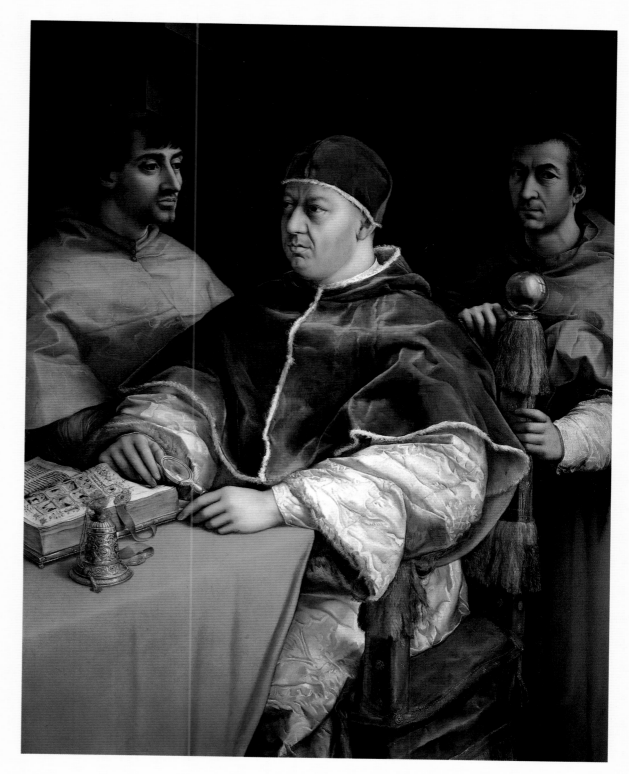

still have seemed that the emperor was not going to react.
But in March 1546 the imperial governor of Milan, the
Duke of Vasto, died. The successor that Charles V chose
was not Ottavio, as the pope had possibly hoped, but
Ferrante Gonzaga. That made his intention to take Parma
and Piacenza back from the Farnese family very clear. A
short while later, Pier Luigi Farnese was murdered and
Piacenza was retaken by the imperial troops. Paul III now

placed his hopes on support from France, where he had
arranged a marriage between his fourth nephew, Orazio,
and a natural daughter of the French heir to the throne,
just in case his imperial card did not take the trick. While
Ottavio was able to hold Parma for the Farnese family, the
magnificent prestigious picture of papal might that Titian
had been in the process of painting no longer served any
purpose. It vanished into the Farnese Palace, unfinished.

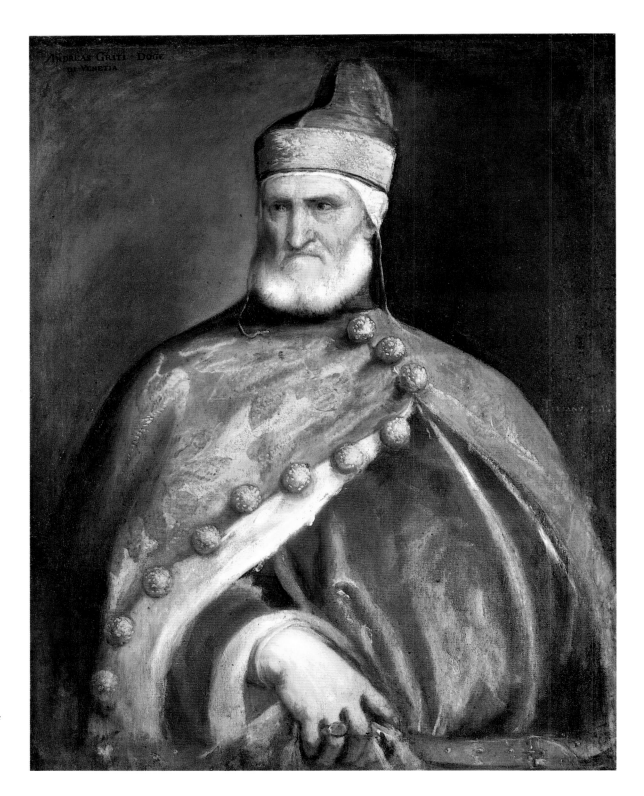

93 *Portrait of Doge Andrea Gritti*, ca. 1545
Oil on canvas, 133 x 103 cm
National Gallery of Art, Kress Collection, Washington

The fine harmony of the reds and golds, and the upward
sweep from the bottom left of the open brocade cloak,
whose strong lines end at the top of the Doge's hat, give
this painting a sense of power and glory. The Doge's
severe gaze, signalling his strength and determination,
deepen this impression. For stylistic reasons (compare the
application of the colors in the portrait of Pope Paul III,
ill. 91) it is nowadays assumed that this portrait was not
painted until about 1545, long after Gritti's death in
1538.

In 1546, Titian abruptly stopped working for the
Pope, leaving the painting of him together with his
grandsons unfinished, even though the artist wrote
to assure the Farneses that he would soon be returning
to Rome. While he was given an honorary citizenship
by the Romans, he had not received the desired living
for his son. Indeed, Aretino had warned his friend
before he left not to expect too much of the papal
court.

Most scholars nowadays agree that his *Portrait of
Doge Andrea Gritti* (ill. 93) was painted shortly after
his return to Venice. This would mean that the portrait
was painted after the Doge died. It nonetheless
succeeds in capturing the powerful personality of the
Doge. Color is just as important here as in the portrait
of *Pope Paul III* (ill. 91) and the *Portrait of Pietro
Aretino* (ill. 94), which was also painted about 1545.

Titian used broad brushstrokes to apply the
highlights to the red garment in Aretino's portrait.
With the exception of the face, the painting appears to
have been dashed off with a few powerful brushstrokes.
It is no surprise that Aretino commented in a letter to
Cosimo de' Medici, to whom he gave the painting,
that his portrait would have been far clearer if he had

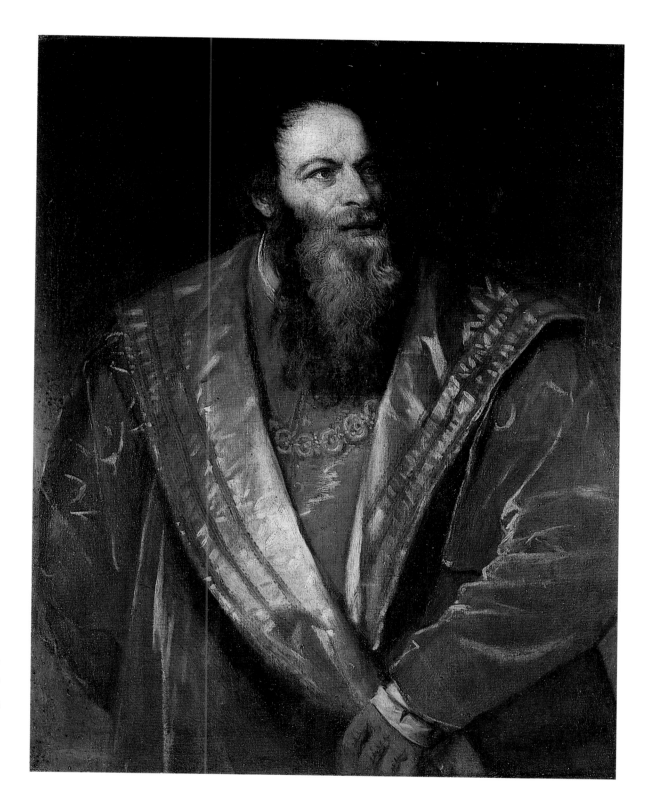

94 *Portrait of Pietro Aretino*, 1545
Oil on canvas, 96.7 x 77.6 cm
Palazzo Pitti, Galleria Palatina, Florence

Titian used rapid brushstrokes to produce the portrait of his friend Pietro Aretino. He uses a pink-tinged yellow to apply highlights to the color of the cloak, creating an impression of valuable heavy silk. He depicts the face in a three-quarter view, providing an interesting contrast between the shining garment and the half-lit face. That Aretino was not particularly happy with the unfinished appearance of the painting sheds some light on the novelty of Titian's freer use of color.

been prepared to pay more money. This expresses more than just the dissatisfaction of a client. Parallels with Venetian art theory come to mind. In the 1530s, Aretino had praised Titian as an artist whose painted reality was far superior to the real world. Looking out of his window at a sunset above the Grand Canal, he remarked that only Titian was capable of capturing the colors of this moment. The more liberal use of paint, which became increasingly important to Titian from the 1540s onwards, was initially met with a lack of appreciation on the part of Aretino.

During the winter of 1547/48, Titian was invited by

the emperor to attend the imperial Diet in Augsburg. Following his victory over the Protestant League at Mühlberg in 1547, Charles V had summoned the leading representatives of the two sides to Augsburg. Titian, who had undertaken the arduous journey over the snowy Alps to Germany despite his advanced age, was inundated with commissions. He painted numerous portraits, of which the most important is *Portrait of Emperor Charles V at Mühlberg* (ill. 96). With this painting, Titian established an entirely new type of portrait in European painting, similar to an equestrian statue but with a greater sense of

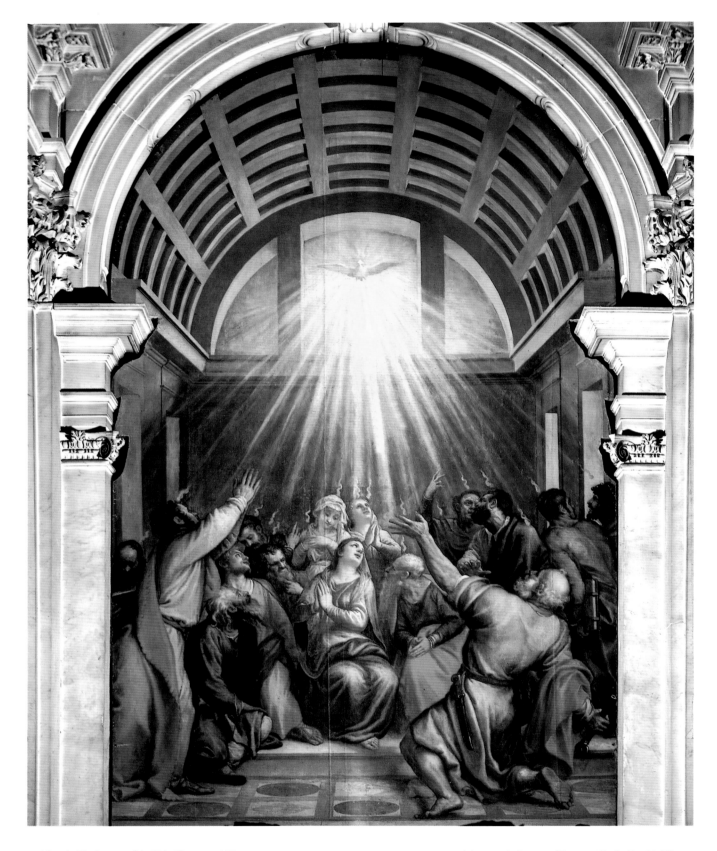

95 (above) *The Descent of the Holy Ghost*, ca. 1545
Oil on canvas, 570 x 260 cm
Santa Maria della Salute, Venice

On Pentecost, the Apostles and holy women are receiving
the Holy Ghost with expressive gestures. The dove seems
to be materializing out of the bright light filling the room.
Titian had already painted a Pentecost picture for the
main altar of Santa Spirito in 1541. That painting,
however, was rejected by the monks. The dispute about
the painting was settled before the Venetian authorities in
1545.

96 (opposite) *Portrait of Emperor Charles V at Mühlberg*,
1548
Oil on canvas, 332 x 279 cm
Museo Nacional del Prado, Madrid

The painting commemorates the emperor's victory over
the Protestant princes at the Battle of Mühlberg on 24
April 1547. The dominant red in the foreground, visible
on Charles' helmet decorations, his sash and the horse's
trim, was the color of the Catholic faction in the many
religious wars of the 16th and 17th centuries.

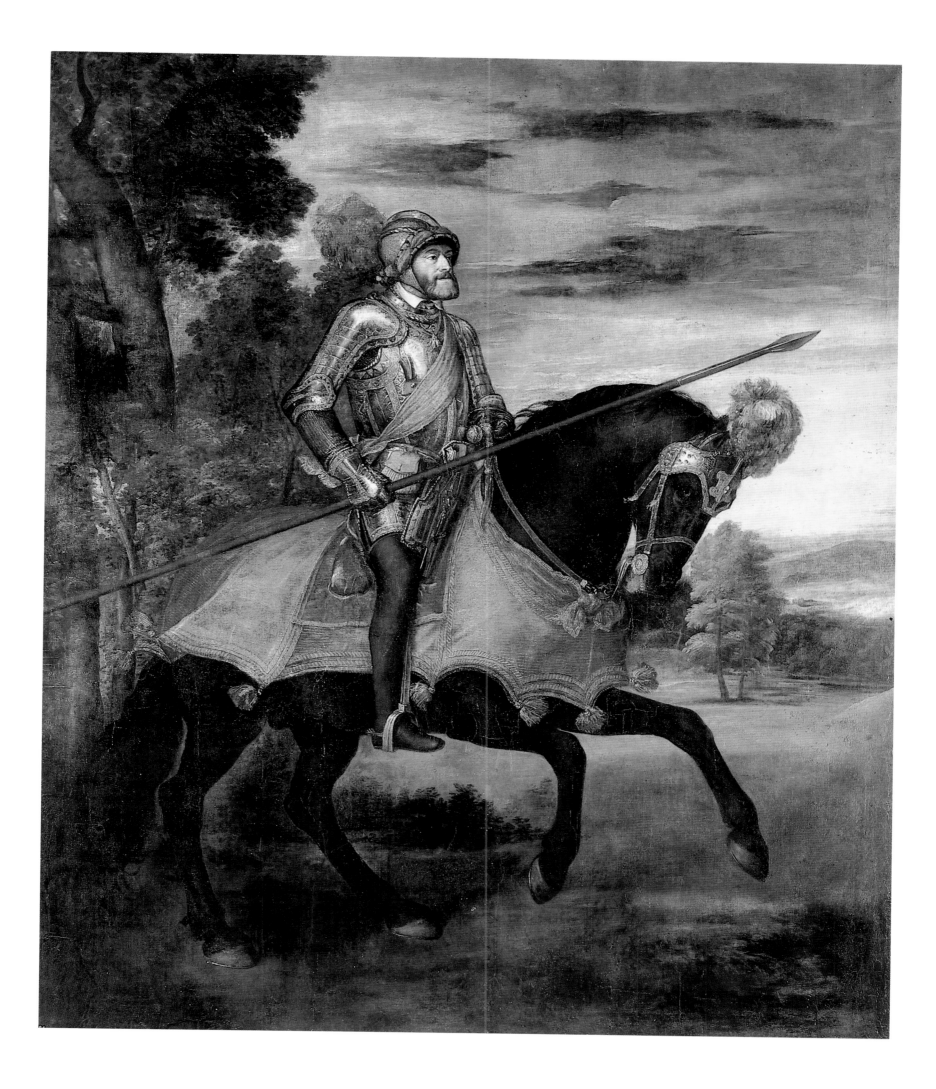

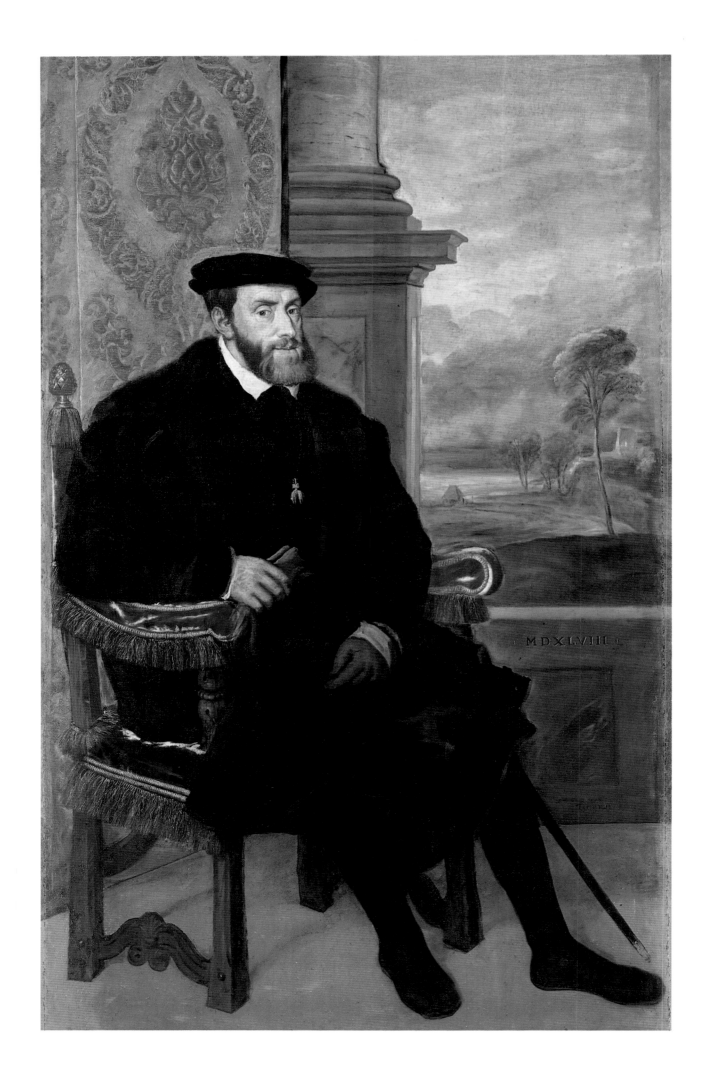

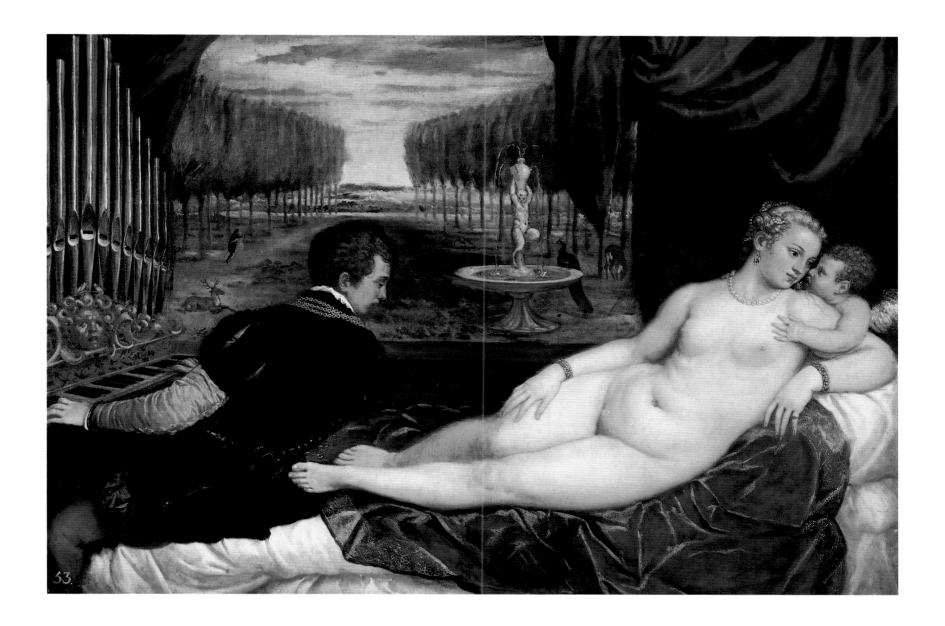

98 (above) *Venus and Cupid with an Organist*, ca. 1548
Oil on canvas, 148 x 217 cm
Museo Nacional del Prado, Madrid

In the 1540s and early 1550s, numerous versions of this theme were painted. All of them are repetitions, with some slight alterations, of a painting for Emperor Charles V that Titian began in 1545 and delivered in Augsburg in 1548. Some scholars consider this painting to be the work that Titian brought to the Diet of Augsburg. However, given that it was overpainted on numerous occasions, doubts have repeatedly been expressed as to whether this can be an original by Titian.

97 (opposite) *Portrait of Charles V Seated*, 1548
Oil on canvas, 205 x 122 cm
Bayerische Staatsgemäldesammlungen, Alte Pinakothek, Munich

Like illustration 96, this portrait was painted during the imperial Diet of Augsburg in 1548. It is, however, thought that Titian did not create the work single-handedly. There is an awkwardness in the foreshortening of the perspective of the chair; and the red carpet is an isolated color contrast, very unusual in Titian's work. But there are also areas of high quality. The face, above all, demonstrates a fine power of observation. The deformation of Charles' lower jaw has been skillfully concealed. The intimate atmosphere of the painting, which contains no regal affectations, is unusual in Titian's portraits of rulers.

movement. The charging horse, the emperor's long lance, and the open landscape on the right give the picture a great dynamic force. This forward momentum is quite naturally identified with the emperor. As a stance, it is the perfect expression that he is powerful, authoritative and confident of victory. Even Charles V's deformed jaw – his lower jaw jutted out further than his upper jaw – is reinterpreted by Titian as a sign of determination. The shining armor and glittering horse's harness are a return to the realism of Titian's earlier years. The landscape, in contrast, consists of broad areas of color.

On his return to Venice, Titian painted many other works for the Habsburgs, most of which he had been commissioned to produce in Augsburg. The altarpiece for the Venetian church of San Giovanni Elemosinario, showing the church's patron saint *St. John the Alms-Giver* (ill. 103), was painted during the same period. Art historian Francesco Valcanover wrote a comment on this painting, and two other paintings for Queen Mary of Hungary, sister of Charles V, in the catalogue for the 1990 Titian exhibitions. He stated that these paintings Titian made real what Venetian art theorists

had been asserting in their argument with the Florentines – that color was superior to drawing, painting superior to sculpture, and Venice superior to Rome.

Another portrait of the emperor (ill. 97) dating from this period continues to puzzle researchers. It is quite certain that it was not produced entirely by Titian alone. However, individual sections are so high in quality that one scarcely feels able to attribute them to any painter other than the great Venetian. For a long time it was assumed that Lambert Sustris (? – after 1565) was the second artist who worked on this portrait and that he completed a design by Titian. The Dutch painter worked in Padua and Venice and, as his works show, was in close contact with Titian. As it is known that Sustris was also in Augsburg, it was naturally assumed that he came to Germany as Titian's colleague. Since the discovery of an important source which Vincenzo Mancini published in his book about Sustris in 1993, it does however appear possible that Sustris came to Augsburg entirely independently of Titian. As a result, the attribution of sections of the Munich portrait to Sustris will have to be re-examined.

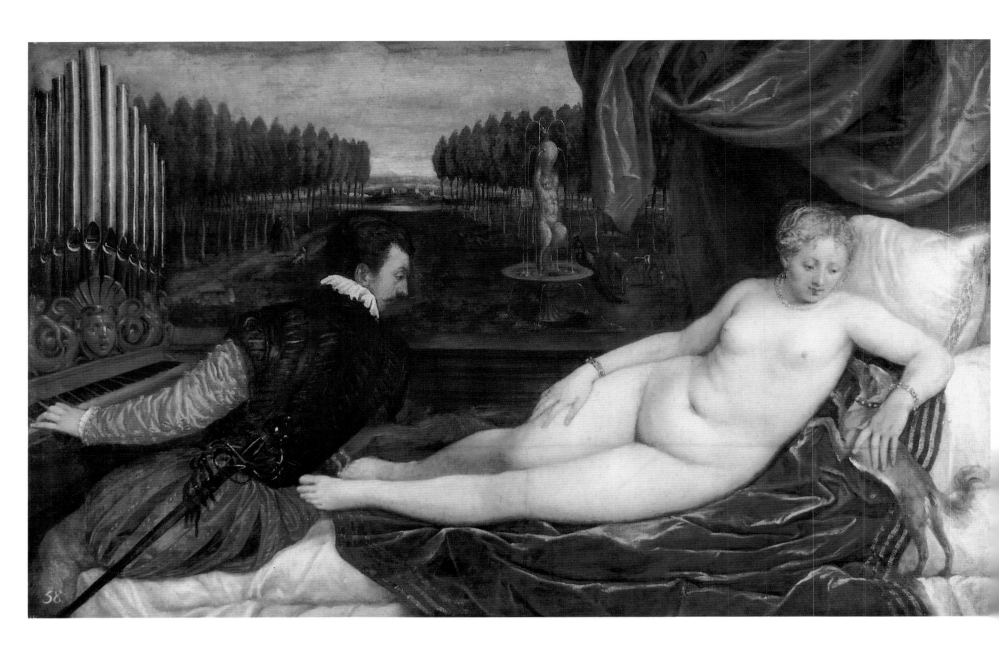

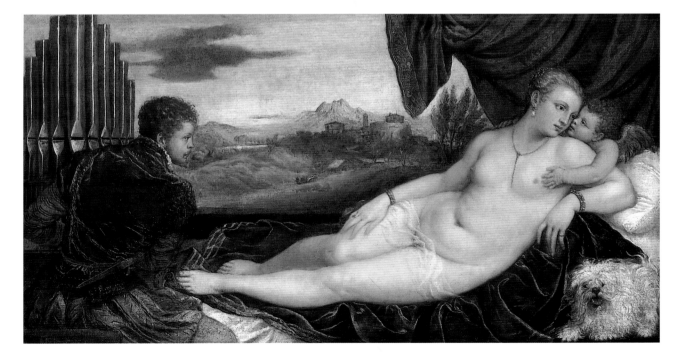

99 (above) *Venus and an Organist and a Little Dog*, ca. 1550
Oil on canvas, 136 x 220 cm
Museo Nacional del Prado, Madrid

In the 1550s there were numerous versions of Titian's painting for Charles V. Most of the clients were members of the emperor's own immediate circle. This painting is a copy produced by Titian's workshop. While it reflects elements of Titian's manner of painting, such as the play of light on the materials and on the pearl necklace, the young man's head and the figure of Venus are clearly of inferior quality.

100 (left) *Venus and Cupid with an Organist (Philip II)*, ca. 1548–1549
Oil on canvas, 115 x 210 cm
Staatliche Museen zu Berlin – Preußischer Kulturbesitz,
Gemäldegalerie, Berlin

This is another original version of the Venus and Cupid theme, this time showing the young Philip II playing the organ. These paintings of Venus are not based on any mythological theme. It has been suggested that a possible explanation for the exceptional combination of a contemporary (in this case even identifiable) person and a naked woman would be an allegory of the senses. The naked skin, the beauty of the scene, and the sound of the organ could represent the senses of touch, sight and hearing.

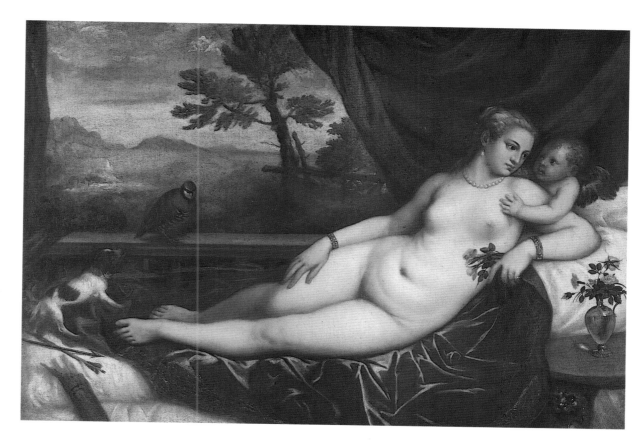

101 *Venus and Cupid*, ca. 1550
Oil on canvas, 139 x 195 cm
Galleria degli Uffizi, Florence

Another version of the extremely successful Venus and
Cupid theme, the majority of which was probably
produced by Titian's workshop.

102 *Venus with Cupid* (detail ill. 101), ca. 1550

The fine painting of the flower vase clearly shows the high
quality of this workshop piece.

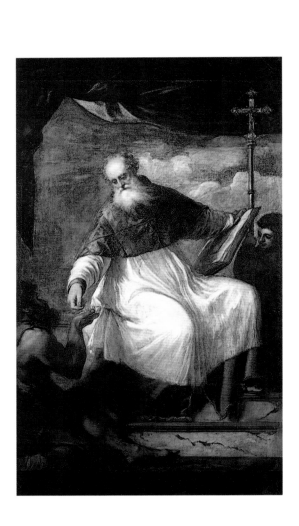

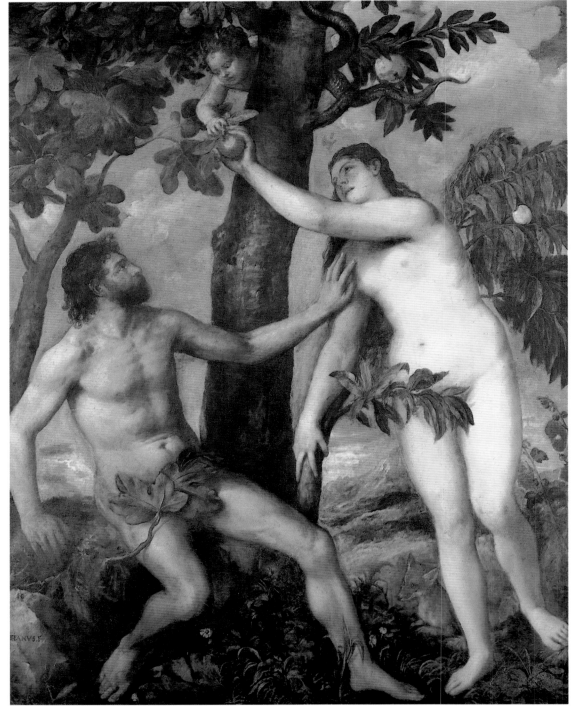

103 *St. John the Alms-Giver*, 1545–1550
Oil on canvas, 229 x 156 cm
San Giovanni Elemosinario, Venice

This painting is the main altarpiece in the church of San Giovanni Elemosinario in Venice. It shows the saint as an alms-giver. The altar frame bears the date 1533, and there are also various sources suggesting an early date. For stylistic reasons, however, this date has been disputed by scholars since the 1930s. Nowadays it is generally accepted that the painting was created after 1545, and probably in about 1550. Sections such as the saint's white surplice, where the color and movement of the fine material have been created with broad brushstrokes in various shades of white, are characteristic of Titian's manner of painting at the beginning of the 1550s.

104 (above) *Adam and Eve*, ca. 1550
Oil on canvas, 240 x 186 cm
Museo Nacional del Prado, Madrid

The combination of blue, dark green and broken reds make this painting particularly charming. The background dissolves in uncertain forms. The painting seems to be comprised solely of a foreground. Here, all the picture elements are related to each other by means of skillful overlapping and contacts. There is considerable sensuous charm in the position of Adam's hand on Eve's right shoulder, just above her beautiful, full breast, as she reaches for the apple with her left hand.

105 (opposite) *Self-Portrait*, ca. 1550–1562
Oil on canvas, 96 x 75 cm
Staatliche Museen zu Berlin – Preußischer Kulturbesitz, Gemäldegalerie, Berlin

This painting has been given a variety of dates ranging from the early 1550s to the 1560s. The manner in which the white is applied as a thick mass of paint in irregular and occasionally very large sections is reminiscent of Titian's style in about 1560, but the painting was not completed. There is only a suggestion of where his left hand is. It is interesting that he omitted any reference to his occupation. The only biographical allusion is the golden chain, the sign of his knighthood.

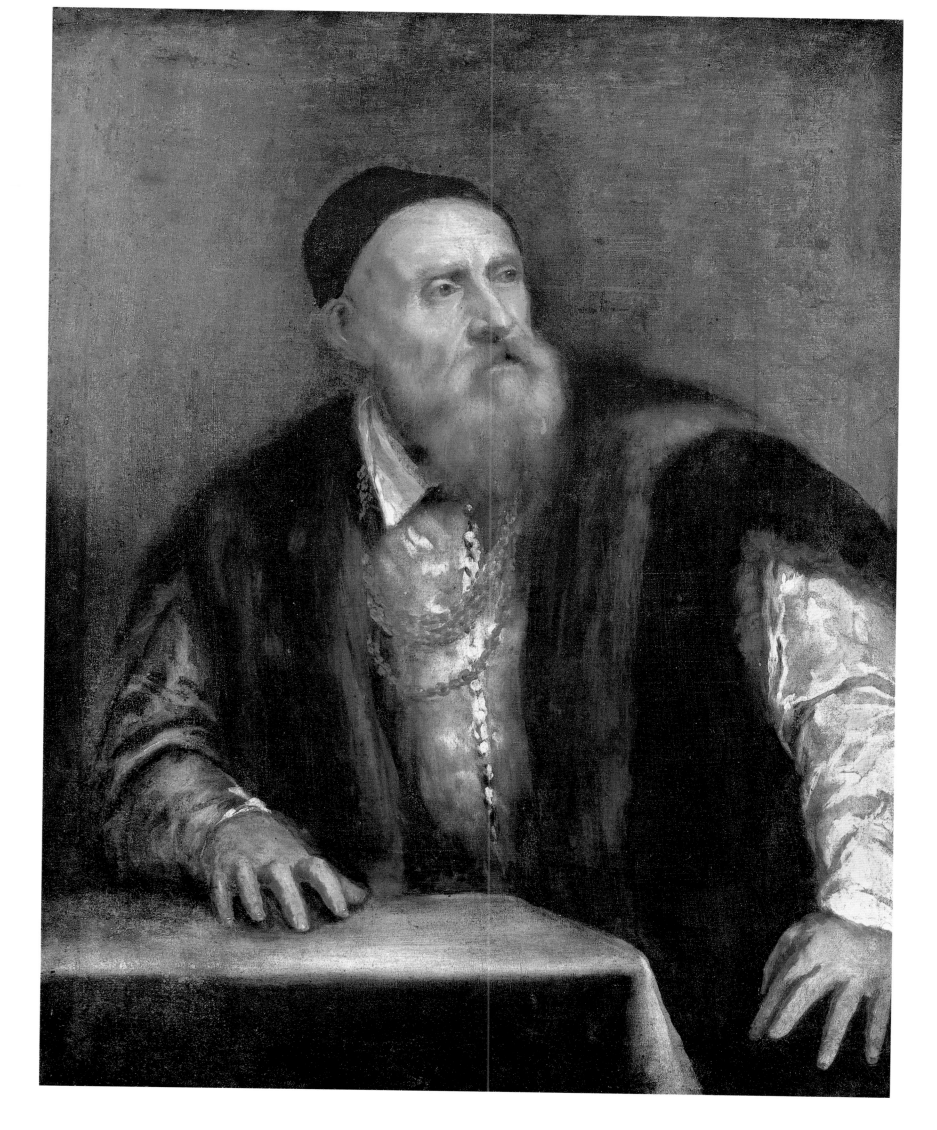

TITIAN'S LATE WORK – THE DYNAMICS OF COLOR

106 *The Trinity in Glory*, ca. 1552–1554
Oil on canvas, 346 x 240 cm
Museo Nacional del Prado, Madrid

Emperor Charles V described the painting in a codicil to his will, in which he ordered that a high altar should be erected containing this painting, as the Last Judgment. It depicts Charles V and members of his family together with angels and biblical figures worshipping the Holy Trinity. Charles V, his wife Isabella of Portugal and their son Philip II appear on the right side, wrapped in white shrouds and accompanied by angels.

At the beginning of the 1550s, Titian was faced in his native city by two young artists whose careers, begun at the end of the 1540s, were developing rapidly: Jacopo Tintoretto (1518–1594) and Paolo Veronese (ca.1528–1588). Whatever the artistic legend, however, it is not likely that Titian faced direct competition from them. The status of their clients was different, and his position as the leading artist in Europe was too secure. Moreover, there is evidence to show that Titian did not rate Tintoretto very highly as an artist.

Titian continued to work for the Habsburg emperors throughout the 1550s and 1560s; at first for Charles V, and later for his son Philip II, the successor to the Spanish throne. Despite the fact that payments from Spain, which had become wealthy by plundering South America's gold treasures, were not very regular and at times did not arrive at all, Titian was paid on a far more generous scale by the Spanish king than by the tight-fisted merchants of Venice. We know that Tintoretto, who gained the majority of Venetian commissions at this time, produced many of his works at cost, or at best for a modest profit only. Titian, on the other hand, was overwhelmed with commissions from all over Europe. However, it would be wrong to conclude from the fact that he now painted fewer works for his native city that there had been a decline of interest in him in Venice. On the contrary, it is further evidence that Titian had long ceased to be a purely Venetian artist. He had become the European prince of painting, and would remain so for posterity.

One of two impressive self-portraits by Titian has survived from the period between 1550 and 1565 (ill. 105). While some art historians assume that this picture was painted as early as 1550, it is generally dated to the period around 1560/62. Various writers have attempted to use this portrait to draw conclusions about Titian's state of mind in the 1550s and early 1560s, a time when he suffered a succession of great misfortunes. When Pietro Aretino died in 1556, Titian lost not only one of his closest friends but also an important advisor in artistic matters. In 1559 his brother Francesco, who had been one of his most important assistants, died, followed in 1961 by his daughter Lavinia. Nevertheless, it would be inappropriate to deduce too much about Titian's own fate from this image of an elderly artist, for even in a self-portrait Titian allowed only certain facets of his personality to be seen. He depicts himself as an old but powerful man, an impression largely created by the fact that his body fills the entire width of the picture. On the right side he is even cut off slightly by the edge of the picture. This artistic device creates the impression that the forceful personality of the sitter is bursting out of the picture. At the same time, the pictorial space around him appears to continue beyond the picture's borders. His clear intention, confirmed by turning his head to the right, is to present the image of a vivid and powerful personality.

Titian effectively emphasizes the mass of his form by means of a voluminous, sleeveless fur coat. The firm positioning of the hands underlines the sense of power, even though the left hand is not fully fleshed out. At first the right hand, resting on a small table, appears to be painted just as sketchily. However, highlights on the narrow, nicely formed finger nails show that this hand must be considered largely completed. Even more than the hands, the garments also are dissolved into areas of color – here far more noticeably than in the portraits he had painted shortly before this. But now there are also fewer bright, luminous passages, which gives the picture a simpler appearance. While the magnificent fur cloak and the golden chain, a sign of his knighthood, indicate his prosperity and raised social position, his painting technique and his use of colors reduces their emphasis. The tactile qualities of the valuable materials are scarcely indicated, so that the impression of modest pride is retained, an impression underlined by the restrained colors. Only the fully lit head, firmly turned to a three quarter profile view, is painted more finely. Bright reflections in his eyes give him an intelligent, alert expression. Direct contact with the observer is achieved by the fact that he is looking to the right, which is Titian's way of avoiding anything provocative in his portrait. At the same time, because he is looking away from the observer, Titian appears withdrawn. This is perhaps why some art historians have used this self-portrait to deduce that Titian lived a more secluded life after the deaths of so many of those close to him.

Late in 1550 Titian was once again invited to an Imperial Diet in Augsburg; again he was commissioned to paint a large number of works for both Charles V and Philip II. For Charles V (who at

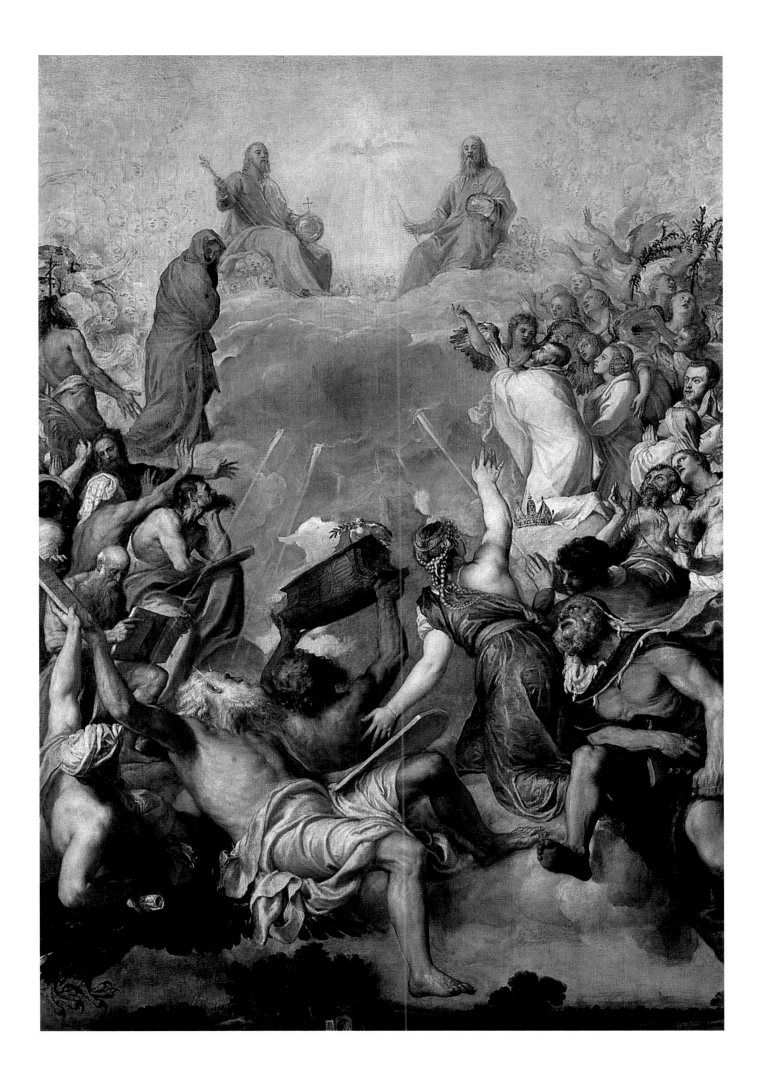

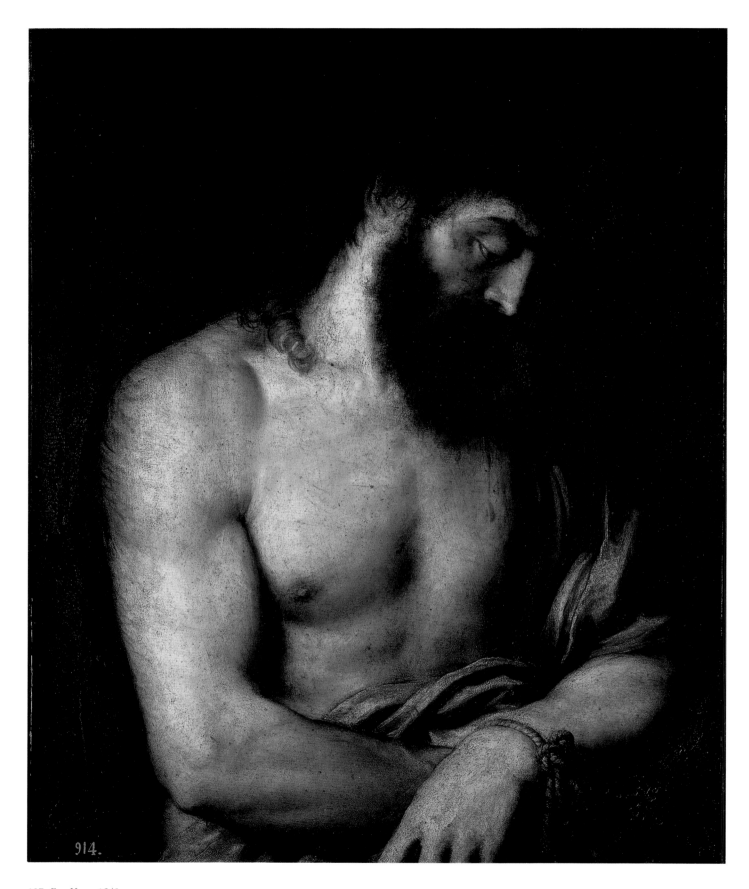

107 *Ecce Homo*, 1548
Oil on slate, 68 x 53 cm
Museo Nacional del Prado, Madrid

According to an inventory taken in 1556, Emperor
Charles V took a Christ on stone with him to the
monastery of Yuste, to which he retired after his
abdication. It was probably this painting, which is the
only known work of this type by Titian.

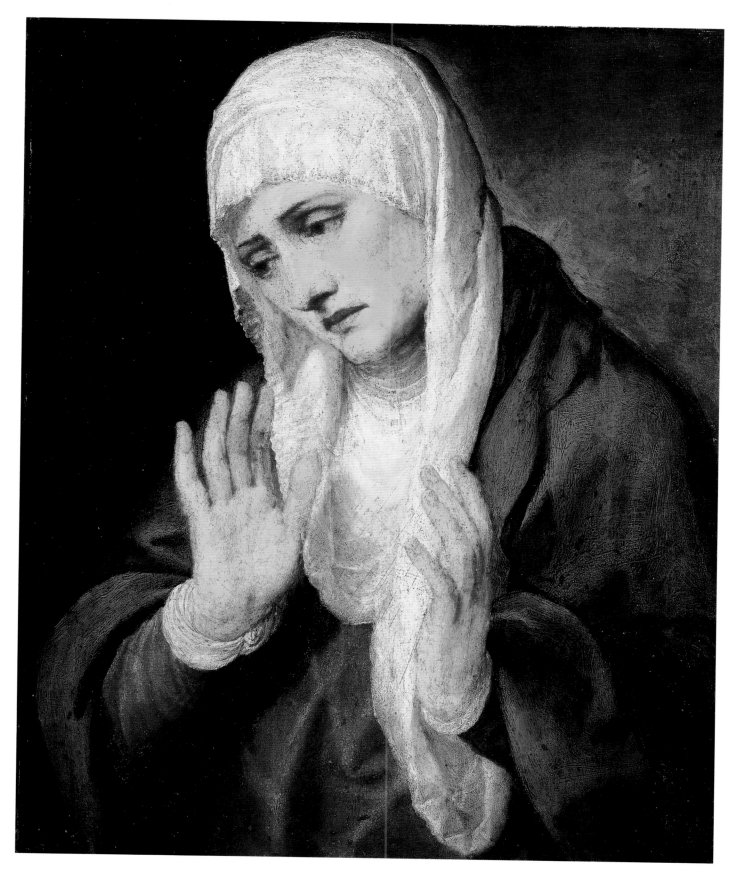

108 *Mater Dolorosa*, 1553/1554
Oil on marble, 68 x 53 cm
Museo Nacional del Prado, Madrid

Paintings showing the grieving Virgin were popular
devotional images. Her pain helped the faithful to under-
stand that Christ gave up His life for our sins. This *Mater
Dolorosa* was painted in 1553/54 as the counterpart of
Ecce Homo (ill. 107), which Titian painted for the
emperor in 1548.

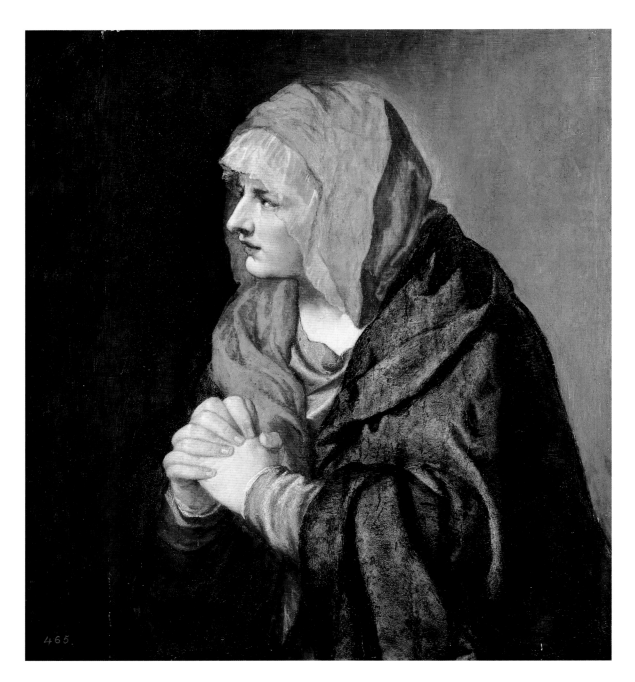

109 *Mater Dolorosa*, ca. 1555
Oil on wood, 68 x 61 cm
Museo Nacional del Prado, Madrid

One of numerous versions of this theme painted by Titian
and his workshop in the 1550s, this painting is
particularly impressive because of the delicate color
scheme of the blue cloak, pink garment, and saffron
yellow veil. Inventories tell us that Charles V also took a
Madonna on wood, together with the Ecce Homo in
illustration 107, with him to the monastery of Yuste.
Some authors assume that this is the work in question.

the meeting of princes announced his imminent
retirement from public office) Titian painted mainly
religious pictures during the remaining years until
Charles' death in 1558. The majority of them (ills. 106
to 109) went with him to the monastery of St. Jerome
in Yuste in Spain, to which he retreated in 1556. For
this secluded place of retirement Charles ordered, in
addition to devotional pictures, the large altar painting
The Trinity in Glory (ill. 106), which depicts the
resurrected members of the imperial family before the
Holy Trinity on Judgment Day. This work was
probably commissioned during the Imperial Diet in
1551. It emerges, from letters both Titian and the
Spanish ambassador in Venice wrote to Charles V, that
Titian was working on the picture by 1553 at the
latest. In 1554 it was taken by sea to Brussels, and from
there was sent to Yuste. In his will, Charles V stipulated
that a high altar should be built using this painting.

For Philip II, Titian painted several portraits (ills.
110, 111), and also mythological scenes and allegories
with a strong erotic element. In his letters to Philip,
Titian described these works as *poesie* and *favole*, vague
terms that can be roughly translated as "poetic
inventions" and "fables" respectively. The use of the
word *poesie* to describe paintings touches on an
important concept of art during the Renaissance. The
expression *ut pictura poesis* ("as in painting, so in
poetry") – taken from a poem on the art of poetry
written by the Latin poet Horace (65 – 8 BC) – was
the basis for treating painting and literature as equals;
it was also the basis for a rivalry between these two arts
that encouraged a theoretical study of painting. This
theme – the question of which of the two art forms,
poetry or painting, was better able to do justice to
a subject – was debated in numerous treatises,
including Lodovico Dolce's *Dialogo della Pittura*

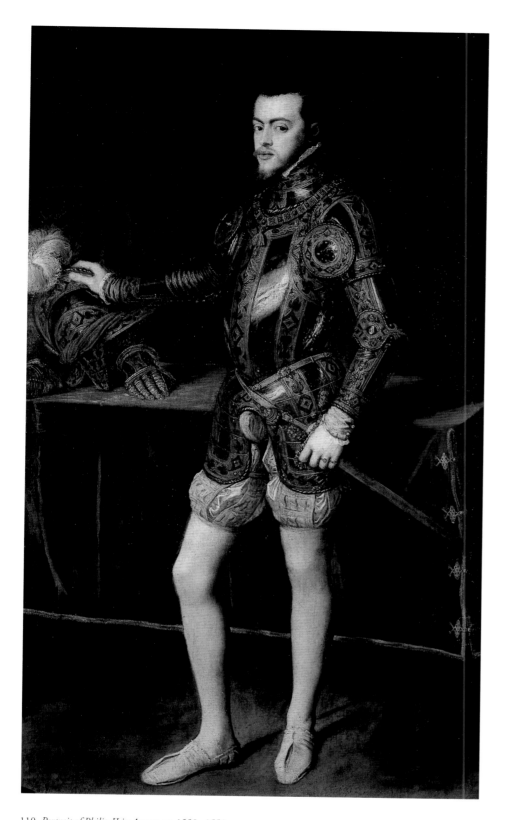

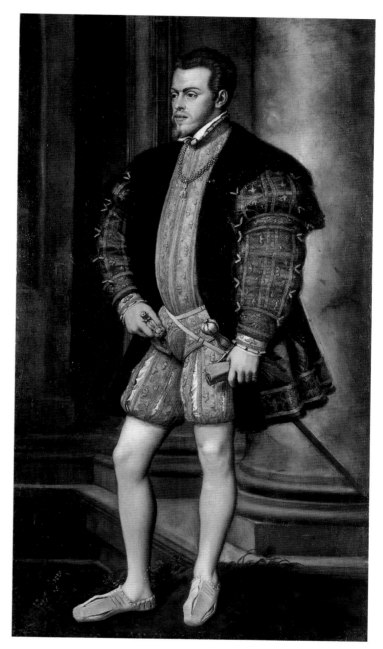

110 *Portrait of Philip II in Armor*, ca. 1550–1551
Oil on canvas, 193 x 111 cm
Museo Nacional del Prado, Madrid

Philip II (1527–1598) was the only son of Charles V and
Isabella of Portugal. In 1551, following the imperial Diet
of Augsburg, he became the regent of Spain. After his
father's abdication, he was crowned the king of Spain.
Titian portrays the prince, aged about twenty-four
dressed in a magnificent, lavishly decorated set of armor.
The whiteness of his skin corresponds to his white
stockings and the greenish golden sheen on his armor. In
this way, the prince's pale complexion appears more
distinguished.

111 *Portrait of Philip II*, ca. 1554
Oil on canvas, 185 x 103 cm
Palazzo Pitti, Galleria Palatina, Florence

Most of this painting must be attributed to a particularly
able member of Titian's workshop. In contrast to
illustration 110, the face of Philip II is made to appear
handsome. The entire method of painting is considerably
more detailed than in Titian's own Prado portrait of
Philip (ill. 110), so it is thought that this portrait was
painted by an associate of Titian's from north of the Alps.
Philip II may well have been more satisfied with this
version, as he had complained to his aunt, Queen Mary
of Hungary, about the imprecise execution of his portrait
in armor.

(Dialogue on Painting). As early as 1969, the German art historian Harald Keller drew attention to the fact that Titian was not the only Venetian to use the term *poesie* to describe secular painting. We can assume, then, that *poesie* was a specialist term for secular themes in paintings based on literary sources.

Four of the numerous pictures painted for Philip II during the 1550s were intended to furnish one room. This emerges from a letter Titian wrote to Philip II in the summer of 1554. Titian mentions not only two works already completed, *Danaë with Nursemaid* (ill. 112) and *Venus and Adonis* (ill. 113), but also two accompanying paintings, *Perseus and Andromeda* and *Jason and Medea*, which were also destined for the same room. In this commission, Titian faced a task similar to the one he had faced once before, at the beginning of his career, with the paintings for Alfonso d'Este's Alabaster Room. But now Titian was not one artist among many, he was the only artist commissioned and was responsible for the entire program. Whether he received precise instructions from Philip II or Philip II's advisors, or whether he

himself was free to choose his themes, is uncertain. What is certain, however, is that he was given complete liberty to execute the individual themes as he saw fit. It also becomes clear from this letter that Titian was principally interested in aspects of form. His comments on the two paintings already completed, *Danaë* and *Venus and Adonis*, deal solely with the fact that he depicts the female nude from both sides in order to provide a "graceful" view for the room for which the paintings were intended. In the same letter, Titian announces his intention to create further interesting views of the body in the painting *Perseus and Andromeda* (in the Wallace Collection, London) and in *Jason and Medea*, which was planned but never completed.

In fact it is not likely that at this point there was a specific room for which these pictures were destined. When Philip II became king of Spain in 1556, on his father's abdication, he did not yet have a permanent residence. During the 1550s and 1560s, both the old castles in Madrid and Toledo, and also the palace of El Pardo and the castle in Aranjuez, were being

112 *Danaë with Nursemaid*, 1553–1554
Oil on canvas, 129 x 180 cm
Museo Nacional del Prado, Madrid

The cupid in the first version of this subject for Alessandro Farnese (ill. 89), an allusion to love, is here replaced by an old woman. Such a nursemaid, who was locked up with Danaë, is mentioned in a variant of the Danaë story in various classical texts. Quite apart from this, she is a very useful contrast as the beauty of the naked Danaë becomes even more pronounced when compared with the ugliness of this old woman.

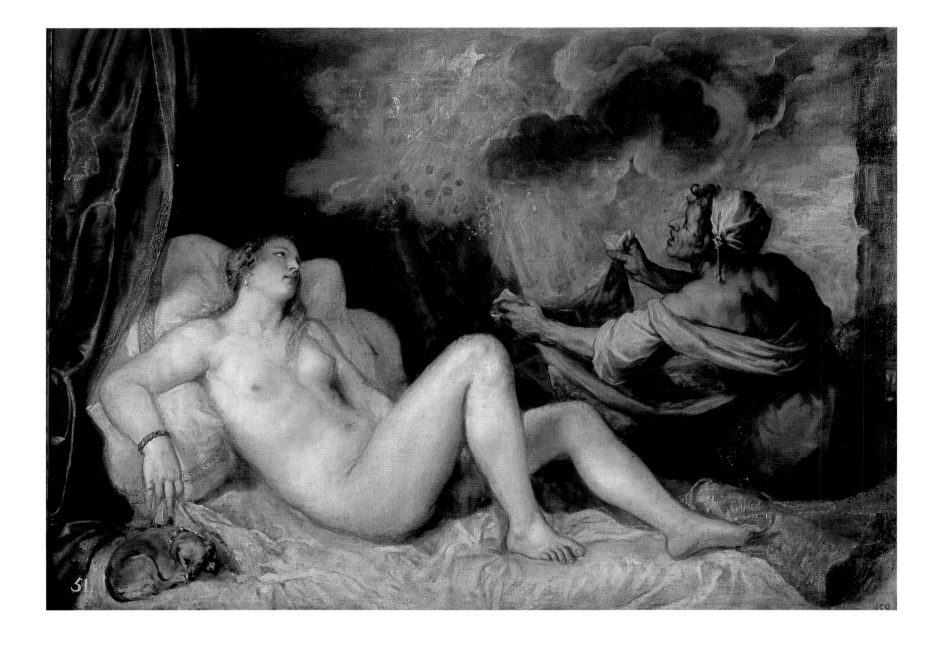

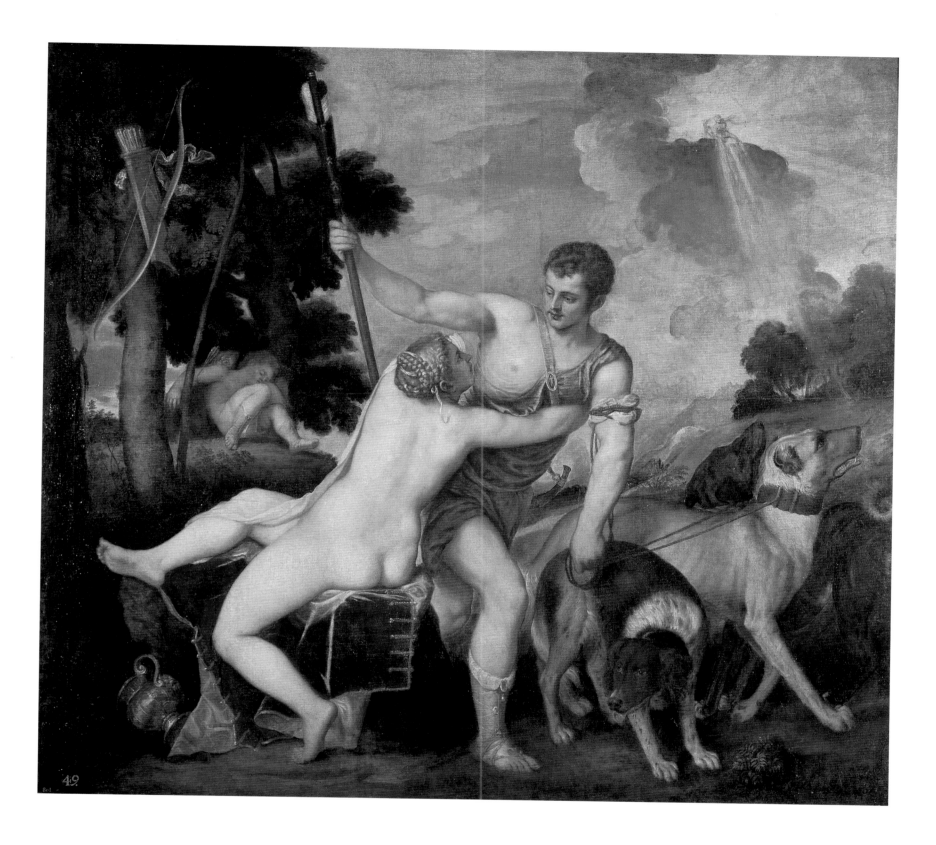

renovated. The building that is most closely connected with the name of Philip II, the Escorial, was not planned until 1557 onwards; construction work started in 1564. Until the mid 1560s, Philip II lived in the castles of Spanish noblemen. He was accompanied on his travels by the entire royal household and by all his possessions, including his paintings. Perhaps this frequent change of place explains the changing plans for the cycle of paintings, and also the length of time Titian worked on them. *Jason and Medea* was never painted. Instead, at the beginning of the 1560s, Titian

finally completed *The Rape of Europa* (in the Isabella Stewart Gardner Museum in Boston).

The literary source for all these paintings is the *Metamorphoses* of the Roman poet Ovid (43 BC–AD 17/18), a collection of mythological tales featuring the transformations undergone by various men and gods. Numerous scholars have attempted to decipher the entire intellectual conception of this cycle of paintings; certainly an important element in these various interpretations is the fact that since the Middle Ages Ovid's mythological stories had been given varying

113 *Venus and Adonis*, 1553–1554
Oil on canvas, 186 x 207 cm
Museo Nacional del Prado, Madrid

This painting is also one of the classical mythological works painted for Philip II and which he himself described as *poesie*. Venus, the goddess of love, falls in love with Adonis, a beautiful youth. Her love is not, however, enough to stop him pursuing his favorite pastime, hunting, which will lead to his undoing, for he is gored to death by a boar. There is an interesting letter from Titian to Philip II which deals with this painting. The artist makes a special point of mentioning that he was particularly interested in depicting the body from both sides.

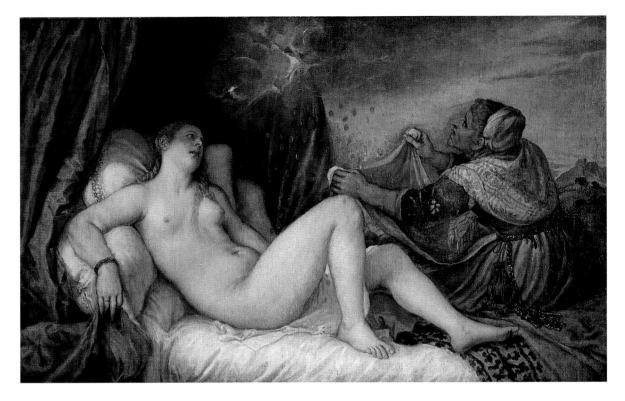

moral, and also Christian, interpretations, which were handed down with the text. One of the first editions to omit any form of moral interpretation was published by Titian's friend Lodovico Dolce in 1553. In a study published in 1985, the art historian Jane C. Nash collected the majority of the (often contradictory) interpretations of the *poesie* Titian painted for Philip II. One interesting point many of the authors of these interpretations have highlighted is Philip's strict Catholicism, which appears to contradict the sensuality of these *poesie*. However, as Nash and others have shown, it is also possible to attribute religious meanings to the paintings. Such an openness of interpretation must have played an important role during the 16th century and may have contributed to the high regard in which the paintings were held. But in statements made both by Titian and by Lodovico Dolce, who writes about these paintings in a letter dating from 1554, there is no reference of any kind to such matters. Dolce writes solely about the Titian's skillful reproduction of the body and about the perfection of the depiction – in other words about purely formal aspects of the painting. This linking of faith and sensuality can also be seen in some of Titian's religious paintings of this period, such as depictions of St. Mary Magdalene, of which Titian's workshop produced many variants (ills. 115, 116), and the richly colored *Adam and Eve* (ill. 104). His workshop now carried out the majority of the paintings more frequently than had previously been the case. There are countless workshop variants of some of the particularly successful compositions, such as the various pictures of Venus (ills. 98–101) and St. Mary Magdalene, as well as several *Ecce Homo* (ill. 107).

At the beginning of the 1550s, Titian started to use a noticeably lighter palette; many of the pictures he painted now have a characteristic pale gold color. His female ideal also changed. At the beginning of his career he had preferred supple, soft and elegantly proportioned limbs which, despite their physicality, still had a certain slenderness; now he preferred more mature bodies, more strongly shaded, with broad hips. Instead of dark, reddish hair, he now painted women with pale blonde hair braided with shining pearls. When these works are compared to Veronese's depictions of women, the similarities are immediately evident. The pale and broken pastel tones are also typical of the younger artist, who, unlike Tintoretto, was sponsored by Titian.

By the end of the 1550s at the latest, Titian had come to value the exploration of color above all other aspects of his art. To begin with, his paintings continued to be characterized by larger areas of color that were already more important than either precisely drawn objects or the clear definition of the picture's space. Towards the end of his life, his paintings were covered with webs of vibrant color. Paintings such as *The Martyrdom of St. Lawrence* (ill. 119), the *Crucifixion* (ills. 117, 118), and *The Annunciation* (ills. 122, 125) illustrate various stages in this development. Also, it becomes clear, if for example we compare the Crucifixion in the Escorial (ill. 117) with the Crucifixion painted just three years later in Ancona (ill. 118), that Titian was still able to find different ways of painting precisely the same subject. This continuing search for new compositions and pictorial inventions distinguishes him from the majority of other painters, and not only those of his own era. But there are also numerous copies of successful compositions reproduced by his own workshop,

114 (above left) *Danaë*, ca. 1552–1553
Oil on canvas, 119 x 187 cm
Hermitage, St. Petersburg

This is another version of the highly successful series on the Danaë theme produced by Titian's workshop. When compared to the version he painted himself (ill. 112), the difference in quality becomes evident. The distorted face of Danaë and her cord-like hair mock any attempt to compare her with the skillfully lit head of the Danaë in Madrid.

115 (above right) *St. Mary Magdalene*, 1567
Oil on canvas, 128 x 103 cm
Gallerie Nazionali di Capodimonte, Naples

Despite the religious subject matter, there is a strong erotic quality in this picture of Mary Magdalene, who has sunk down in a posture of pious penitence, tears in her eyes as she gazes up to heaven. In contrast to the version painted for Francesco Maria della Rovere (ill. 70), in this version her breasts are covered, but the extremely skimpy covering is if anything more provocative. Most scholars assume that this painting is the picture that Titian gave to Alessandro Farnese (ill. 88) in 1567.

116 (opposite) *Penitent St. Mary Magdalene*, 1565
Oil on canvas, 118 x 97 cm
Hermitage, St. Petersburg

The Magdalene in St. Petersburg is considered to be the most important work of this group. It was kept by Titian, and remained in his own house until he died. In 1581 his son Pomponio sold his entire remaining works to Cristoforo Barbarigo. In 1850, the Barbarigo collection was moved to the Hermitage. The work is particularly impressive because of the beauty of the colors and the wonderful play of the light – Titian depicts the changes of color it creates right down to the shadows cast on Magdalene's breast by the cloth.

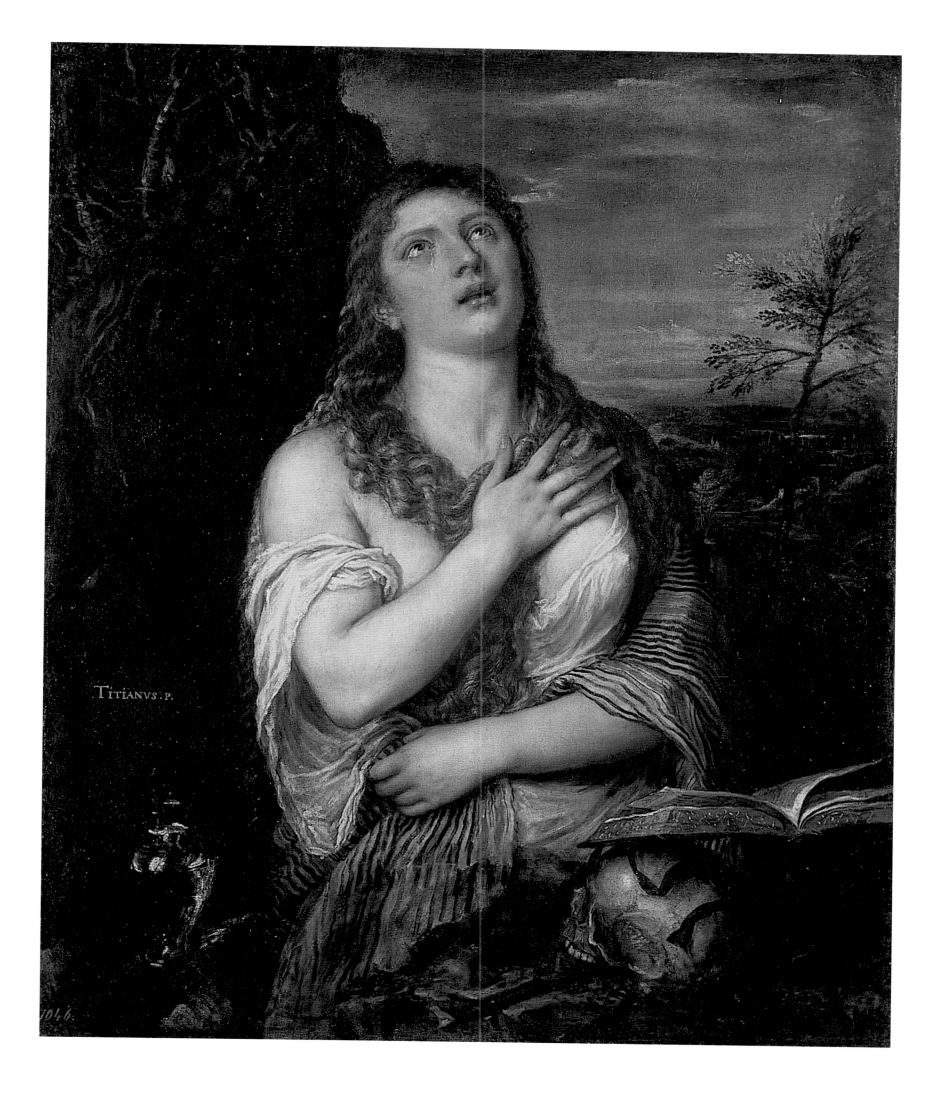

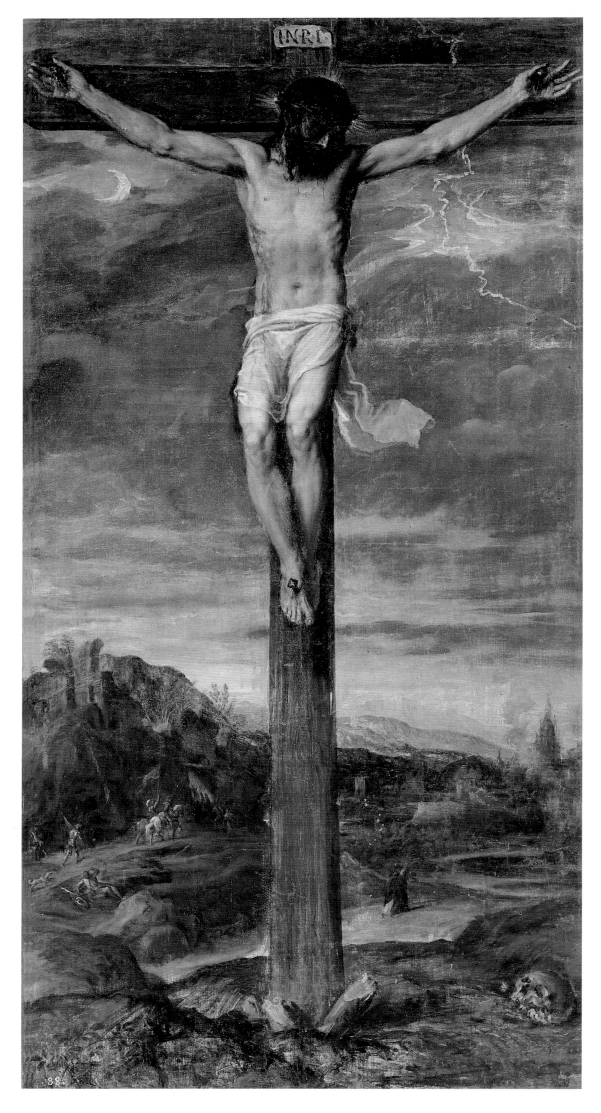

117 *Crucifixion*, ca. 1555
Oil on canvas, 214 x 109 cm
Monastero di San Lorenzo, Sacristia, Escorial

Particularly impressive about this painting are the
wonderful colors and the modulated lights on the body of
Christ, as well as the carefully painted landscape, which is
a rare feature in Titian's late work. The ruins, the city in
the background, and the marvellous colors of the hills are
reminiscent of Veronese's early landscapes. The cross,
isolated in front of the broad landscape, gives the painting
a timeless quality that emphasizes its devotional function.
The work's theme is not the moment of the crucifixion,
but the loneliness of death.

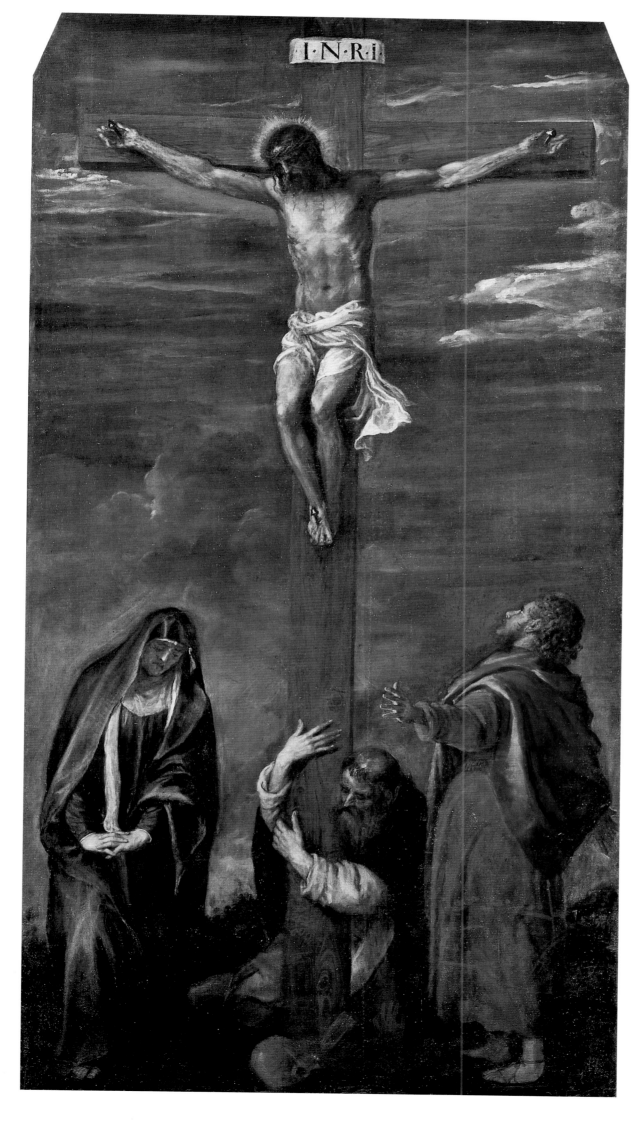

118 *Crucifixion*, 1558
Oil on canvas, 371 x 197 cm
San Domenico, Ancona

Though this was painted only a little later than the superb
Crucifixion in the Escorial (ill. 117), there are already
clear signs that Titian's style has progressed to the point
where he is painting purely with color. The scene with the
mourners is taking place only in the foreground. The sky
and the figures under the Cross are all painted in dark
colors. Blue and black dominate the scene; white is used
to produce dramatic highlights. Titian succeeds in
representing St. Dominic's sorrow as he embraces the
Cross almost entirely by means of the distribution of light
and the broad sweeping brushstrokes.

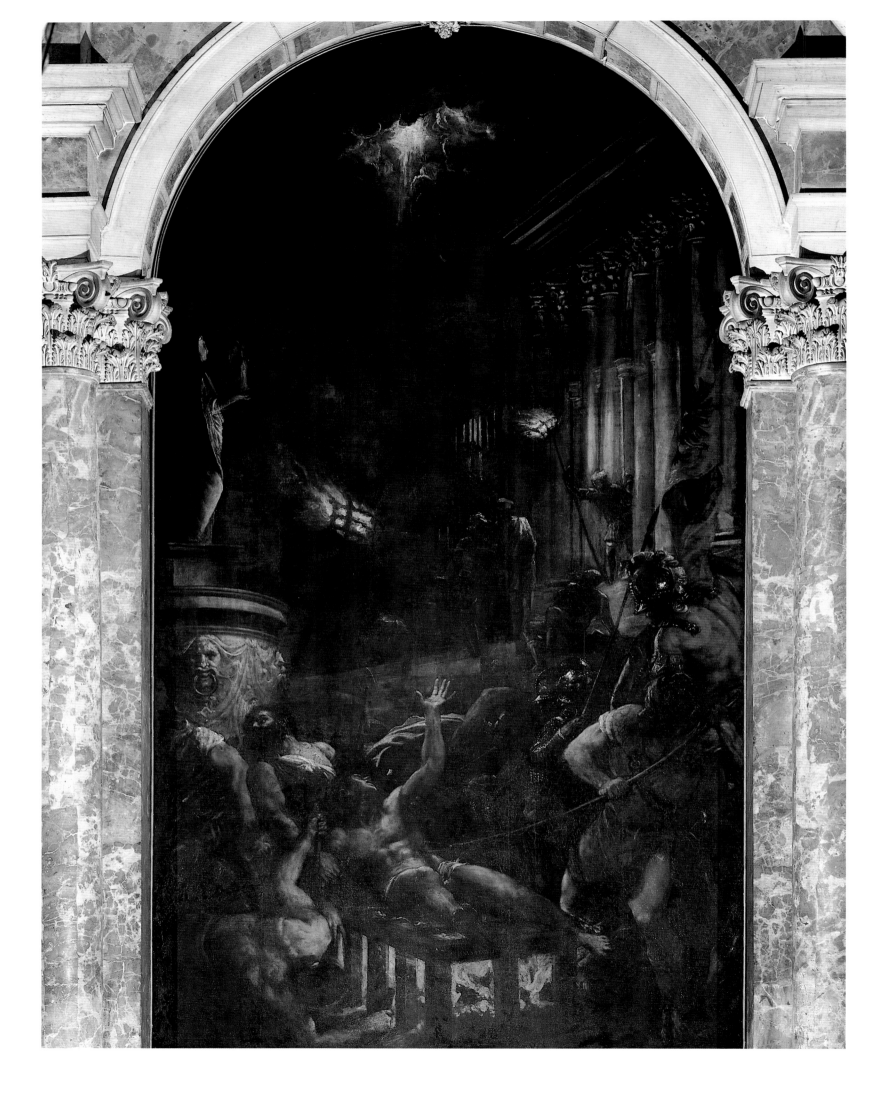

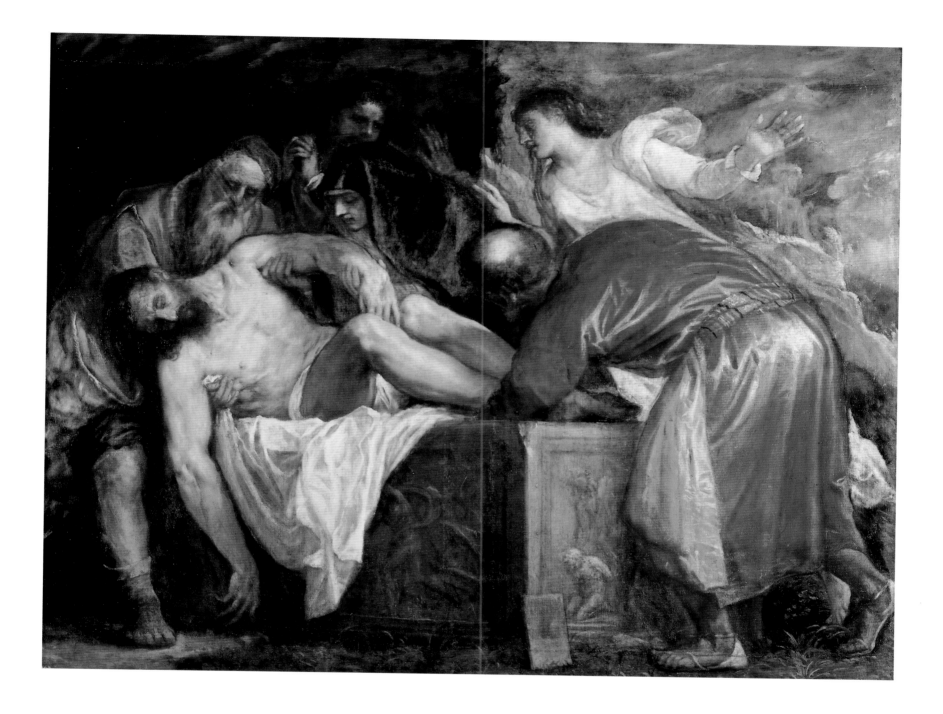

120 (above) *The Entombment*, 1559
Oil on canvas, 137 x 175 cm
Museo Nacional del Prado, Madrid

In this picture, the sense of space that plays such an important role in the *Entombment* painted in the 1520s (ill. 33) is now largely ignored. The position of the figures behind the sarcophagus is unclear, and the figures of Mary and of John, who is standing behind her, are little more than a concentration of color. The painting represents an important step towards the style of the 1560s, in which Titian creates effects solely with color.

119 (opposite) *The Martyrdom of St. Lawrence*, ca. 1548–1559
Oil on canvas, 493 x 277 cm
Chiesa dei Gesuiti, Venice

Here Titian chose to depict a night scene so that the light of the fire by which St. Lawrence was being martyred would be particularly effective. Only parts of the architecture are rendered visible through streams of light and this gives the entire painting a tense air of menace.

probably with touches added by the master himself at the urging of his clients.

In the Escorial Crucifixion (ill. 117), a broad landscape stretches out behind the Cross. In the middle distance, the holy women are returning to Jerusalem; on the left, soldiers are heading towards the city in the background. The Cross has been moved right up to the foreground and is seen from below; the landscape, in contrast, is seen from slightly above. At the bottom of the picture only a narrow strip of ground separates the observer from the foot of the Cross; higher up, the cross bar stretches across the entire width of the picture. In this way the Cross completely dominates the picture. The landscape behind looks like a specific place seen at a definite time; its very expanse, however, conveys an impression of timelessness. While the landscape and figures are depicted in great detail, the sky dissolves into a sea of

color that bathes the upper part of the picture, where the body of the dead Christ is, in a dramatic play of color. Formal contrasts – such as the movement of the turbulent sky and the unmoving rigidity of the corpse – reflect the emotional conflicts implicit in the drama of the events.

How different, in contrast, is the Crucifixion in Ancona (ill. 118), painted just a few years later. Here, Titian's main theme is not the tragic isolation of Christ, but the grief of Mary, St. John and St. Dominic. Here the image gains its timeless quality not from the landscape, which is almost imperceptible, but from the fact that it depicts a saint who lived in the late 12th and early 13th centuries alongside Mary and John beneath the Cross. Every form of naturalistic narration has disappeared; it is the use of light and color alone that determine the impact of the picture. The only point of comparison between the two

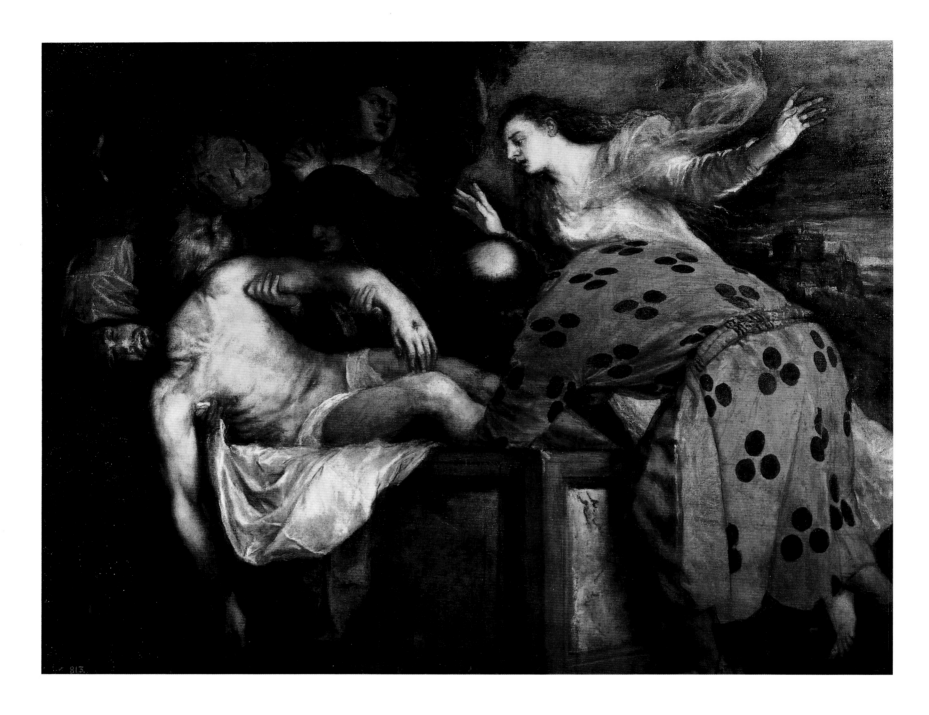

121 (above) *The Entombment*, ca. 1570
Oil on canvas, 130 x 168 cm
Museo Nacional del Prado, Madrid

In his monograph on Titian, Harold E. Wethey stated that the
quality of this painting was far inferior to the other two
Entombments (ills. 33, 120). The conspicuously spotted cloak of
the man in the right foreground destroys the balance of the
composition, and the figures on the left, despite their number
and their variety of colors, are not able to make up for this fault.
The darkening of the colors over time has possibly weakened the
picture's impact. In earlier times, these were clearly not
considered weaknesses, for numerous copies are also known to
have been made of this painting.

122 (opposite, left) *The Annunciation*, 1559–1564
Oil on canvas, 403 x 235 cm
San Salvatore, Venice

This painting was commissioned by 1559 at the latest, but
probably not finished until 1564. Mary's room is similar to that
in the earlier Annunciation (ill. 34) in Treviso, but is no longer of
central importance given the magnificent colors of the scene.
Titian conceived the events as a divine vision, swathing
everything in a cloud of color. Particularly worthy of note are the
flowers at the bottom right, glowing like flames. They are a
reference to the burning bush which Moses saw, a symbol of the
Virgin Birth.

123 (opposite, right) *The Annunciation* (detail ill. 122),
1559–1564

The gently glowing colors of the angel – from the shining dark
gold wings, to the skin tones made up of peach shades and the
soft iridescent garment, whose color is some indeterminable
shade of pink, light blue, gold and white – are some of the most
masterly examples of Titian's use of color in his late period.

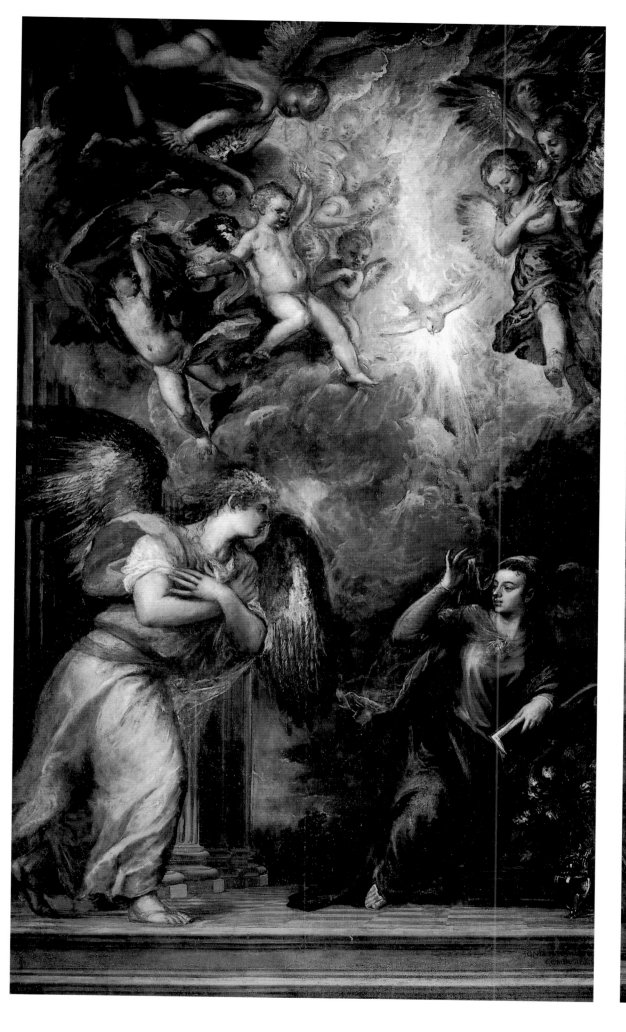

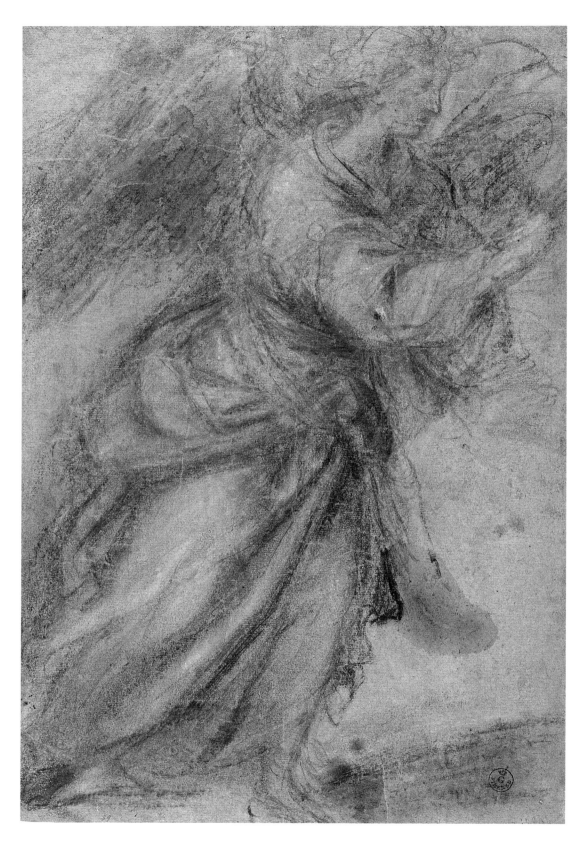

Crucifixions is the sky. In his avoidance of details, Titian goes so far as to leave the faces of Christ and Mary unlit, and therefore unclear. The figures of Mary and St. Dominic appear to have no volume. Mary's figure is completely contained within the contours of her blue cloak. The red of her other garment does not create a contrast because, being a plum red, it seems just another shade of the cloak's blue. St. Dominic embraces the foot of the Cross from behind. As a result, he is only partially visible, and appears even more fragmented because of the stark contrast between the white and black in his habit. The shining white of his garment forms a curved line that begins at the bottom left next to the Cross, continues behind the Cross to the right, starts to rise and then continues in the pale hands, twisting itself like foliage around the Cross.

Downcast, Mary is wrapped tightly in her cloak. There are only a few further features, such as the eyes, red with crying, that shine out from the darkness of her face, and her hands, which are turned outwards, characterizing her feelings. In the case of St. Dominic, his despair is conveyed by the movement of the white line of the garment, which almost achieves an abstract life of its own as it twines around the trunk of the Cross.

The mythological paintings Titian painted for Philip II from the late 1550s onwards, such as *Diana and Actaeon* (ill. 127) and *Diana and Callisto* (ill.126), are painted in light and, at times, astonishingly varied shades of color. These two Diana pictures painted for Philip II extend the cycle of mythological pictures based on scenes in Ovid's *Metamorphoses*. Their vivid colors clearly distinguish them from the two earlier paintings in this series, *Danaë with Nursemaid* (ill. 112) and *Venus and Adonis* (ill. 113). But even in the Diana pictures the depiction of the nude seen from various angles and in various movements continues to be an important aspect of the composition. It is even given priority over creating a faithful depiction of the literary source. In Ovid's description of the scenes in which Actaeon discovers Diana in the wood, her nymphs surround her immediately, so that Actaeon sees only the top half of her body. By contrast, in Titian's depiction in *Diana and Actaeon* (ill. 127), the goddess is not immediately surrounded by a circle of her nymphs; she is shown full length, she and her nymphs illustrating a range of poses. The scene probably depicts the instant at which Actaeon first sees the naked bathers – but it does not look as if the nymphs are about to jump up immediately in order to

124 (above) *Angel of the Annunciation*, ca. 1559
Charcoal and white chalk on paper, 42.2 x 27.9 cm
Galleria degli Uffizi, Gabinetto dei Disegni e delle
Stampe, Florence

This drawing would have been a preparatory study for the Annunciation in San Salvatore (ill. 122), even though the position of the arms is different. In this study, Titian has already created the gentle transitions of color in the light and shadow, which in the painting will be dissolved to create a vibrantly vivid colorfulness.

125 (opposite) *The Annunciation*, ca. 1557
Oil on canvas, 280 x 210 cm
San Domenico Maggiore, Naples

In this painting the miracle of the Annunciation is also conceived as a vision. But the use of colors and the conception of the figures in this painting are of an inferior quality to those in the marvellous version in Venice (ill. 122).

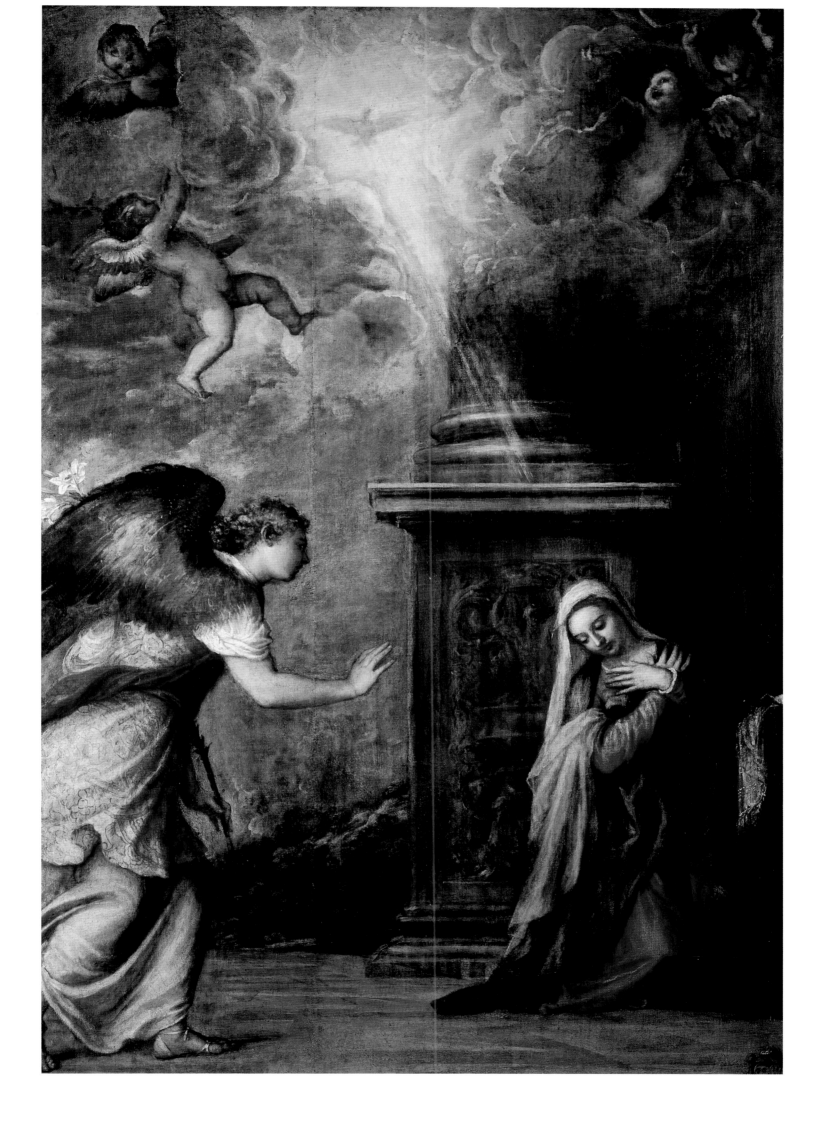

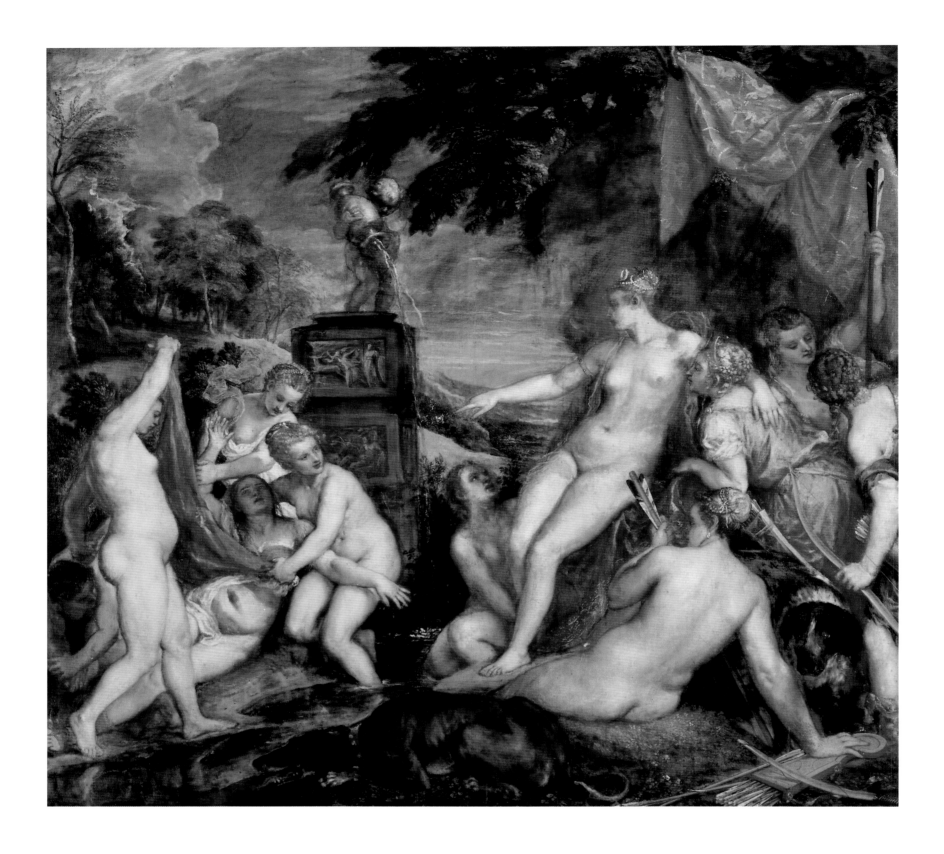

126 *Diana and Callisto*, 1556–1559
Oil on canvas, 188 x 206 cm
National Gallery of Scotland (on loan from the Duke of
Sutherland), Edinburgh

Jupiter, the principal god of Roman mythology, impreg-
nates the nymph Callisto, who is part of the entourage of
the chaste goddess of hunting, Diana, and therefore also
sworn to chastity. As they bathe together, the goddess
discovers that Callisto is pregnant and disowns her. This
painting, is badly damaged. But the contrast between the
lilac sky and the green vegetation ensures that the
painting's colors are still as enchanting as ever.

stand in front of their mistress. Titian has moderated
the fright that, according to Ovid, the nymphs
received from the sudden appearance of the unknown
man. The surprised bathers display a wide range of
reactions, from the complete lack of interest shown by
the nymph drying Diana's leg, to the open curiosity of
the nymph who is hiding behind the column.

The gentle colors of *Danaë with Nursemaid* (ill. 112)
have given way to strong contrasts. Dark emerald
green appears next to strong, bright red and blue,

completed with delicate purple, sky blue, pink and
gold tones. A similarly unusual color composition, one
also characterized by strong colors, is that of *Venus
Blindfolding Cupid* (ill. 129), which was painted some
years later. In *Venus Blindfolding Cupid*, however, the
sky, which gleams with shades of red, orange and
peach, picking up on the colors in the foreground,
creates a more harmonious effect that that achieved in
the pictures of Diana, which have a bold and
shimmering colorfulness.

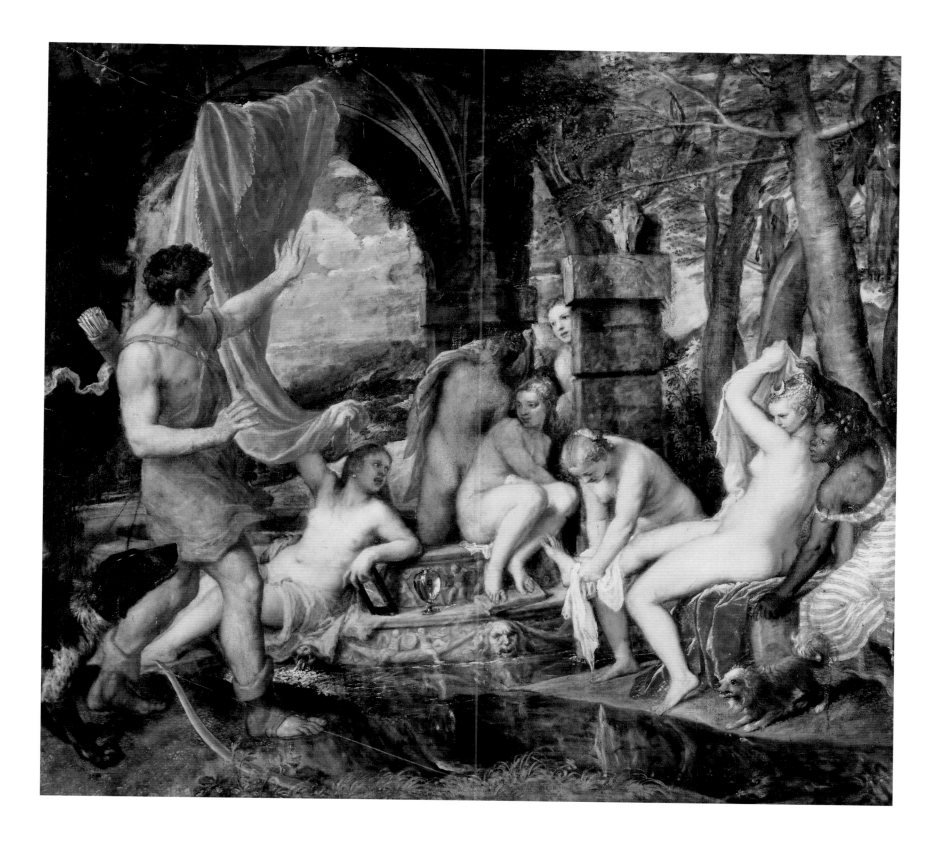

While in these mythological paintings Titian was principally experimenting with unusual combinations of colors and color effects, in the religious paintings of the late 1550s and early 1560s he began more and more to repress pictorial space and the volume of figures in favor of color. This is true of the *Crucifixion* (ill. 118) in Ancona as well as for *The Entombment* (ill. 120), *Christ Crowned with Thorns* (ill. 141) and the Annunciations (ills. 122, 125). The Annunciations in particular gain their visionary character from a use of

color that dissolves the figures and their surroundings. Eventually this use of color – often quite independent of the natural color of objects – came to be applied to the mythological pictures. The painting *The Death of Actaeon* (ill. 130), in which Titian once more dealt with the Diana myth for his Ovid cycle, acts as a link between the mythological works of the late 1550s and early 1660s and the religious works of this period. Now the colors of the sky, earth and trees hardly differ. The picture is dominated by yellow, gold, brown and

127 *Diana and Actaeon*, 1556–1559
Oil on canvas, 188 x 206 cm
National Gallery of Scotland (on loan from the Duke of Sutherland), Edinburgh

Actaeon the hunter comes across Diana, the classical goddess of hunting, and her nymphs as they are bathing. As he has seen the chaste goddess while she is naked, he is turned into a stag and is torn apart by his own dogs, who fail to recognize him. This painting is captivating because of its rich and unusual colors; nor does it shy away from using loud colors such as the bright red on Actaeon's turned-down boots.

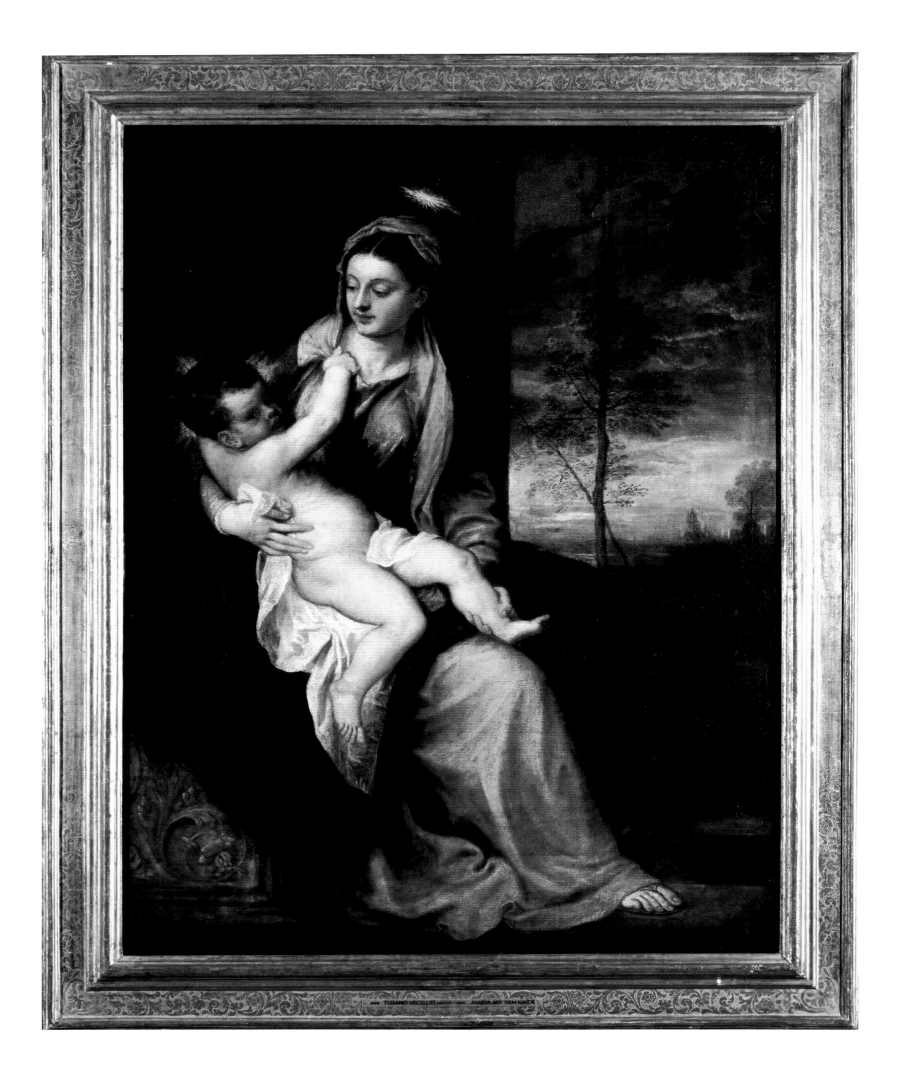

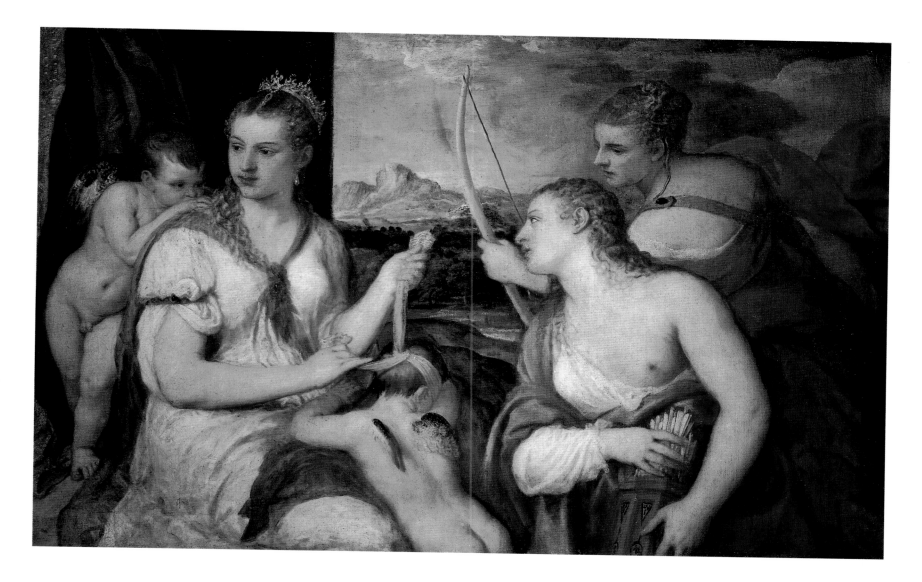

gray tones, in places combined with green, blue, and a little red. Only Diana is highlighted by the bright gold and the pink shimmering red of her dress. By using the same red for the garments worn by Actaeon, who is being torn apart by his dogs, Titian emphasizes Actaeon's role as the second main figure. However, the naked parts of Diana's body, together with stag's head of Actaeon, almost merge into the same yellow, brown and gray tones that dominate the entire picture. Only in the way he applies the color does Titian distinguish the individual objects. He paints the sky more evenly and softly than he paints the trees, whose leaves he indicates with broad, more or less blurred brush strokes. Diana's skin tones have been standardized to create a smooth surface, and her dress is dissolved into numerous fine shades of color. The left-hand side of the picture, where Diana stands, is characterized by a more even application of color that makes the surface of the picture appear smoother. On the right-hand side of the picture, where the dramatic death of Actaeon is shown, the colors are applied thickly with a smaller brush, creating an impression of restless movement that intensifies into a whirl of colors around Actaeon. In this way both color, and the way color is applied, play an important role in a determining the nature of a picture's content. Another example is *The Flaying of*

Marsyas (ill. 131), a breathtaking late masterpiece; here the colors at first conceal the cruelty of what is taking place, but when looked at more closely emphasize the monstrous nature of the scene depicted. The picture's strange colors, built up tones of gray, green, sand, and dull purple, create an increasingly melancholy and threatening mood.

The artist Jacopo Palma il Giovane (1544–1628) provided a fascinating description of the way in which Titian worked. He started by sketching his subject with just a few strokes using a full, thick brush. He then continued using the same brush, with whatever traces of paint were left in it, to produce the colorful reflections of light. When he had finished for that day, he would lean the canvas against the wall, face down, and let the paint dry before he continued working on it at a later date. During the last phase of his work he used a wide range of colors, frequently applying them with his fingers in order to achieve the desired effect. Vasari, who visited Titian in his workshop in 1566 and described the same technique, was clearly very impressed by these paintings. In his life of Titian, Vasari describes in some detail the effect of these paintings: "they cannot be viewed from near to, but appear perfect at a distance. This method of painting is the reason for the clumsy pictures painted by the

129 (above) *Venus Blindfolding Cupid*, ca. 1565
Oil on canvas, 118 x 185 cm
Galleria Borghese, Rome

This entire painting is covered by a unified golden red shade that is particularly apparent in the color of the sky. The color scheme is completed by an economical use of blues and greens. Titian decided not to use the powerful, impasto highlights that are such a frequent feature of his works during the 1550s. In old inventories, the figures in the painting are identified as either the Three Graces or Venus and two nymphs. In fact, the work depicts Venus blindfolding Cupid, the little god of love, and two nymphs who bring Cupid's bow and arrows.

128 (opposite) *Madonna and Child in an Evening Landscape*, 1562–1565
Oil on canvas, 174 x 133 cm
Bayerische Staatsgemäldesammlungen, Alte Pinakothek, Munich

The art historian Harold Wethey has compared the large heavy figure in this picture to the sculptures of Sansovino and Michelangelo. The composition of the picture, opening out onto a landscape, is reminiscent of a type of portrait frequently used by Titian and his workshop. The position of the Madonna, whose lower body is mainly in the center of the picture and whose upper body is turned to the left half, is a further example of Titian's unusual talent for composition – he was always finding new ways of developing long-established pictorial formulas.

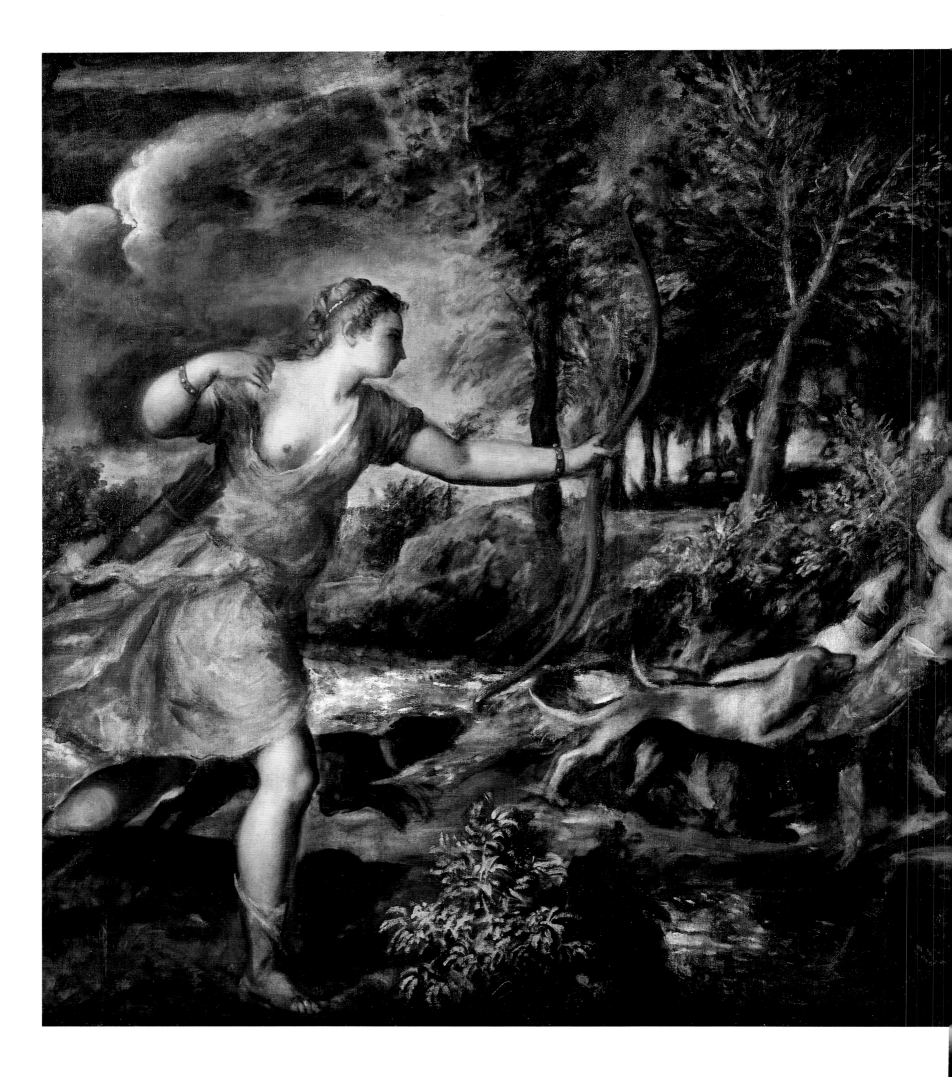

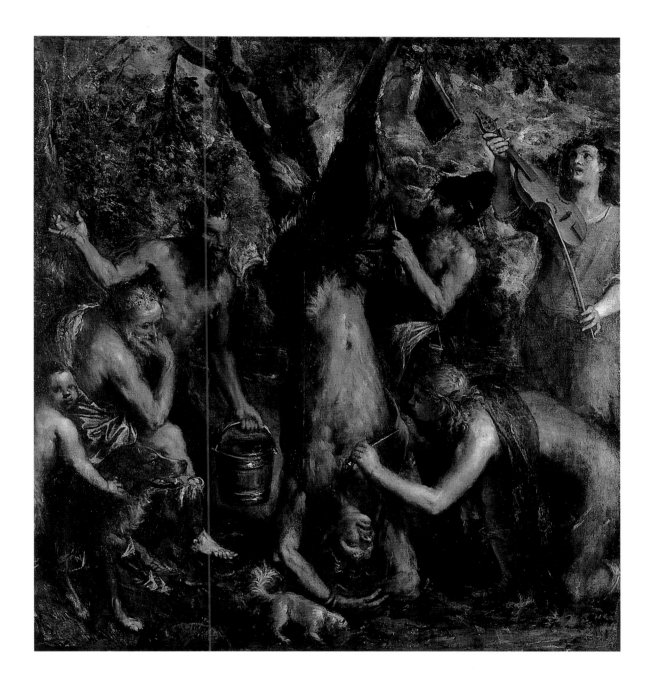

130 (links) *The Death of Actaeon*, ca. 1559 or
1570–1575
Oil on canvas, 179 x 198 cm
The National Gallery, London

This painting shows Actaeon who, having been changed
into a stag, is hunted by Diana and torn apart by his own
dogs. Letters show that the work was already planned in
1559, in connection with the pictures of Diana bathing
(ills. 126, 127). There are, however, stylistic reasons –
such as the forest, which dissolves into patches of color
around Actaeon on the right side – for considering a later
date to be more likely.

131 (above) *The Flaying of Marsyas*, 1575–1576
Oil on canvas, 212 x 207 cm
State Museum, Kromeriz

The Flaying of Marsyas is the sum of all Titian's
experiments with color during the 1560s and 1570s. In
contrast to the *St. Sebastian* (ill. 142), this painting is
built up using countless colors. Marsyas the satyr
challenged the god Apollo to take part in a musical
competition. He lost and his punishment was to be flayed
alive. At first, the horrific process seems to disappear
behind the shimmering colors. One needs to look more
closely in order to see that Apollo has already begun
stripping his skin; a little dog is licking at the satyr's
blood.

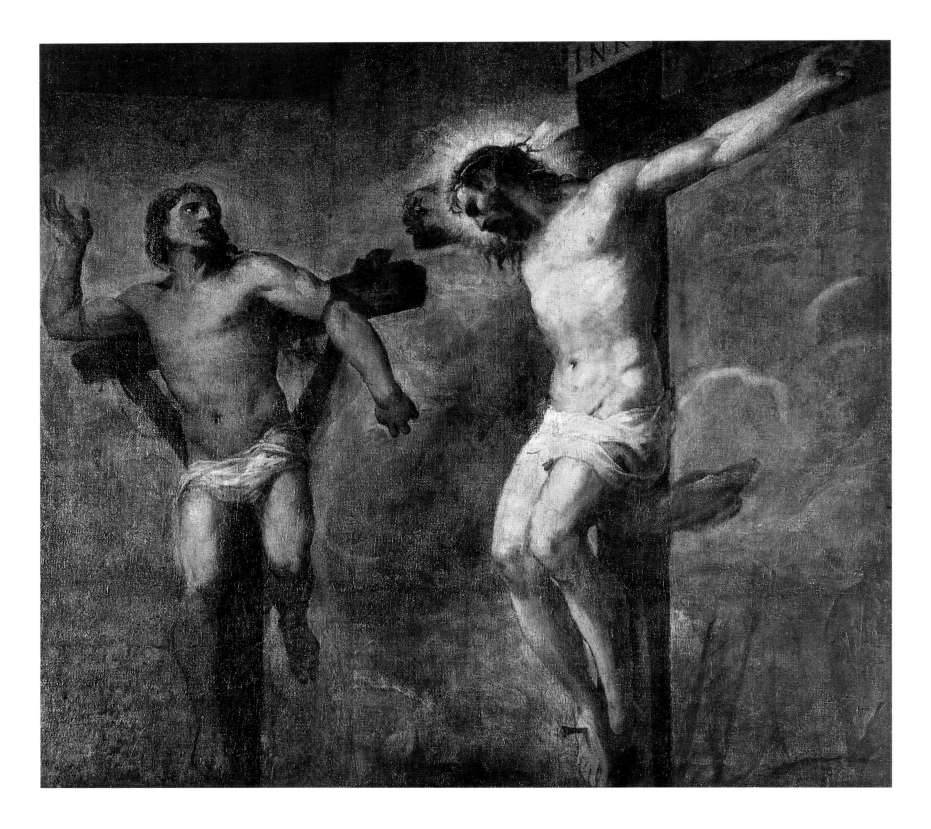

132 (above) *Christ and the Good Thief*, ca. 1566
Oil on canvas, 137 x 149 cm
Pinacoteca Nazionale, Bologna

There is considerable disagreement about the attribution
of this work to Titian. While the manner in which the
colors are applied is reminiscent of his late work, the
extraordinary spatial effect, which is mainly produced by
the turning of the thief's cross, can be observed in none of
his later works. The way the light falls would also be an
unusual feature in Titian's works in the 1560s. If this
indeed is not one of his paintings, it is nonetheless one of
the highest quality examples of the adoption of elements
of his style by other artists.

133 (opposite) *Allegory of Time Governed by Prudence*,
ca. 1565
Oil on canvas, 75.6 x 68.6 cm
The National Gallery, London

This is an exceptional portrait which depicts the aged
Titian on the left above a wolf's head, his son Orazio in
the center above the head of a lion, and his nephew
Marco above a dog's head. They represent time governed
by prudence. The Latin inscription also relates to this
theme. Though it was common enough during the
Renaissance to use three human heads to symbolize the
ages of man, and to use three animal heads to symbolize
prudence, it was very unusual to use them as the theme of
a painting. As Titian used personal motifs, it can be
assumed that he chose the subject matter himself.

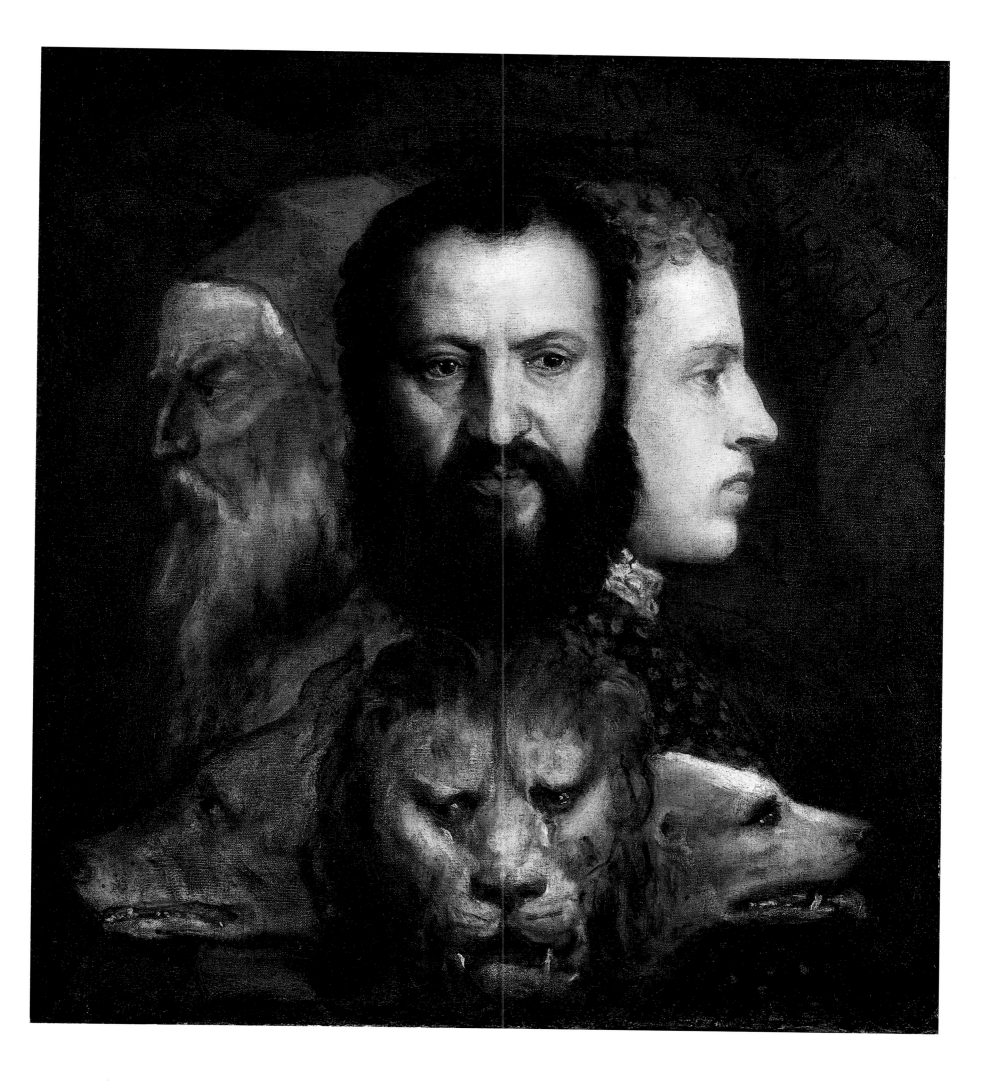

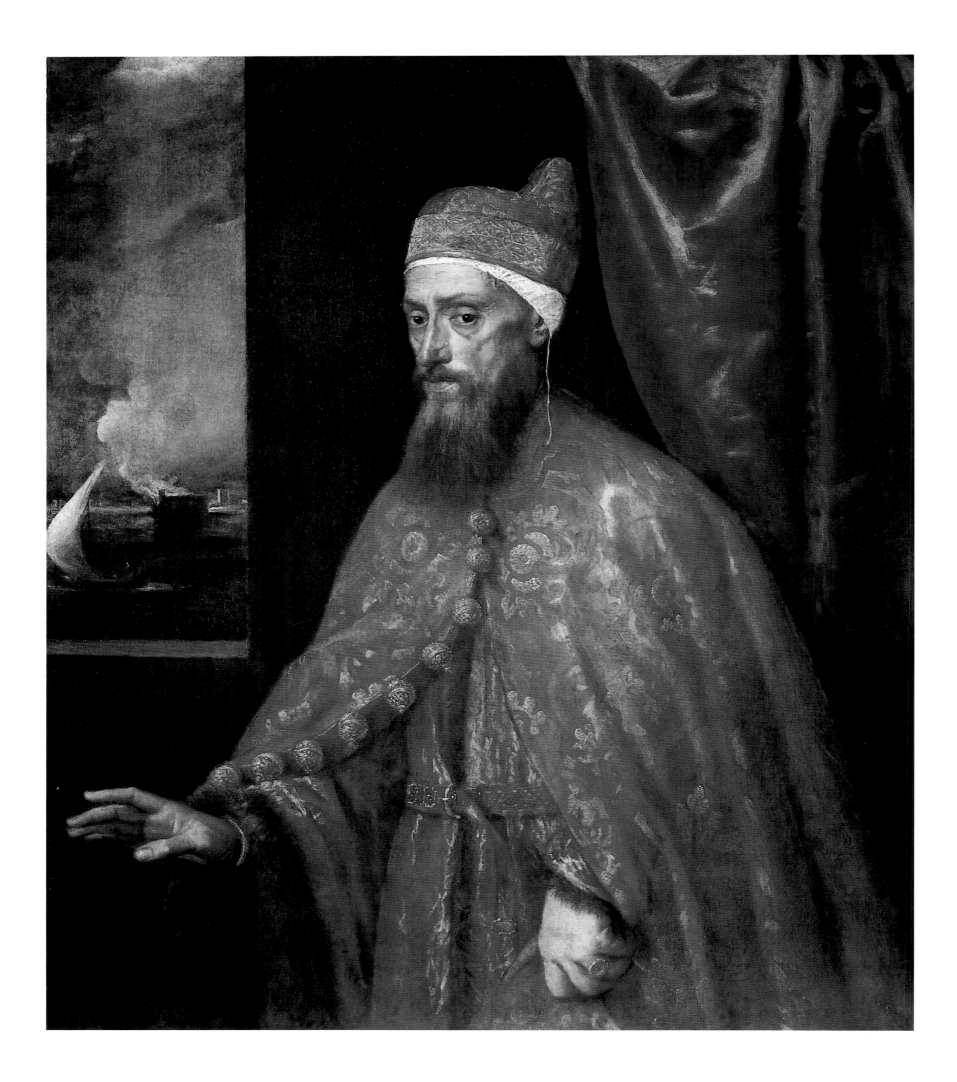

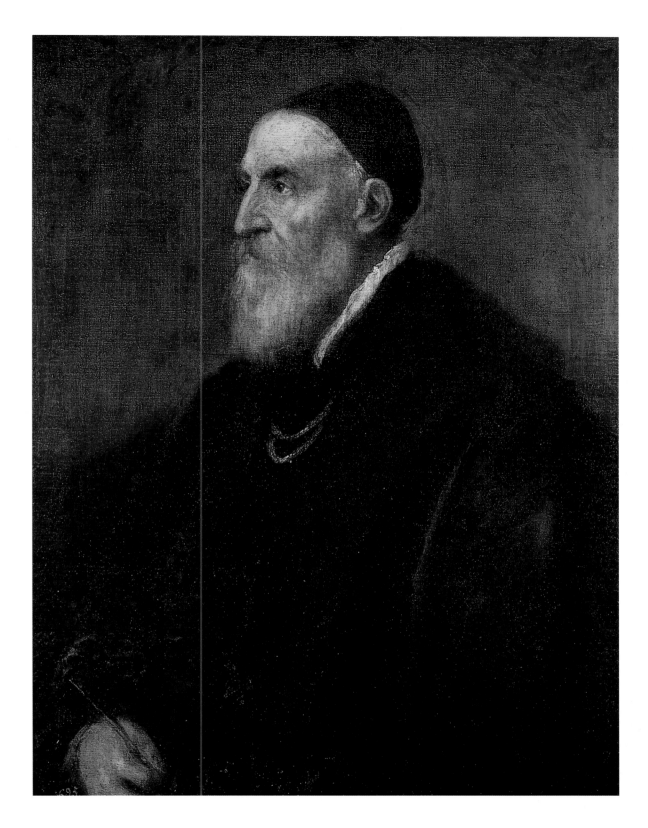

134 (opposite) *Portrait of the Doge Francesco Venier*,
after 1564
Oil on canvas, 114 x 99 cm
Museo Thyssen-Bornemisza, Madrid

Francesco Venier (1490–1556) was elected Doge on 11
June 1554. He reigned for scarcely two years, until 2 June
1556. This portrait is an excellent example of the way
Titian used color during his late period. The picture does
not break up into countless colors. Only in the garment is
there a fine play of golden hues, underlining the delicacy
of the frail Doge. So far there has been no explanation for
the fire in the lagoon, which is visible through the
window. In terms of color, the fire provides an important
contrast with the blue sky.

135 (above) *Self-Portrait*, ca. 1566
Oil on canvas, 86 x 69 cm
Museo Nacional del Prado, Madrid

Titian's late self-portrait demonstrates the same refined
use of color as the portrait of Doge Venier (ill. 134).
There is an almost breathtaking virtuosity displayed in
the way Titian paints the portrait using shades of black
and brown. Only the face is emphasized with small
touches of white. No other painter of his age ever
succeeded in producing anything like this.

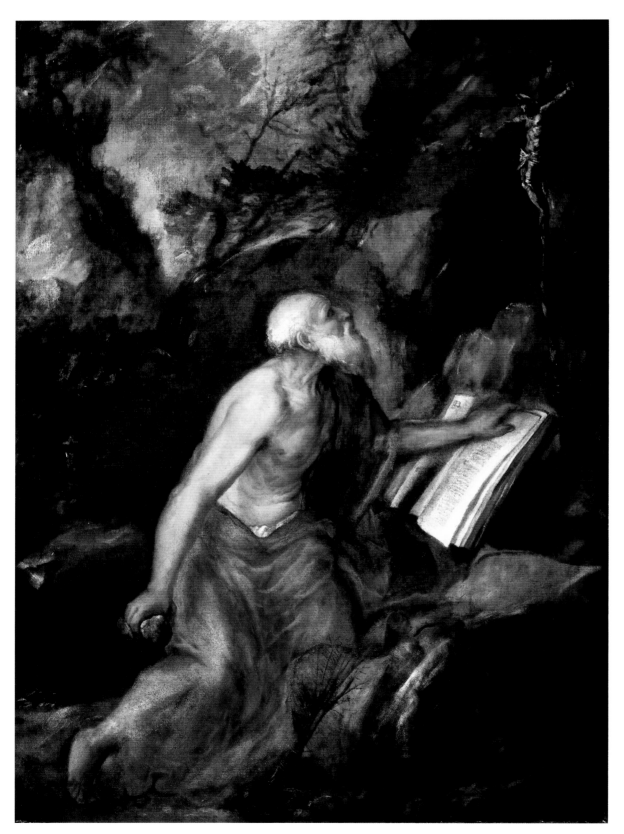

136 (left) *St. Jerome*, ca. 1570–1575
Oil on canvas, 137.5 x 97 cm
Museo Thyssen-Bornemisza, Madrid

St. Jerome as a hermit, praying before a crucifix in the
solitude of the wilderness, is a theme that Titian returned
to again and again during the course of his career.
Numerous researchers consider this painting to be
unfinished, due to the almost abstract background. The
figure of the saint and the very plastic appearance of the
crucifix show that the work was at an advanced stage.

137 (opposite) *St. Jerome*, ca. 1575
Oil on canvas, 184 x 177 cm
Nuevos Museos, Escorial

As in many of Titian's late works, there are justified
doubts as to the extent to which Titian worked on this
painting. It is indeed extremely difficult to judge whether
figures as flat as those in this picture are indeed part of the
artist's late work. The same is true of the books and the
hour-glass on the left.

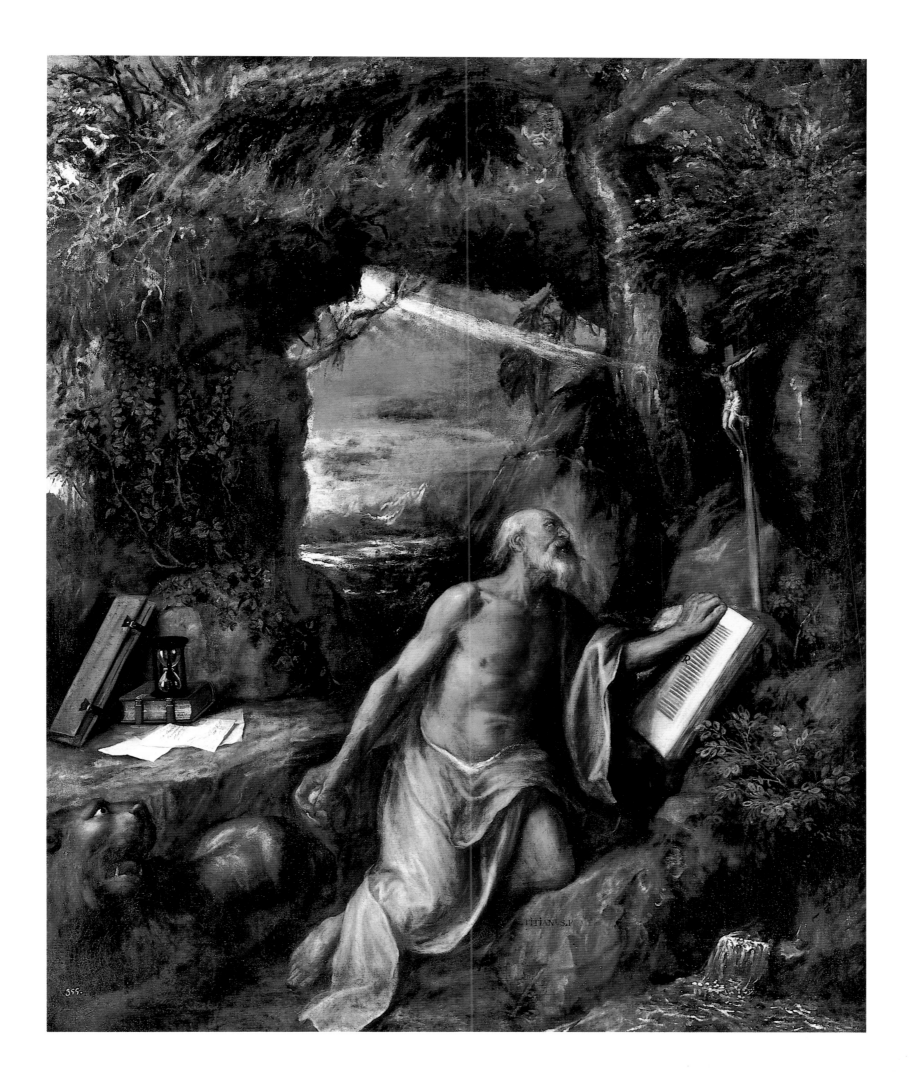

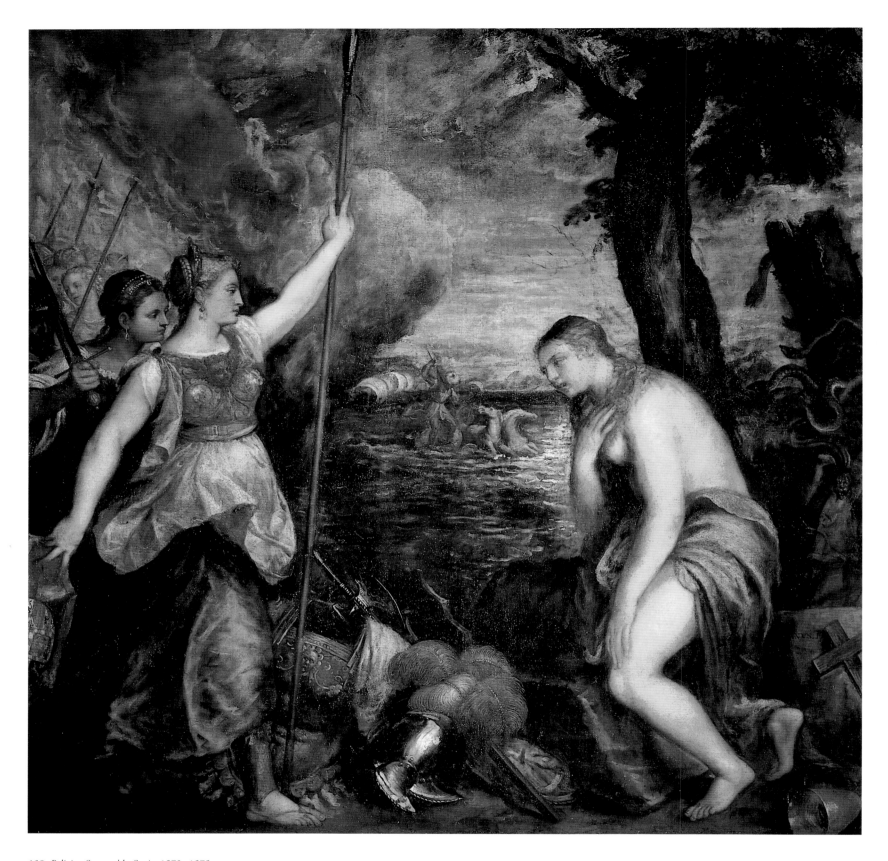

138 *Religion Succored by Spain*, 1572–1575
Oil on canvas, 168 x 168 cm
Museo Nacional del Prado, Madrid

The kneeling woman holding the chalice and cross is a
personification of Religion being attacked by the serpents
of Unbelief. From the left, though, the personification of
Spain is approaching, wearing a fluttering garment, to
assist Religion. The painting is alluding to the leading role
that Spain played in the wars of religion. At the same
time, the background commemorates the victory of the
Christian fleet over the Turks in the Battle of Lepanto in
1571.

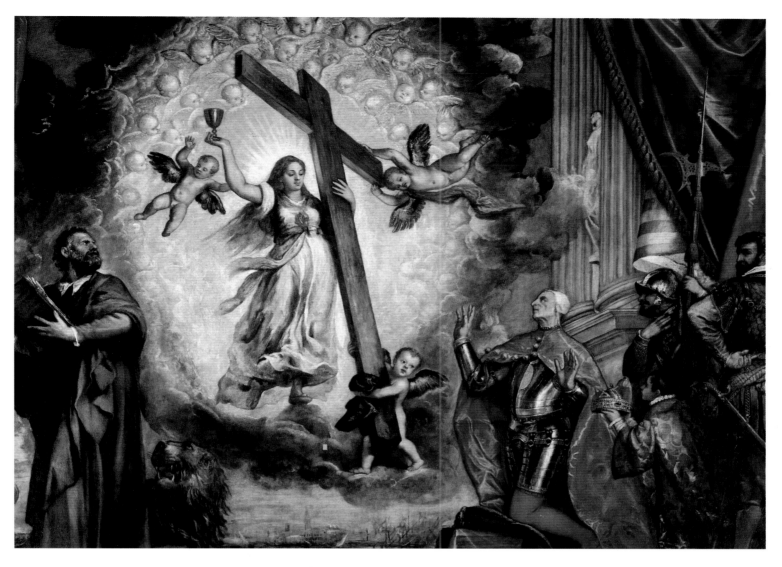

139 (above) *Doge Antonio Grimani Kneeling Before the Faith*, 1555–1576
Oil on canvas, 365 x 500 cm
Palazzo Ducale, Sala delle Quattro Porte, Venice

Though the painting was commissioned as early as 1555, it was not completed by the time Titian died. It is not only a votive picture for Doge Antonio Grimani (1436–1523), who is shown kneeling in front of a personification of the Faith, but is also a complex allegory of Venice. In the background the silhouette of the city is visible, and in the foreground St. Mark, the patron saint of Venice, appears opposite the Doge. Most of the work was probably carried out by his workshop.

140 (left) *Doge Antonio Grimani Kneeling before the Faith* (detail ill. 139), 1555–1576

In the background, St. Mark's Square, and in front of it the lagoon and the numerous ships upon which the wealth and safety of Venice were founded emerge as from a haze of color.

131

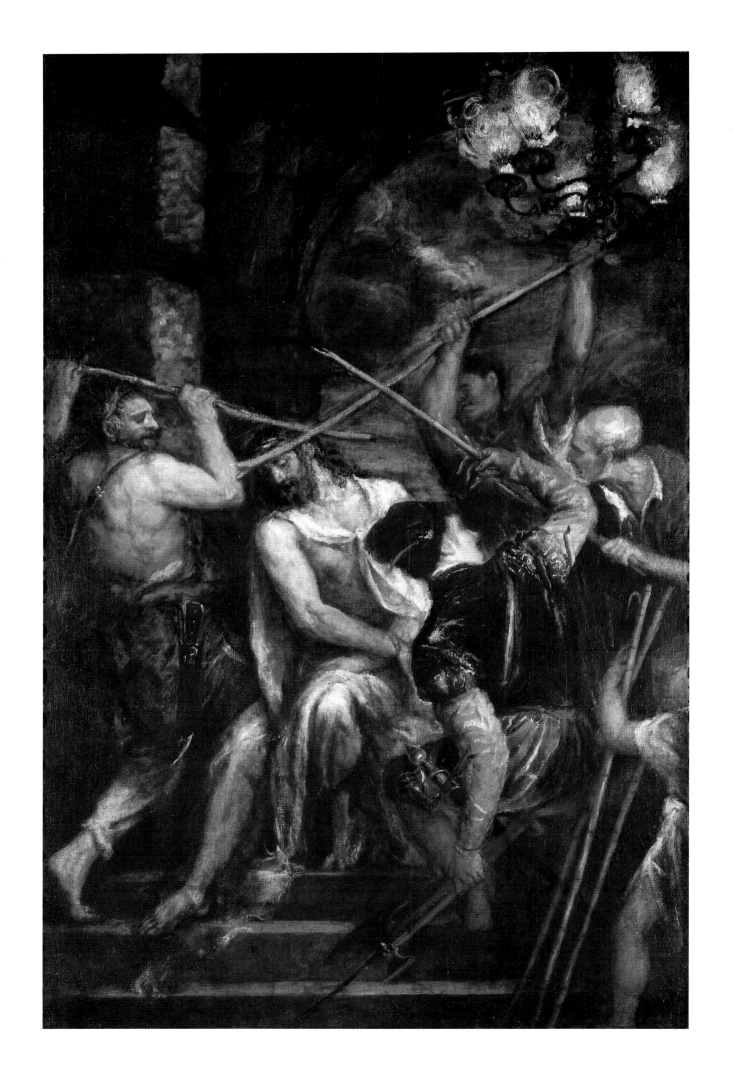

many artists who have tried to imitate Titian and show themselves practised masters; for although Titian's works seem to many to have been created without much effort, this is far from the truth and those who think so are deceiving themselves." The art historian Theodor Hetzer, who in 1935 published a book on Titian's use of color, summed up his method of painting very aptly: "There is a colorful play of light glimmering and gleaming across the entire picture. The thick application of the paint and the rough grainy canvas that Titian now preferred cause the picture to radiate countless lights and reflections [...] Every square centimeter has the same intensity of movement as the entire surface. Nothing is undissolved or dull, nor does anything require a broader context in order to be effective. What we get is something in the nature of a picture that has been broken down into atoms of color; each fleck of color exists independently and is as valid as any other."

Not all of Titian's late paintings, however, show this process taken to such extremes. In some of them certainly, such as *St. Sebastian* (ill. 145), the figure and landscape seem to emerge from colors that seem to cover the canvas at random and form a thick carpet of color, or, as Palma Giovane put it, a "bed of color". By contrast, in the allegory *Religion Succored by Spain* (ill. 138), there are much more subtle gradations of color. But here, too, the sheer variety of colors needed to produce the delicate sheen on the red outer garment worn by the personification of Spain is astonishing. From the end of the 1550s there were no further developments in the style of the works that Titian painted. He developed an individual solution for each of his canvases, some of which, as Palma describes, were painted over several years. Late works such as *Portrait of Doge Francesco Venier* (ill. 134) also show such individual solutions. In the painting of the Doge, the magnificence of the robes with the interwoven gold threads – so noticeable a feature in the *Portrait of Doge Andrea Gritti* (ill. 93) – has been moderated to a delicate shimmering that seems to cover the entire painting with its sheen. By applying the colors gently, Titian succeeded in capturing the character of the Doge, who, though physically extremely weak during his period in office, was very strong-minded. By contrast, in the *Allegory of Time Governed by Prudence* (ill. 133), which shows Titian with his son Orazio and his nephew Marco, he achieves his effect mainly through his use of light. Titian's self-portrait,

personifying the past, is disappearing into the twilight, and even seems to physically dissolve into it. Orazio, the personification of the present, is lit from the side, so that half of his face is in shadow; and the profile of the young Marco, the future, is fully lit.

In Titian's late *Self-Portrait* (ill.135), his figure almost dissolves into the dark background. Though this is in part due to the aging of the pigments of a painting that was originally somewhat lighter, the dark effect was quite intentional. His face is accentuated by the almost white highlights on the collar and the hair shining beneath his cap. The background is slightly lighter around his head. He also used highlights on things that were important to him. He emphasizes his golden chain as well as the brush he is holding, which he paints almost black on black as an indication of his artistic skill. His use of dark colors, together with his technical mastery, combine to create an impression of a man of strength and modesty who had no wish to conceal his art and his imperial title. This self-portrait once again gives us an impressive image of his ability and personality.

His final artistic legacy, a *Pietà* (ill. 143) he began painting for his own tomb, was to remain unfinished, as did many of the paintings of the latter years of his life. Titian had intended this work for the church of Santa Maria Gloriosa dei Frari, in which he wished to be buried. Titian died on 27 August 1576, in his house in Biri Grande. There had been a serious outbreak of plague in Venice and as a result the city authorities, who had advanced ideas in medical matters, forbade funeral ceremonies in order to reduce the risk of infection. But an exception was made for the city's great son, whose art had contributed in so many ways to the Republic's fame. He was buried on 28 August 1576, in Santa Maria Gloriosa dei Frari, after a brief ceremony. The attendance of the canons of San Marco at his funeral officially honored the republic's greatest artist. His monument in the city was not erected until the 19th century. The great artists of the following centuries have repeatedly referred to him. In very different ways, his art influenced painters such as Nicolas Poussin, Peter Paul Rubens, Anthony van Dyck, Diego Velázquez, Rembrandt, Francisco Goya, Eugène Delacroix, Édouard Manet, and Auguste Renoir, to name but a few. An indication of the high regard in which Titian's achievement was held was the fact that in the 17th century the artist Luca Giordano (1634–1705) rose to fame by forging works by Titian.

141 *Christ Crowned with Thorns*, ca. 1570–1576
Oil on canvas, 280 x 181 cm
Bayerische Staatsgemäldesammlungen, Alte Pinakothek, Munich

This painting uses the same composition as the *Christ Crowned with Thorns* in the Louvre (ill. 81). Here, however, Titian has omitted any definition of space. The individual picture elements appear to emerge out of the dark masses of color. The sheer wealth of colors is not noticeable until one looks more closely. Mustard yellow and broken reds provide some strong colors highlights in the foreground. Large sections of the painting on the right were not completed. Like so many works during his late period, this work also remained unfinished.

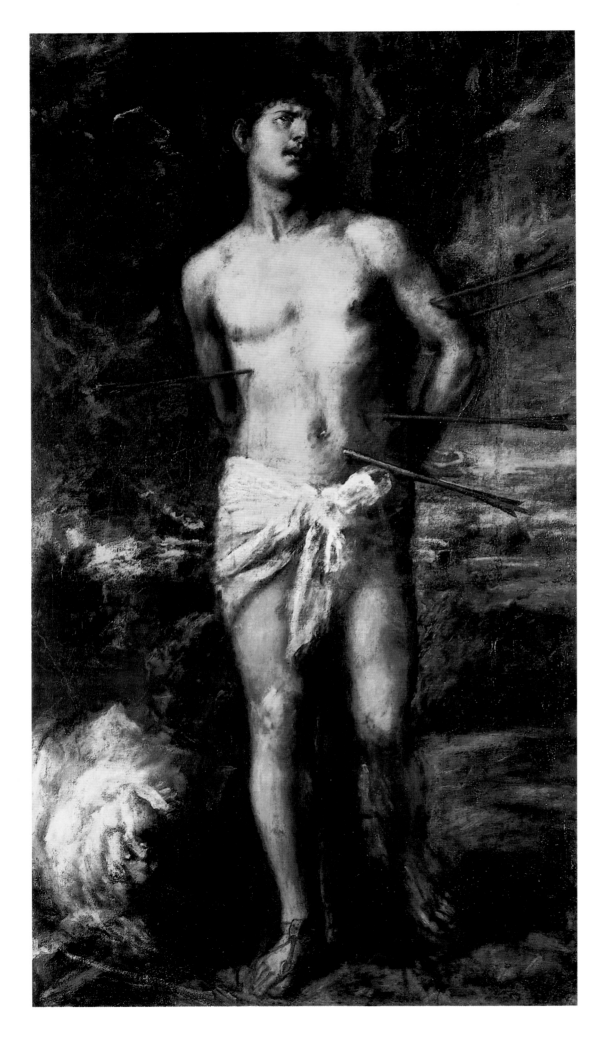

142 (left) *St. Sebastian*, 1575
Oil on canvas, 210 x 115 cm
Hermitage, St. Petersburg

Together with his *The Flaying of Marsyas* (ill. 131), the
Sebastian is one of the greatest masterpieces of Titian's late
work. The painting is built up using only shades of black,
gold and brown, with a very few touches of red. The
saint's body appears to emerge from the surrounding
colors as an intensification of color. Vasari's enthusiastic
description of Titian's method of painting by creating
patches of color that "cannot be viewed from nearby, but
appear perfect at a distance", is particularly applicable in
this instance.

143 (opposite) *Pietà*, 1576, completed later
Oil on canvas, 378 x 347 cm
Gallerie dell'Accademia, Venice

Titian planned to donate this painting to the church of
Santa Maria Gloriosa dei Frari in the hope that he would
obtain one of the much-desired burial places there.
During his lifetime, however, he failed to reach an
agreement with the friars. The picture was not finished
and was eventually completed by Palma Giovane. The
painting depicts the dead Christ and his grieving mother,
but also shows Magdalene in an unusually violent
movement, something which has been taken as an
allusion to the terrible plague which raged in Venice while
Titian was working on it.

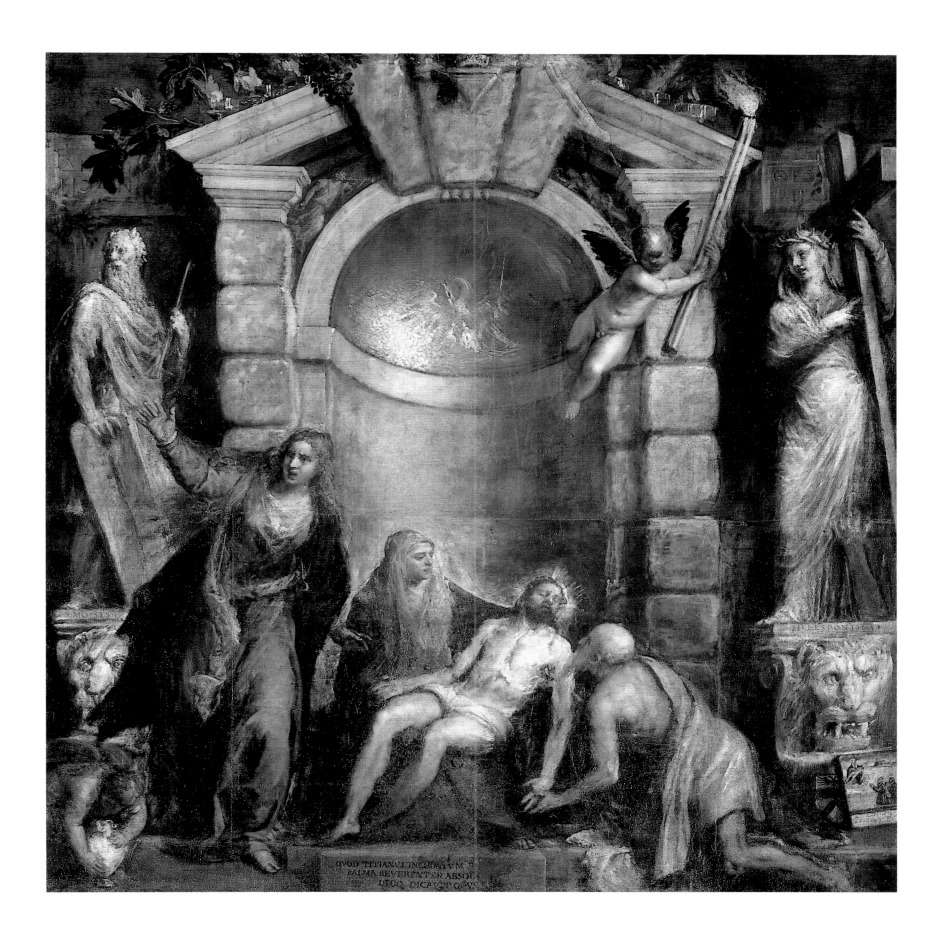

CHRONOLOGY

1488–1490 Titian is born in Pieve di Cadore.

ca. 1498 Titian and his brother go to Venice.

1508–1509 Titian works on the frescoes in the newly rebuilt Fondaco dei Tedeschi.

1510 Titian works on the frescoes in the Scuola del Santo in Padua. Venice is affected by a serious outbreak of plague which claims Giorgione as one of its victims.

1513 Titian is invited to the papal court in Rome by Pietro Bembo. He declines, instead offering his services to the Venetian state. In a petition, he asks to be given the Sensaria and a commission to work on pictures for the Sala del Maggior Consiglio. During the same year, he opens his own workshop near San Samuele.

1516 He starts work for Alfonso d'Este in Ferrara. He is also commissioned to produce the *Assumption of the Virgin*.

1518 The *Assumption of the Virgin* is unveiled on 19 May.

1519 On 24 April, Titian is commissioned to paint the *Pesaro Altarpiece*.

1523 Titian produces works in the Doge's Palace and for Alfonso d'Este in Ferrara. First contact with Federico II Gonzaga, Duke of Mantua.

1526 The *Pesaro Altarpiece* is unveiled on 8 December.

1528 Titian is commissioned to paint the *Martyrdom of St. Peter Martyr* for the church of San Giovanni e Paolo in Venice.

1529 In October Federico II Gonzaga arranges his first meeting with Emperor Charles V in Parma.

1530 Titian is working mainly for Federico II Gonzaga. The Altarpiece *Martyrdom of St. Peter Martyr* is completed.

1531 In September, Titian moves into the house in Biri Grande in the parish of San Canciano, where he lives for the rest of his life.

1532 Titian makes contact with Francesco Maria della Rovere, Duke of Urbino.

1533 In January, Titian again meets Charles V, in Bologna. He paints a portrait of the emperor, who makes Titian a Count Palatine and Knight of the Golden Spur.

1537 The nuns of Santa Maria degli Angeli on Murano reject an Annunciation which Titian has painted for them, instead giving the commission to Pordenone.

1538 Though Titian finally completes an overdue battle painting for the Doge's Palace in August, the *sensaria* is revoked due to the work's late completion and given to his greatest rival, Pordenone.

1539 The *Presentation of the Virgin at the Temple* is unveiled on 6 March. Titian is given back the *sensaria*.

1541 In Milan, Titian delivers his painting *Alfonso d'Avalos Addressing his Troops*.

1543 On the occasion of the meeting of Pope Paul III and Charles V in Busseto, Titian paints the pope's portrait.

1545 Titian travels via Urbino to Rome, accompanied by his son Orazio. He views classical works in the Belvedere in the company of Sebastiano del Piombo and Giorgio Vasari. He also meets Michelangelo.

1546 Titian is given honorary citizenship of Rome on 19 March, and then returns to Venice.

1548 Titian travels to Augsburg in January at the invitation of Charles V, and does not return to Venice until October.

1550 At the request of Charles V, Titian once again travels to the Imperial Diet in Augsburg.

1551 In August, Titian returns to Venice from Augsburg. He becomes a member of the Scuola di San Rocco.

1556 Death of Pietro Aretino.

1559 Titian's eldest brother Francesco dies.

1566 Titian demands that Cornelis Cort give him the rights to prints made of his paintings. The Council of Ten gives him the rights, as well as those to Niccolò Boldrini's prints. Titian is made a member of the Florentine Accademia dell' Disegno, together with Andrea Palladio and Tintoretto.

1575 On 24 September, Titian sends the painting *Religion Succored by Spain* to Philip II.

1576 Since June 1575, a major outbreak of the plague has been raging in Venice, and it will last until the summer of the following year and claim about 50,000 lives. Titian dies on 27 August, though it is uncertain whether of the plague or of old age. A short time later, his son Orazio succumbs to the plague.

GLOSSARY

Alabaster Room (It. *Camerino d'Alabastro*), the private study of Duke Alfonso I d'Este in his palace in Ferrara. The original décor has not survived, so we can only speculate why it bore this name. This is where he kept his paintings by Giovanni Bellini, Titian, and Dosso Dossi.

allegory (Gk. *allegorein*, "say differently"), a work of art which represents some abstract quality or idea, either by means of a single figure (personification) or by grouping objects and figures together. In addition to the Christian allegories of the Middle Ages, Renaissance allegories make frequent allusions to Greek and Roman legends and literature.

altar panel, a painting that stands on or behind an altar. Early altar panels were made to stand alone; gradually they came to form the central work of elaborate altarpieces that combined several panels within a carved framework.

altarpiece, a picture or sculpture that stands on or behind an altar. Many altarpieces were very simple (a single panel painting), though some were huge and complex works, a few combining both painting and sculpture within a carved framework. From the 14th to 16th century, the altarpiece was one of the most important commissions in European art; it was through the altarpiece that some of the most decisive developments in painting and sculpture came about.

Arcadia (a mountainous area of Greece), in Greek and Roman literature, a place were a contented life of rural simplicity is lived, an earthly paradise peopled by shepherds.

attribute (Lat. *attributum*, "added"), a symbolic object which is conventionally used to identify a particular person, usually a saint. In the case of martyrs, it is usually the nature of their martyrdom.

Augustinians, in the Roman Catholic Church, a mendicant order founded in 1256 under the rule of St. Augustine (354–430 AD). The order became widespread in the 14th and 15th centuries, renowned for its scholarship and teaching. Under the influence of humanism during the Renaissance, Augustinians played a leading role in seeking Church reform.

aureole (Lat. [*corona*] *aureola*, "golden [crown]"), a circle of light shown surrounding a holy person, a halo.

Bacchus, in Greek and Roman mythology, the god of wine and fertility. Bacchic (or **bacchanalian**) rites were often orgiastic.

Baroque (Port. *barocco*, "an irregular pearl or stone"), the period in art history from about 1600 to about 1750. In this sense the term covers a wide range of styles and artists. In painting and sculpture there were three main forms of Baroque: (1) sumptuous display, a style associated with the Catholic Counter Reformation and the absolutist courts of Europe (Bernini, Rubens); (2) dramatic realism (Caravaggio); and (3) everyday realism, a development seen in particular in Holland (Rembrandt, Vermeer). In architecture, there was an emphasis on expressiveness and grandeur, achieved through scale, the dramatic use of light and shadow, and increasingly elaborate decoration. In a more limited sense the term Baroque often refers to the first of these categories.

campanile, (It. "bell tower"), a church bell tower, often standing detached from the body of the church. Well-known examples include the Campanile of St. Mark's Cathedral in Venice, and "Leaning Tower" of Pisa.

cassone, pl. **cassoni** (It.) in Medieval and Renaissance Italy, a large chest, usually a marriage chest, for storing linen, documents or valuables. They were often elaborately carved and decorated and sometimes had painted panels set into them. Artists who are known to have painted *cassone* panels include Botticelli, Uccello, and del Sarto.

classical, relating to the culture of ancient Greece and Rome (**classical Antiquity**). The classical world played a profoundly important role in the Renaissance, with Italian scholars, writers, and artists seeing their own period as the rebirth (the "renaissance") of classical values after the Middle Ages. The classical world was considered golden age for the arts, literature, philosophy, and politics. Concepts of the classical, however, changed greatly from one period to the next. Roman literature provided the starting point in the 14th century, scholars patiently finding, editing and translating a wide range of texts. In the 15th century Greek literature, philosophy and art – together with the close study of the remains of Roman buildings and sculptures – expanded the concept of the classical and ensured it remained a vital source of ideas and inspiration.

Council of Ten (It. *Consiglio dei Dieci*), the highest decision-making body in the Venetian state. As head of the state, the **Doge** was higher in the political hierarchy, but needed to use considerable personal authority if he wanted to challenge a decision made by the Council. The members were elected for a fixed term from the Senate, composed entirely of the city's aristocrats.

Counter Reformation, 16th- and 17th-century reform movement in the Roman Catholic Church. Prompted initially by internal criticism, it was given greater momentum by emergence of Protestantism. The Counter Reformation led to a new emphasis on teaching, missionary work, and the suppression of heresy. In Catholic countries there was the deliberate cultivation of the arts in supporting the Church's message, with works both explicitly illustrating doctrine and also aiming to make a direct appeal to the

emotions. Among the major artists of the Counter Reformation were Bernini, Rubens, and Caravaggio.

Diet, a general assembly of the lay and ecclesiastic princes of the Holy Roman Empire.

Doge (Lat, *dux,* "leader"), the elected head of the Venetian state.

Dominicans (Lat. *Ordo Praedictatorum,* Order of Preachers), a Roman Catholic order of mendicant friars founded by St. Dominic in 1216 to spread the faith through preaching and teaching. The Dominicans were one of the most influential religious orders in the later Middle Ages, their intellectual authority being established by such figures as Albertus Magnus and St.Thomas Aquinas. The Dominicans played the leading role in the Inquisition.

ducat (Lat. *ducatus,* "duchy"), a gold coin used widely in Europe during the Middle Ages and the Renaissance.

Ecce Homo (Lat. "Behold the Man!"), the words of Pontius Pilate in the Gospel of St John (19, 5) when he presents Jesus to the crowds. Hence, in art, a depiction of Jesus, bound and flogged, wearing a crown of thorns and a scarlet robe.

Franciscans, a Roman Catholic order of mendicant friars founded by St. Francis of Assisi (given papal approval in 1223). Committed to charitable and missionary work, they stressed the veneration of the Holy Virgin, a fact that was highly significant in the development of images of the Madonna in Italian art. In time the absolute poverty of the early Franciscans gave way to a far more relaxed view of property and wealth, and the Franciscans became some of the most important patrons of art in the early Renaissance.

fresco (It. "fresh"), wall painting technique in which pigments are applied to wet (fresh) plaster (*intonaco*). The pigments bind with the drying plaster to form a very durable image. Only a small area can be painted in a day, and these areas, drying to a slightly different tint, can in time be seen. Small amounts of retouching and detail work could be carried out on the dry plaster, a technique known as *a secco* fresco.

hatching, in a drawing, print or painting, a series of close parallel lines that create the effect of shadow, and therefore contour and three-dimensionality. In **cross-hatching** the lines overlap.

humanism, an intellectual movement that began in Italy in the 14th century. Based on the rediscovery of the classical world, it replaced the Medieval view of humanity as fundamentally sinful and weak with a new and confident emphasis on humanity's innate moral dignity and intellectual and creative potential. A new attitude to the world rather than a set of specific ideas, humanism was reflected in literature and the arts, in scholarship and philosophy, and in the birth of modern science.

iconography (Gk. "description of images"), the systematic study and identification of the subject-matter and symbolism of art works, as opposed to their style; the set of symbolic forms on which a given work is based. Originally, the study and identification of classical portraits. Renaissance art drew heavily on two **iconographical** traditions: Christianity, and ancient Greek and Roman art, thought and literature.

impasto (It.), the technique of applying paint very thickly.

La Serenissima, (It. "the most serene"), the name given to their city by the Venetians.

League of Cambrai, an alliance formed in 1508 by the Emperor Maximilian and Louis XII of France, joined by Pope Julius and others, nominally to fight the Ottoman Turks, but in reality to take the extensive mainland territories of Venice. Venice suffered some initial losses, but with the collapse of the alliance in 1510 virtually all of this territory was regained.

Loggetta, the entrance to the Campanile of St. Mark's Cathedral in Venice, noted for its elegant architecture and statues.

Mannerism (It. *maniera,* "manner, style"), a movement in Italian art from about 1520 to 1600. Developing out of the Renaissance, Mannerism rejected Renaissance balance and harmony in favor of emotional intensity and ambiguity. In **Mannerist** painting, this was expressed mainly through severe distortions of perspective and scale; complex and crowded compositions; strong, sometimes harsh or discordant colors; and elongated figures in exaggerated poses. In architecture, there was a playful exaggeration of Renaissance forms (largely in scale and proportion) and the greater use of bizarre decoration. Mannerism gave way to the Baroque.

Mater Dolorosa (Lat. Mother of Sorrows), a depiction of the Virgin Mary lamenting Christ's torment and crucifixion. There are several forms: she can be shown with her heart pierced by a sword; witnessing Christ's ascent of Calvary; standing at the foot of the Cross; watching as the body of Christ is brought down from the Cross (Deposition); or sitting with His body across her lap (Pietà).

oil paint, a painting medium in which pigments are mixed with drying oils, such as linseed, walnut or poppy. Though oils had been used in the Middle Ages, it was not until the van Eyck brothers in the early 15th century that the medium became fully developed. It reached Italy during the 1460s and by the end of the century had largely replaced tempera. It was preferred

for its brilliance of detail, its richness of color, and its greater tonal range.

palette (Lat. *pala*, "spade"), the board on which an artist mixes colors; the range of colors an artist uses.

pastoral (Lat. *pastor*, "shepherd"), relating to a romantic or idealized image of rural life; in classical literature, to a world peopled by shepherds, nymphs, and satyrs.

Pietà (Lat. [*Maria Santissima della*] *Pietà*, "Most Holy Mary of Pity"), a depiction of the Virgin Mary with the crucified body of Jesus across her lap. Developing principally in Germany in the 14th century (where it was known as *Vesperbilt*), the Pietà became a familiar part of Renaissance religious imagery. One of the best-known examples is Michelangelo's *Pietà* (1497–1500) in St. Peter's, Rome.

polyptych (Gk. *poluptukhos*, "folded many times"), a painting (usually an altarpiece) made up of a number of panels fastened together. Some polyptychs were very elaborate, the panels being housed in richly carved and decorated wooden frameworks. Duccio's *Maestà* (1308–1311) is a well-known example.

putti sing. **putto** (It. "boys"), plump naked little children, usually boys, most commonly found in late Renaissance and Baroque works. They can be either sacred (angels) or secular (the attendants of Venus).

Quattrocento (It. "four hundred"), the 15th century in Italian art. The term is often used of the new style of art that was characteristic of the Early Renaissance, in particular works by Masaccio, Brunelleschi, Donatello, Botticelli, Fra Angelico and others. It was preceded by the **Trecento** and followed by the **Cinquecento**.

Reformation, 16th-century movement that began as a search for reform within Roman Catholic Church and led subsequently to the establishment of Protestantism. This split in Western Christendom had profound political consequences, with the whole of Europe dividing into opposed and often hostile camps. Among the Reformation's leading figures were Jan Huss, Martin Luther, and John Calvin. In Catholic countries patronage of art remained with the Church and courts; in many Protestant countries patronage was increasingly in the hands of the middle classes and new subjects for art were developed to replace the religious imagery that was seen as idolatrous.

Ring of the Fisherman, the official ring of the Pope. First mentioned in the 13th century, and in constant use from the 15th. The ring bears a picture of the apostle Peter, the first bishop of Rome, whose successors the popes are, and the name of the pope in office.

rustication (Lat. *rusticus*, "rural"), in architecture, stonework in which large, square blocks are used, usually with their surfaces deliberately left rough. The intended effect is of massiveness and strength.

Sack of Rome, the plundering of Rome by the mercenaries of Emperor Charles V. They occupied the city from 6 May 1527 to 17 February 1528.

Sacra Conversazione (It. "holy conversation"), a representation of the Virgin and Child attended by saints. There is seldom a literal conversation depicted, though as the theme developed the interaction between the participants – expressed through gesture, glance and movement – greatly increased. The saints depicted are usually the saint the church or altar is dedicated to, local saints, or those chosen by the patron who commissioned the work.

scuole, sing. *sculoa* (It. "school"), in Venice, the religious and social organizations attached to the guilds. They were often wealthy, and played a leading role as patrons of Venetian art.

sotto in sù (It. "up from under"), perspective in which people and objects are seen from below and shown with extreme foreshortening.

studiolo, a small room in a Renaissance palace to which the rich or powerful retired to study their rare books and contemplate their works of art. The *studiolo* became a symbol of a person's humanist learning and artistic refinement. Among the best known are those of Duke Federico da Montefeltro in Urbino, and Isabella D'Este in Mantua.

tempera (Lat. *temperare*, "to mix in due proportion"), a method of painting in which the pigments are mixed with an emulsion of water and egg yolks or whole eggs (sometimes glue or milk). Tempera was widely used in Italian art in the 14th and 15th centuries, both for panel painting and fresco, then being replaced by oil paint. Tempera colors are bright and translucent, though because the paint dried very quickly there is little time to blend them, graduated tones being created by adding lighter or darker dots or lines of color to an area of dried paint.

Terra Ferma (Lat. *terra firma,* "solid ground"), the mainland possessions of the Venetian Republic.

woodcut, a print made from a wood block. The design is drawn on a smooth block of wood and then cut out, leaving the design to be printed standing in relief. The person who carved the woodcut often worked to a design by another artist.

SELECTED BIBLIOGRAPHY

The Genius of Venice, 1500–1600, exhibition catalogue, London 1983

Titian, Prince of Painters, exhibition catalogue, Munich/Venice 1990

Le Siècle de Titien, exhibition catalogue, Paris 1993

Chiari Moretto Wiel, Maria Agnese: Tiziano Corpus dei disegni, Milan 1989

Dolce, Lodovico: Dialogo della pittura inititolato l'Aretino, 1557, ed. by Paola Barocchi, in Trattati d'arte del Cinquecento, II, Bari 1960–62

Hetzer, Theodor: Tizian. Geschichte seiner Farbe, Frankfurt a. M. 1935

Manca, Joseph (ed.): in Studies in the History of Art 45, Hanover/London 1993

Muraro, Michelangelo und David Rosand: Tiziano e la silografia veneziana del Cinquecento, Venice 1976

Pallucchini, Rodolfo: Tiziano, 2 vols., Florence 1969

Rosand, David (ed.): Titian. His world and legacy, New York 1982

Tiziano e Venezia, Convegno Internazionale di Studi, Venice 1976, Vicenza 1980

Vasari, Giorgio: Le vite de'più eccellenti Pittori, Scultori e Architettori, 1568, ed. by Giovanni Milanesi, 9 vols., Florence 1878–1885

Wethey, Harold E.: The Paintings of Titian, 3 vols., London 1969–1975

PHOTOGRAPHIC CREDITS